Rizzoli **Electa**

QUEER
MAXIMALISM
✕
MACHINE
DAZZLE

my heartfelt gratitude to everyone who made *Queer Maximalism* a reality. The contributors to the exhibition and this publication generate a guest list to the greatest party of all time. THANK YOU!

The Museum of Arts and Design and everyone in it, how do you do it? Elissa Auther, the day we met changed my life. There is no other way to say it. Alida Jekabson, you're still here after hours of looking at pictures of me in every state imaginable. Special thanks to Sasha Nixon and Willow Holdorf for EVERYTHING! And Tim Rodgers, I only have one request . . . Lie to me!

I bow down to all the donors to MAD and this beast of an exhibition. You are a driving force behind the power of creativity to make the world a better place, bless you!

Thank you Isabel Venero, Rizzoli Electa, and authors for this exquisite publication. Mike Albo, you were one of my first muses – the glitz and glitter paved the way for everything that followed. Mx Justin Vivian Bond, trashy, gorgeous, and instant looks good on you! Especially after a couple bottles of Whispering Angel. madison moore, you are beyond fabulous, I want moore, moore, moore! David Román, money, tickets, passport, honey! I will design luggage based on your dedication to cross continents to see a show! Sally Gray, let's have lunch and wear hats, my treat! Kalle Westerling, I'm happy you're keeping track of all of this so I remember what the hell I did last year. And Taylor Mac, the skies we fly, the nests we build, the eggs we lay and the worms we feed the children get me out of bed in the morning. The higher the heels, the closer to the Goddess!

Speaking of the Goddess . . . So many stages with so few pages, so let's start with a huge ovation to Pomegranate Arts, producers of *A 24-Decade History of Popular Music*. To Linda Brumbach, Alisa Regas, Rachel Katwan, and Jeremy Lydic, I am so proud of the work we make. I can't do it without you. Here's to many more collaborations and the world! This work was further made possible by the Park Avenue Armory, MASS MoCA stars Kristy Edmunds and Sue Killam, team Curran theater, team St. Ann's Warehouse, team Materials for the Arts, and many other producers and assistants we've had on the road over the years – you know who you are.

Treasure awaits thanks to Duke Dang, Works & Process at the Guggenheim, Rockefeller Brothers Fund, and Lumberyard in Catskill

Making *Treasure* was a dream come true. I shared that stage with Viva DeConcini, Bernice Boom Boom Brooks, Mary Feaster, Gordon Beeferman, and Marika Hughes. Crafty assistants Elizabeth Laule and Maya Dzwil, you both saved my caboose! Models Dusty Shoulders, Tangerine Jones, Francis Sorensen, Emma Bizzack, Kemar Jewel, Otis Del Core, Darlinda Just Darlinda, Una Osato, Michi Osato, Matty Crosland, Ashton Muñiz, and Ellen Zerkin, I love you all! Gregory Kramer, I am finally a cover girl, thanks to you!

Natasha Bowdoin, we made magic together with help from Alison Weaver and the Moody Center for the Arts! Your installations are not safe from spontaneous high concept camouflaged drag activation in stilettos! Shining a pin spot on models Jillian, Joseph, Elissa, Davis, Seth, and Nonie.

Godfrey Reggio, you are a wonder! Thank you everyone at opticnerve for the Red Hook memories with Jon Kane, Mara Campione, Sussan Deyhim, Mike Tyson, Tara Starling Khozein, Brian Belotti, John Flax, and everyone else. Extra special squeeze to Apollo Garcia for the spark!

To my original family, the Dazzle Dancers, you took this Machine to be your unlawfully shredded spandex. I WORSHIP YOU: Dazzle, Pretty Boy, Cherry, hoLe, Robbie, Vinnie, Sochny, Rinky Dinky Dazzle, Chunky Cupcake, Besamé, DT, Edible, Negro Noir, Chalupa, Propecia Dasani Destiny POTS, Booty Du Chef, Cornflake, Smoky, Houdini, Shawarmi, Dazzle Star, and oh so many others.

Extended gratitude to United States Artists, Monira Foundation, Charlotte, Andrew Martin-Weber, the Pixie Harlots, Jim Bott, Phoebe Legere, Earl Dax, Bec Stupak Diop, The Jackie Factory, the GLAMericans, Leslie Chihuly, Holly Jacobson, Willa Folmar, Jack Rivas, Jonathan Marder, Kambiz Shekdar, Charles Katzenstein, Mikael Karlsson, Kathe Mull, Gerard Kouwenhoven, Patrick Fromuth, team Branded Saloon, and everyone else along the way.

Eileen, you see me, I love you.

Finally, I must thank me. Buying that one-way ticket to New York in 1994 is the first and best decision I ever made for myself. I recommend following your heart and trusting your deepest instincts. Be yourself, be strong, and with patience, the universe will open.

There are a multitude of people behind this catalog and the exhibition it accompanies, and I am grateful to all of them. Above all, I would like to thank the artist Machine Dazzle, whose approach to design, hand-making, and sculpture as a wearable art form contributes a new, unique chapter to the Museum of Arts and Design's history of exploring creative communities where craft is at the center of the story. Thank you as well to Machine's many collaborators spanning the artistic spheres of cabaret and drag, theatrical set design, performance art, New York nightlife, and fashion. Your enthusiasm and desire to help support this project were key to its development and realization. This project is an in-depth investigation into the relationship of craft to the construction of queer identities and histories. To Machine (and his queer cohort), thank you for your courage and dedication to the marvelously over decorated, the affirmation of hybridity over purity, and the valuing of different kinds of bodies in the pursuit of an inclusive society.

There are many others who have played very important roles in the realization of this project. Thank you to Linda Brumbach and Alisa Regas of Pomegranate Arts for their unflagging support of the exhibition from the beginning. I am immensely grateful to them for the loan to the exhibition of the costumes from *A 24-Decade History of Popular Music* and for supporting Machine through the process of restoring them. The exhibition couldn't have been realized without the inclusion of this important body of work. My gratitude also extends to additional lenders to the exhibition, including Taylor Mac, Mx Justin Vivian Bond, the Dazzle Dancers, Godfrey Reggio, Natasha Bowdoin, and Leslie Chihuly.

I am honored to include my writing about Machine Dazzle alongside the essays of the other contributors to this publication: Mike Albo, Mx Justin Vivian Bond, Sally Gray, Taylor Mac, madison moore, David Román, and Kalle Westerling. The unique perspective each of you brought to the history and interpretation of Machine's costume design as a critical creative form plays a crucial role in the overarching objective of the exhibition to ground his practice in contemporary visual culture. To Isabel Venero, I thank you for believing in the exhibition, and thus recognizing the potential of the book, as well as thoughtfully shaping its design with the wonderful Jesse Kidwell. A special thanks goes out to all the photographers who took the time to document Machine's career over the years and generously contributed their work to the book — in many

cases your photographs are the sole evidence we have of Machine's earliest works. Thank you to Grant Klarich Johnson, who encouraged me to pursue the idea of exhibiting Machine's costumes in the first place. Your conviction kept the idea alive in my mind through myriad setbacks associated with the pandemic. Throughout the development of the exhibition and publication I benefited immensely from the questions, feedback, and insight of Patrick Greaney. His perspective on the significance and challenges of writing about unorthodox histories of art was a constant reassurance of the value of the project.

Developing and carrying out an exhibition of this size, scope, and design takes a large team, and numerous colleagues at MAD have been instrumental to its success. This project would have never left the drawing board without the dedication, creative vision, and expertise of Willow Holdorf, Sasha Nixon, and Thuto Durkac-Somo. Thank you for creating a multi-sensory experience for visitors. Hugs to the entire Education Department for hosting Machine as an artist resident before and during the course the exhibition. Thank you also to Wendi Parson, Iman Nelson, and Alix Finkelstein for the specialized thinking that goes into translating a physical exhibition into digital and social media forms for a broad public audience, and to Elana Hart for directing the grant writing. A very special acknowledgement and thanks is owed to Alida Jekabson, the curatorial assistant dedicated to this exhibition. I cannot express enough my gratitude for your commitment, insightfulness, problem solving acumen, and graceful project management of this exhibition and publication. When my attention was frequently pulled elsewhere, you continued to keep the project moving forward.

I would like to thank MAD's director Tim Rodgers and the museum's board of trustees for their enthusiasm surrounding the exhibition and warm welcome of Machine into the museum's orbit of events and programs. I also gratefully acknowledge funding from the National Endowment for the Arts in support of the exhibition. Last, but not least, I am very thankful to Andrew Martin-Weber, whose generous spirit and deep appreciation for the theatrical genius of Machine Dazzle was instrumental to the realization of the exhibition at its highest level.

Elissa Auther

A MACHINE THAT DAZZLES

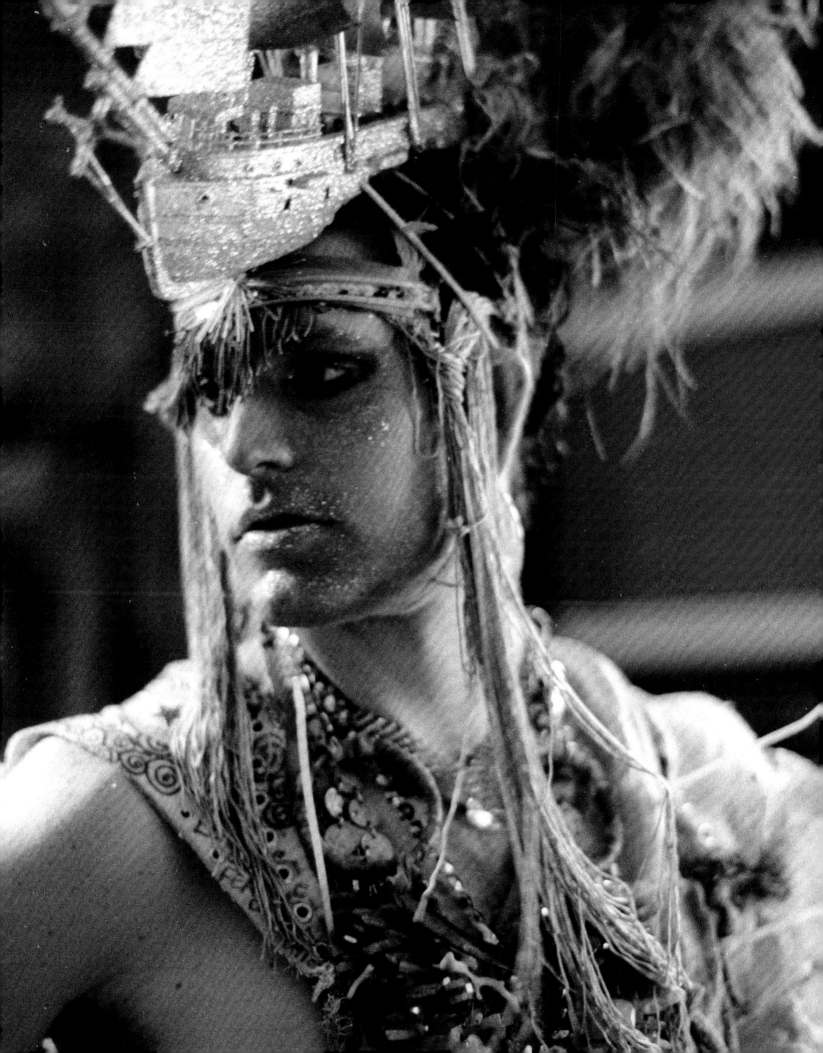

The name Machine Dazzle – an unlikely juxtaposition of an apparatus powered by an engine with the verb meaning to take one's breath away or temporarily leave one blinded (in a good way) – was adopted by the artist Matthew Flower when he joined the performance group the Dazzle Dancers (p. 13). Founded in New York in 1996, the Dazzle Dancers are best characterized as *Solid Gold* meets radical cultural liberation. They are known for their cheeky sense of humor and a propensity to get naked. The moniker Machine referenced the artist's seemingly inexhaustible reserve of energy when it came to dancing. Today, the name aptly describes artist and designer Machine Dazzle's non-stop, inventive approach to the art of costuming and performance.

Born in 1972 in Upper Darby, Pennsylvania, Machine spent his childhood in the suburbs of Houston, Texas, and his teens in Idaho and Colorado. When you ask him about early formative experiences, there are two stories he highlights as responsible for opening the horizon of possibility inspiring his future as an artist and designer. The first story features Machine as an unsupervised eight-year-old who rode his bike to the local movie theater to see *Xanadu.* He was enthralled. The excesses of this Olivia Newton-John roller-skating musical fantasy – the fashion, fabrics, time travel, dance, and otherworldly lighting effects – made an impression that continues to fuel his decoratively dense, kaleidoscopic aesthetic. "I credit Bobbie Mannix, who was the costume designer [for *Xanadu*], as starting my path . . . It's all her fault," he claims.[1] In the second story, Machine asks for tickets to *The Nutcracker* for his tenth birthday gift. Not only was he transported by the magical staging of the piece, but it was also the first time he had seen children performing on stage. The experience was both "a rush and a little bit depressing,"[2] he recalls, due to the way it mixed the elation of identification with the distress of knowing that he lacked access to a world where creative talent was valued and nurtured.

It wasn't until he attended the University of Colorado Boulder, as an art major that Machine found a world that supported his creative development. Buoyed by the experience, he moved to New York City in 1994 to pursue life as an artist. He landed in an orbit of overlapping creative scenes and practices, from avant-garde art and performance to the theatrical subgenres of cabaret and drag to the audacious nightlife club culture and the street parades of New York – and all of it shaped his distinctive, over-the-top, maximalist approach to design.

Machine's introduction to performance art took place at Exit Art, the legendary alternative exhibition space in SoHo known as a hotbed of

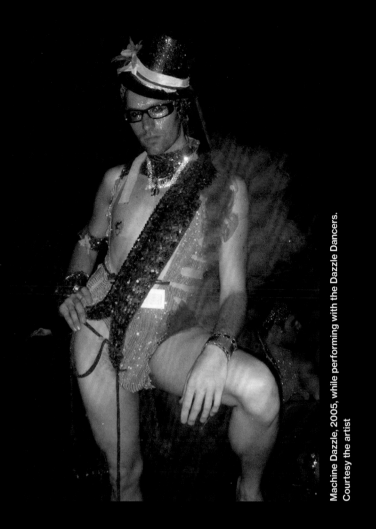

Machine Dazzle, 2005, while performing with the Dazzle Dancers. Courtesy the artist

cross-disciplinary practice bringing together art, theater, poetry, film and video, and music under one roof. Founded in 1982 by the art historian and curator Jeanette Ingberman and the artist Papo Colo, Exit Art hosted a radical program of exhibitions and performances focusing on marginalized artists whose work was outside the aesthetic and political mainstream.[3] Machine joined the staff at Exit Art and in addition to learning how to mount exhibitions and installations, he became familiar with the fluid movement between creative styles and genres that was a hallmark of the venue's program. That provided a foundation upon which Machine developed his own practice, spanning a wide range of visual and performing art forms and contexts. In addition to working at Exit Art, Machine exhibited drawings and staged his first performance pieces there.[4] One of them, Machine recalls, for the show *The Shape of Sound,* was about *Star Wars,* another film with a lasting influence on his style. The performance involved Machine activating an installation by Colo consisting of used tires strewn about an otherwise empty gallery.

Within this raw landscape, Machine appeared dressed as a combination of Darth Vader and Princess Leia and proceeded to give birth to a storm-trooper, with a mash-up score invented to evoke the distinctive sound-scape of the film cued to the iconic costuming.

The queer theatrical subgenres of cabaret and drag, and the performances of in-house divas and entertainers at nightclubs in the mid- to late 1990s, also played an important role in Machine's develop-ment as an artist. Machine was a regular at venues like the Meatpacking District nightclub Mother, where at Jackie 60 – one of the club's weekly parties – he imbibed the performances of a range of drag and burlesque luminaries, including Joey Arias and Julie Atlas Muz, and the transgender entertainer and party host Amanda Lepore. Musical acts and performances at other queer and trans-oriented parties, like SqueezeBox! at Don Hill's, Homocore at CBGB, and the beloved Stevie Nicks tribute party Night of 1000 Stevies, were also influential creative milieus for Machine that emphasized audacious forms of self-presentation where costume was equal parts sculpture, stage set, and a form of social and political positioning.

For Machine the street was (and continues to be) a theater, and he began using it as a stage soon after he arrived in New York. The evolution of his design style can be gleaned from photographs of his yearly appearances at the Mermaid Parade (pp. 11, 14), the Invasion of the Pines on Fire Island (p. 15), Pride-related and Queer Liberation Marches (p. 19),

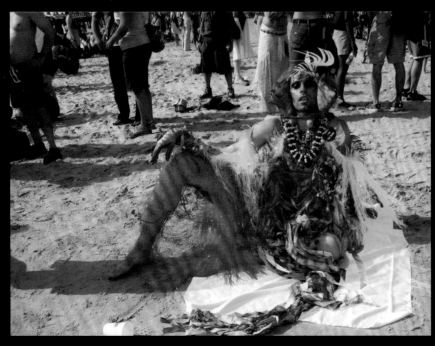

Machine Dazzle, Coney Island Mermaid Parade, 2004, Brooklyn, NY. Courtesy the artist

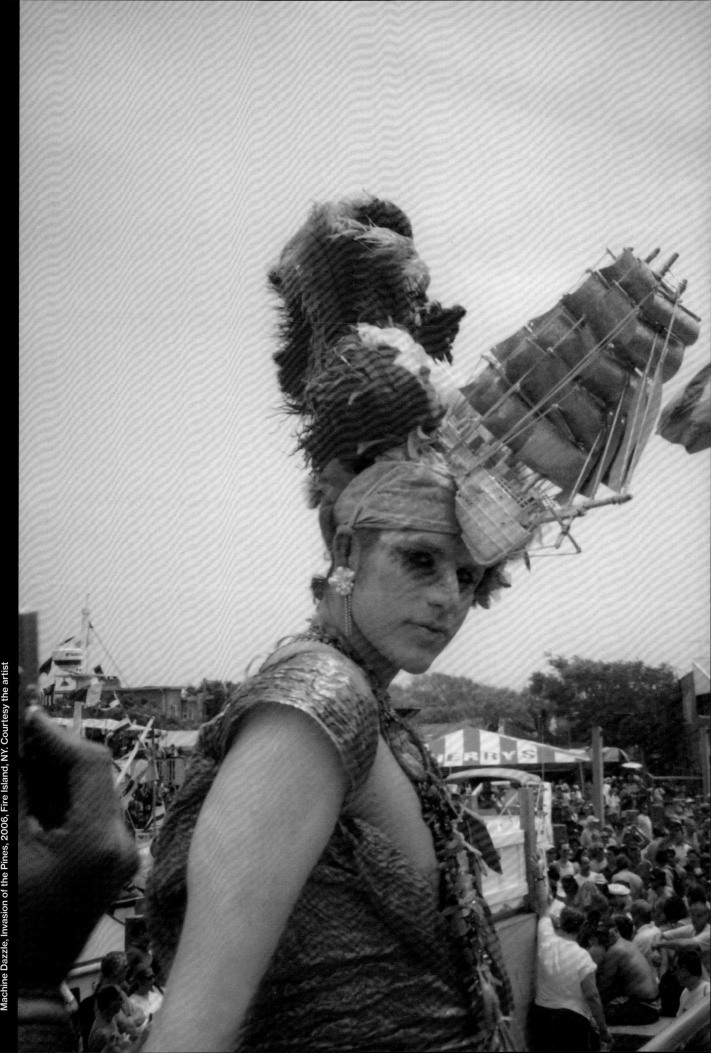

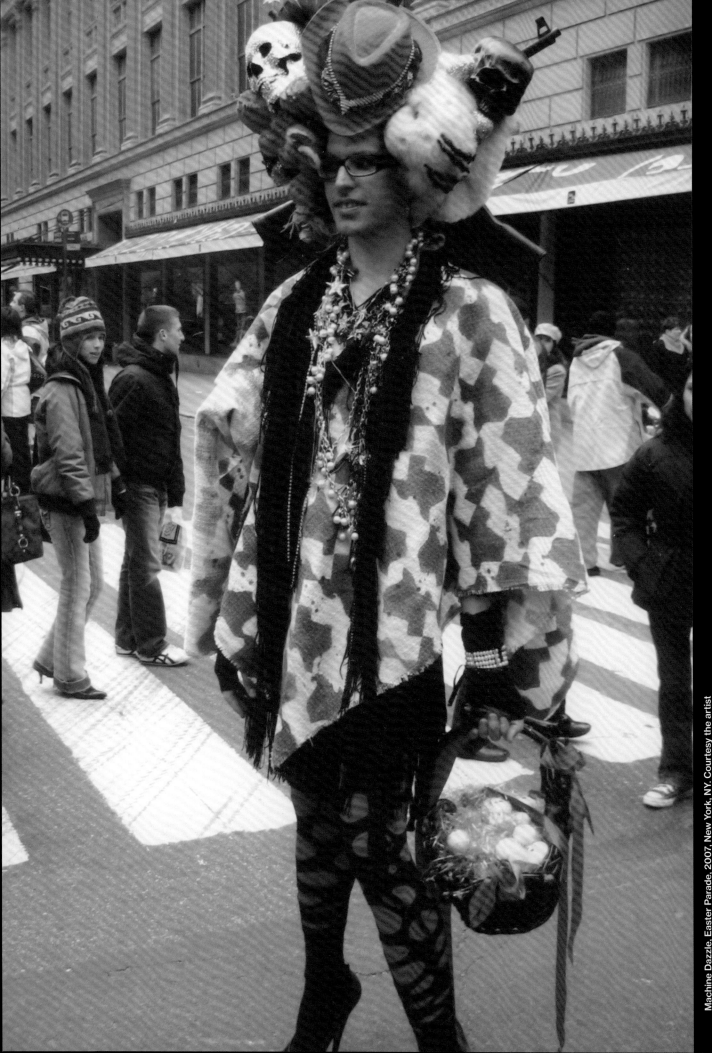

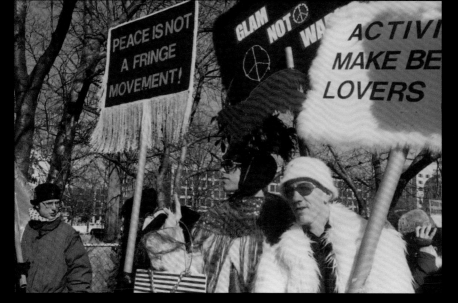

Machine Dazzle, GLAMericans for Peace, 2003, Washington, D.C. Courtesy the artist

and the Halloween and Easter parades (p. 16), as well as his participation in political demonstrations with Gays Against Guns and GLAMericans for Peace (above).[5] Evident from the beginning in photographs of the costumes and getups for these contexts and events is Machine's resourceful, creative use of disparate, often salvaged materials – fabric remnants, surplus trim, discount trinkets, souvenirs, costume jewelry, and scavenged fake flowers. Machine is a self-taught designer, and there is a distinctive do-it-yourself approach to the clever, whimsical, and witty combination of these eclectic materials. He admits, "I use a sewing machine like a lot of people would use a hammer. I destroy my sewing machines . . . I mean, I have skills, but I'm a costume designer; I'm not a tailor. I make headpieces; but I'm not a milliner."[6] His queer bricolage self-consciously makes a display out of cast-offs that he cobbles together into a culture created for himself. "There are all these [queer] creatives in history who might have been looked at as being crazy . . . and I feel like I'm representing them. I love the counter-culture: the punks, the DIY people, the people who never really fit into society. I think about that every time I sit down to my sewing machine."[7] As he came to create works for other queer performers in cabaret or theatrical settings, Machine has preserved an unusually high level of independence as a designer in the sense that his creations do not illustrate a mono-logue, script, or song lyric. Nor is he a maker of period-style costumes. Instead, these are wearable "living sculptures,"[8] as the theater historian

A Machine That Dazzles Auther

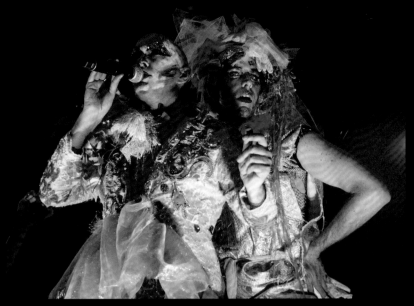

Machine Dazzle on stage with Taylor Mac, *A 24-Decade History of Popular Music*, 2016.
Photo: Josef Beyer

Kalle Westerling calls them, that create visual and emotional resonance between his selection and treatment of materials and the queer bodies that bring them to life on stage. As he insists, "I'm more interested in what a costume is about, rather than how it's made. I don't need precise lines. I want the story. . . . I'm an audience-oriented designer."[9]

Machine made his professional foray into design around the year 2000, creating costumes in the early aughts and beyond for Julie Atlas Muz and a host of others, including Lady Rizo, Glenn Marla, Faye Driscoll, Jeremy Wade, Stanley Love, Bianca Leigh, and Miguel Gutierrez.[10] In 2001 he became involved with the Dazzle Dancers (p. 13), first by way of costuming and then also as a dancer, and his involvement with the group led to his adoption of the name Machine Dazzle. By far the most prominent of the performance troupes Machine has worked with, the Dazzle Dancers staged appearances that highlight the fluid movement of his design across the worlds of music, queer culture, and the contemporary art world; they have appeared on stage with Blondie, at numerous queer parties and clubs, and as part of New York City's Art Parade (p. 22).[11]

Founding member Mike Albo, who writes about the Dazzle Dancers' formation in this volume, notes the gleeful ethos of the troupe as "about embracing all body types, being naked, seeking peace."[12] This kind of fun was a political act in New York City under the reign of mayor Rudy Giuliani, whose quality-of-life platform included targeting clubs and unofficial parties with new and existing regulations, with the end goal of

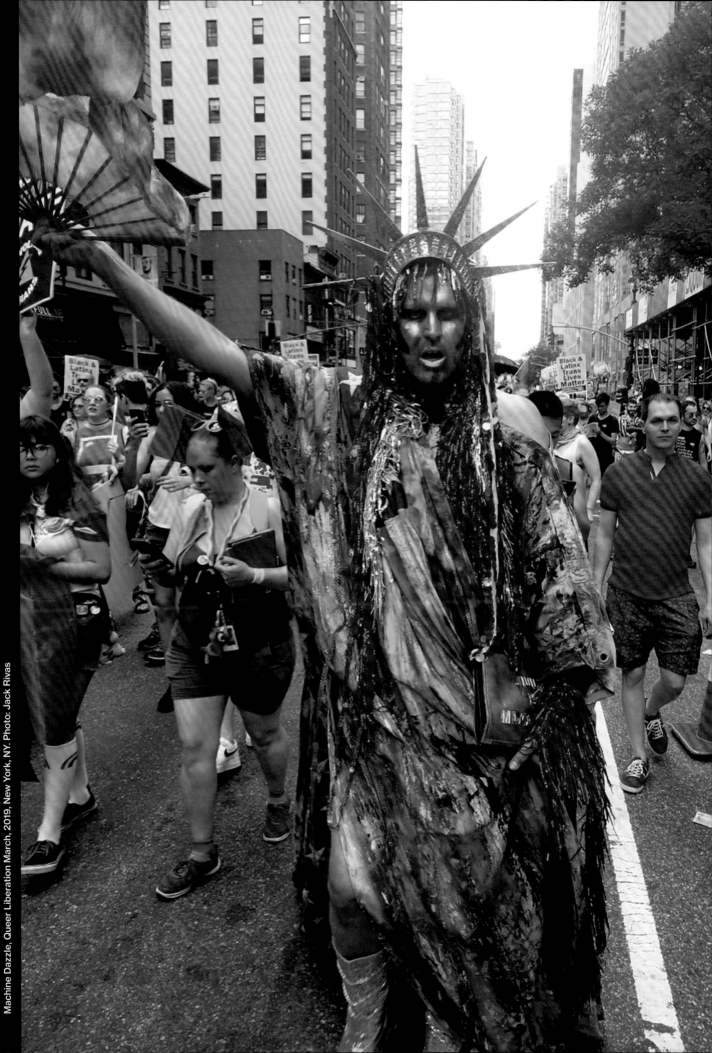

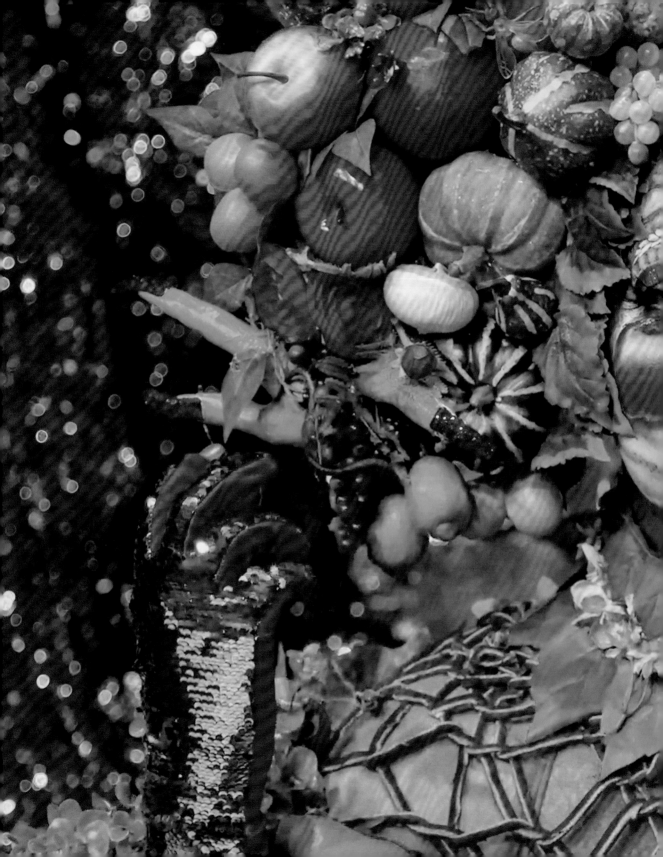

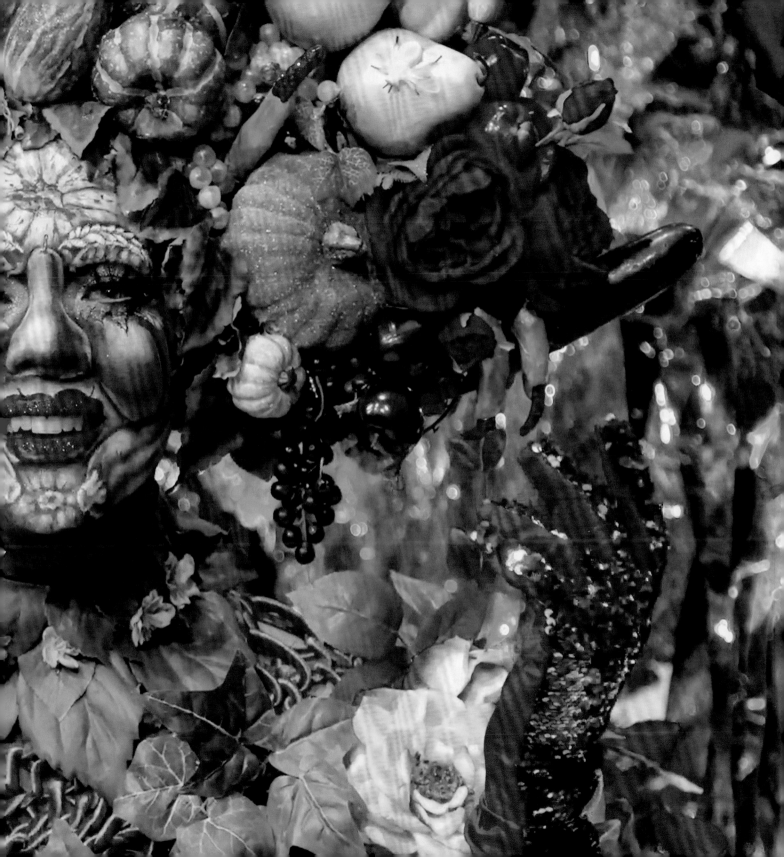

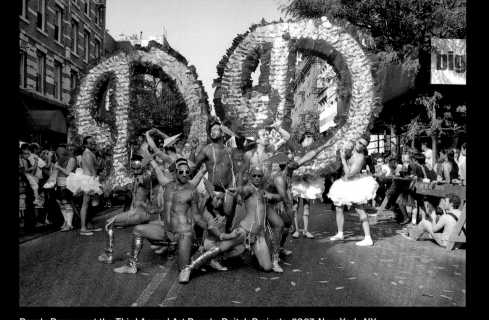

Dazzle Dancers at the Third Annual Art Parade, Deitch Projects, 2007, New York, NY.
Courtesy hoLe Dazzle

ining many out of existence. However, a diverse crowd intent on defying
he pacification of nightlife in the city carried on, and as the journalist of
New York City nightlife Michael Musto has written about this period, "In
his new era of tightening regulations, being outrageous took on a differ-
ent air."[13] The Dazzle Dancers were representative of what outrageous
could look like, taking to the stage in spandex and glitter with choreogra-
phy borrowed from the routines from the local strip club and backup
dancers on 1980s countdown shows. Machine joined the Dazzle Dancers
as the costume designer, and the look he created and honed — fondly
known as the D-string — became a principal element of the camp aes-
thetic of the troupe. Simple and meant to be shed on stage, the D-string
consisted of tubes of metallic, neon-hued, or animal print spandex placed
over the body and then shaped to it with a multitude of strategically
placed cuts. The look was topped off with an abundance of body glitter
and glitter-adjacent makeup that became the group's signature style in
the heyday of their appearances in the first decade of the new millen-
nium. The synergy between the costuming and the crowd-pleasing ama-
teurism of the troupe's dancing is captured in its fullest expression in
the music video the Dazzle Dancers created for their 2008 CD release,
The Love Boat (p. 23).[14] Everyone does their best to keep to the beat, and
you can't miss the homage to *Xanadu* in the sparkling special effects.

In the early 2000s, Machine also worked with the cabaret
artist and recording artist Mx Justin Vivian Bond, and he established a

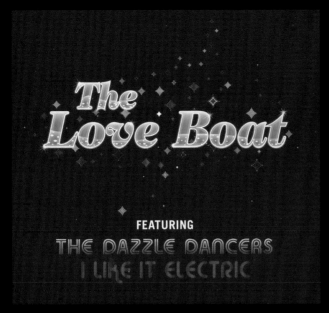

Cover for *The Love Boat*, featuring the Dazzle Dancers, 2008.
Produced by I Like It Electric and Craig C. for the Other One and Peace
Bisquit, Brooklyn, NY. Courtesy the artist

professional partnership as the costume designer for the singer-songwriter, playwright, and performance artist Taylor Mac – a relationship that continues today (pp. 20–21). Among others, Machine created Mx Bond's set and costumes for *Re:Galli Blonde (A Sissy Fix)*, a performance about the Roman Empire's gender variant Order of the Galli (p. 81), and their looks for the 2007 and 2008 cabarets *Lustre, a Midwinter Trans-Fest* and *Lustre: A Summer Solstice Trans-Perversion*.[15] A notable XXX creation for Mx Bond's solo show at Poisson Rouge, *Happy Tranniversary!,* (p. 69) survives and is included in this exhibition; it is composed of multiple layers of individually laminated photographs cut from gay porn magazines that slide around like fringe. As part of Bond's cabarets in this period, Machine also performed with the Pixie Harlots, a comedic drag troupe for which he designed his own costumes.[16] The troupe made regular appearances at numerous clubs and parties in New York City between 2005 and 2008.[17]

Machine's work with Taylor Mac began in 2008 with *The Lily's Revenge: A Flowergory Manifold* (p. 74), a five-act play that opened in 2009.[18] The piece blended elements of Japanese Noh theater, burlesque, puppetry, musicals, and dance in a story about love and marriage against the backdrop of the period's anti-gay marriage rhetoric and legislation. The setting for the story of a bride and a hopeful lily was a garden/

dressed as a potted Lily (p. 25). Machine designed forty costumes for the production, and although they do not survive, even backstage snapshots highlight his ingenious stagecraft in the design and combination of relatively modest materials for a maximal take on the botanical theme. Machine himself appeared in the play as a daisy, setting the precedent for subsequent collaborations with Mac that would come to incorporate official on-stage appearances in the roles of designer and dresser.

The next collaboration with Mac was for the 2011 production *The Walk Across America for Mother Earth* (p. 27). Described as "political activism meets bedazzled drag show,"[19] *Walk Across America* is the adventure of two young friends fleeing suburbia to join a group of activists on a protest march from D.C. to Nevada. For this piece, Machine created multiple "glorious, lunatic regalia," inspired by *commedia dell'arte*, a sixteenth-century theater genre that originated in Italy, filtered through contemporary archetypes such as the hippie, the gay militant, and the radical feminist.[20]

Shortly after *Walk Across America* premiered, Machine began work on what would become his tour de force of design to date—his costumes for Mac's *A 24-Decade History of Popular Music*, which premiered in 2016 and toured through 2019.[21] A "radical faerie realness ritual" in Mac's words, *A 24-Decade History* is a revisionist history of the United States since 1776, explored through 246 songs popular in communities throughout the country. It was conceived to be performed in a single twenty-four-hour period. Machine created a costume for each decade with some incorporating layers that were unveiled as the songs progressed. Machine also appeared onstage as Mac's dresser, changing him in front of the audience for every decade, every hour, of the show. For these appearances another twenty-two costumes were created and worn by Machine (pp. 18, 29).[22] To provide an example of the uniqueness of *A 24-Decade History* as a performance concept and the design challenge it posed for costuming, acts one and two (covering the period from 1776 to 1836) narrated the American Revolution from the perspective of Yankee Doodle Dandy; the first-wave feminist movement; drinking songs versus temperance songs; the intertwining of colonization and heteronormativity; and songs popular with children during the Indian Removal Act, among other themes. Act seven—1956 through 1986—is summarized as "Bayard Rustin's March on Washington leads to Queer riots" and "sexual deviance as revolution in the backroom sex party."[23]

Machine's costumes for this complex work draw freely from each decade's clothing styles, but they do more than that. They evoke the

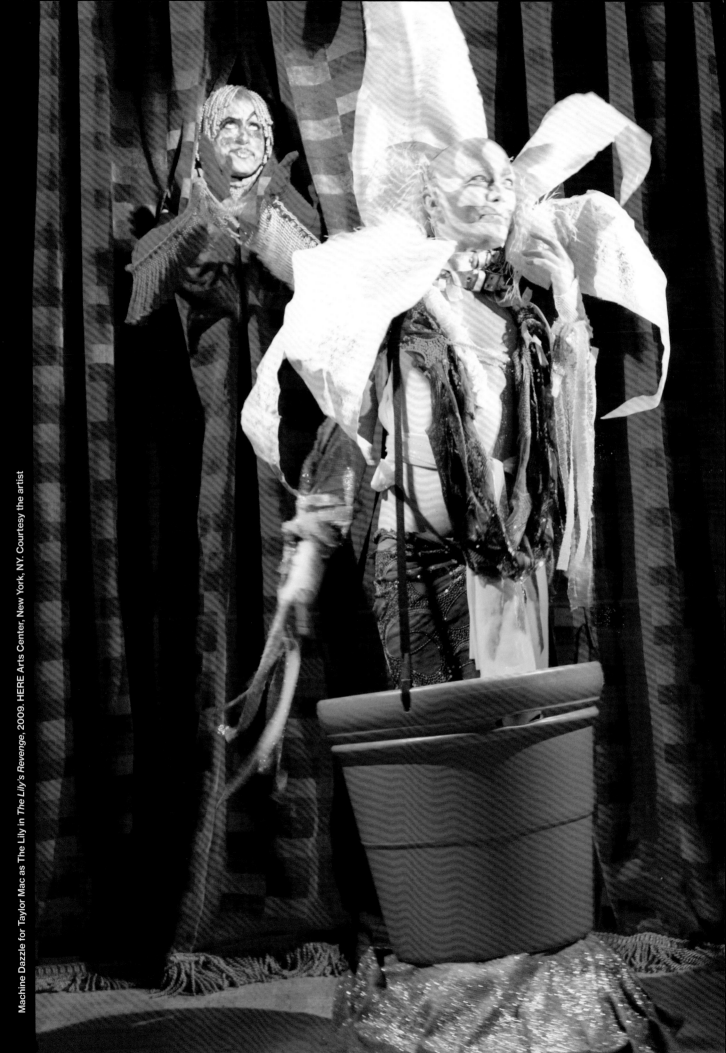

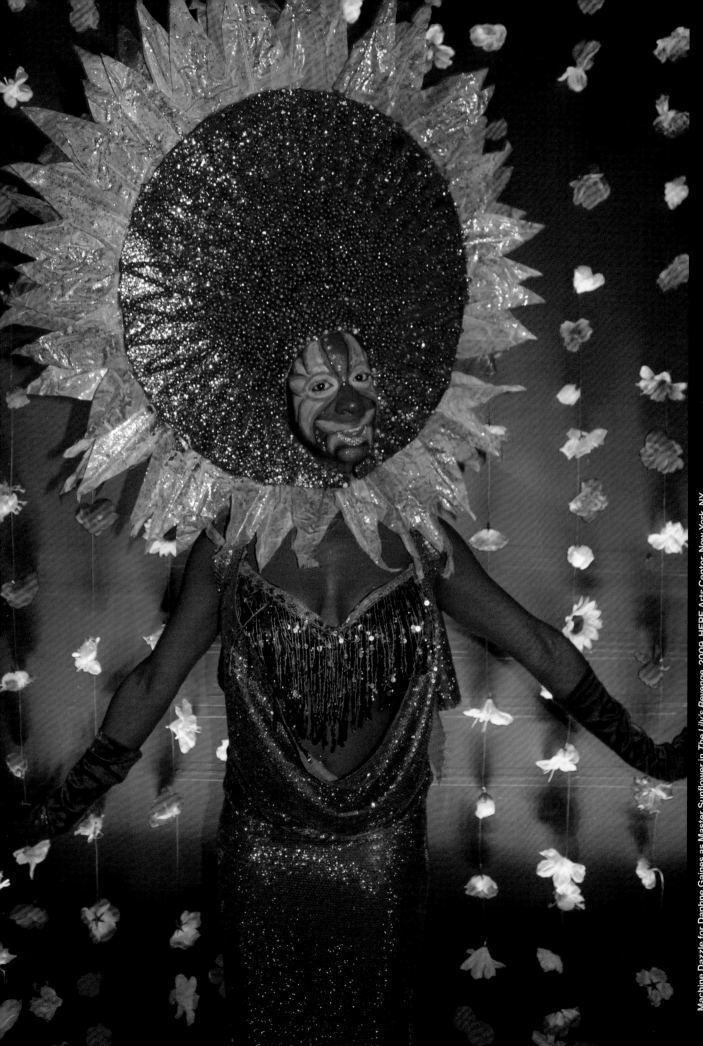

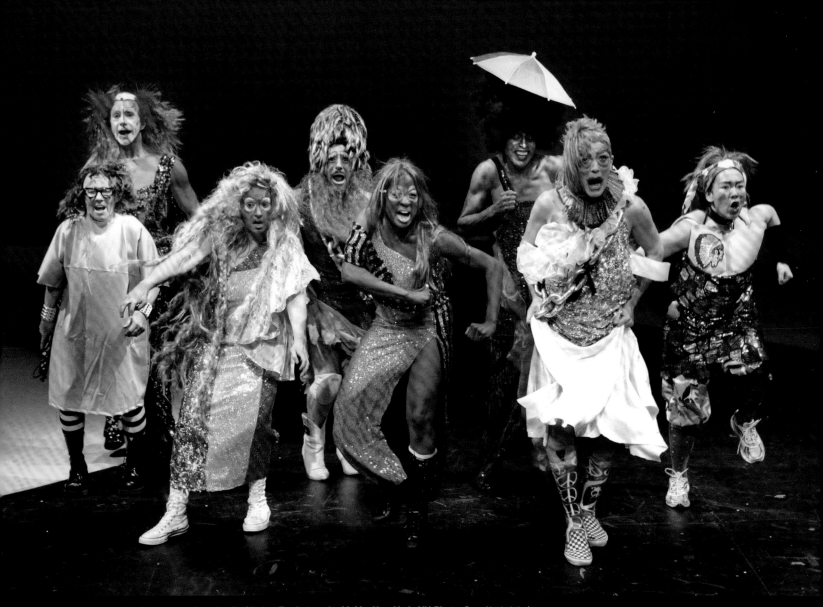

A scene from *The Walk Across America for Mother Earth*, 2011, La MaMa, New York, NY. Photo: Sara Krulwich / The New York Times / Redux

politics, social trends, inventions, tragedies, and other notable events of each given era. He explains, "I would look at what people were wearing for a start, just to get a general silhouette."[24] The final result reawakens the past for the present, often through the use of common, mass-produced objects presented in unfamiliar ways. There are visual references to major inventions, such as the steam engine and the typewriter, and the use of actual gas masks, multitudes of Slinky toys, zippers, 3D movie glasses, and yards of camouflage fabric, among a host of other objects repurposed for headpieces, wigs, and garments. The layered iconography of an era Machine created wasn't intended to illustrate the American songbook from which Mac draws, but rather to offer a parallel story that further amplified the queer recontextualization of the songs. For instance, for decade one, songs popular during the American Revolution (p. 30), rather than dress Mac in a (perhaps expected) star-spangled banner ensemble, Machine designed a cheerleaderesque sequined sports jersey numbered thirteen and paired it with an eighteenth-century hoop skirt festooned with a string of primary colored, plastic pennant flags of the sort used to celebrate the grand opening of a strip mall. The look was topped off with an allusion to a Fourth of July fireworks display in the form of a silver, lattice-like armature covered in Mylar star-shaped bows that Mac wore like a jetpack. This hilarious take on themes of team spirit, the celebration of founding moments, and American entrepreneurial drive presented its own visual commentary on Mac's deconstruction of patriotic songs without serving as illustrations. For decade twenty-three (1996 through 2006), songs popular with radical lesbians (p. 31), Mac bore prosthetic breasts scrawled with the words *goddess* and *sister*, wore cargo shorts, combat boots, and a voluminous full-length fringed vest made from plaid flannel shirts, and gave birth to himself on stage through a butterfly/vulva-shaped fabric sculpture that descended from the ceiling to become another garment. Combining vaginal imagery à la Judy Chicago, with the butch realness of earlier lesbian generations, 1990s riot grrrls, and grunge punk, the ensemble brought to life a whole history of feminist bodies and sartorial politics for a set of songs by artists that ranged from k.d. lang to Sleater-Kinney. As the staging of *A 24-Decade History* was minimal, these costumes also functioned as stage sets that transformed before the eyes of the audience as Machine appeared on stage to undress and redress Mac, pushing the narrative along.

A 24-Decade History of Popular Music brought increased attention to Machine's work as a costume designer, and the show received the

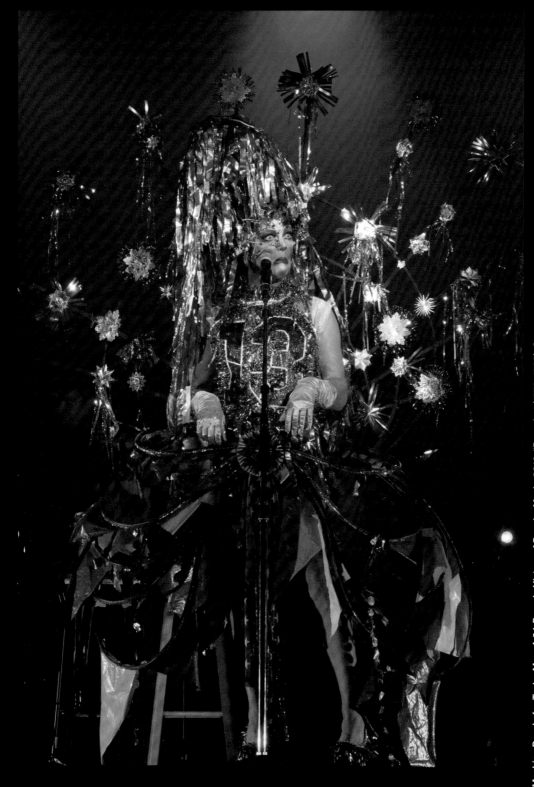

Machine Dazzle for Taylor Mac, *A 24-Decade History of Popular Music*, 2016, "Decade 1 (1776–1786): Songs Popular During the American Revolution." Mixed media, fabric, sequins, and plastic; dimensions variable. Courtesy Pomegranate Arts, NJ. Photo: Josef Beyer

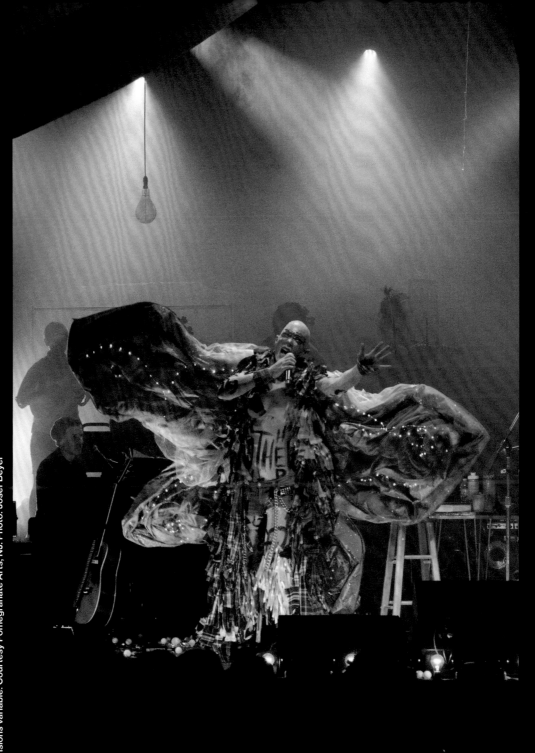

Machine Dazzle for Taylor Mac, *A 24-Decade History of Popular Music*, 2016, "Decade 23 (1996–2006): Songs Popular with Radical Lesbians." Latex, mixed-blend fabric, paint, chains, plastic, ribbons, and holiday lights; dimensions variable. Courtesy Pomegranate Arts, NJ. Photo: Josef Beyer

Bessie Award for Outstanding Visual Design in 2017. The same year Machine received a Henry Hewes Award for costume design. A residency at the Park Avenue Armory supporting the creation of the *24-Decade History* costumes led to additional collaborations with Urban Bush Women and the director and performance artist Niegel Smith for *The Fre*.[25] With Taylor Mac, Machine has also created costumes and sets for *Holiday Sauce* (pp. 20–21), an annual queer Christmas cabaret fantasia running since 2017 in which he has performed (as a Christmas tree). Recent and current work with Mac includes the costumes for *Whitman in the Woods* and *The Hang*, a musical production highlighting queer cultural icons.[26]

The catwalk or runway fashion show as a performance context is also a touchpoint for Machine's work. In 2001, he presented new, original creations at a "fashion brunch" titled *Machine Made* and advertised as "Costume, Elegance, Sculpture, Trash" that included an appearance by the Dazzle Dancers.[27] The runway format also appeared in a collaboration with the artist Natasha Bowdoin. In her 2019 installation *Sideways to the Sun* at Houston's Moody Center for the Arts, Bowdoin created an environment consisting of an immersive floor-to-ceiling treatment in a hand-cut, monumentally scaled, Alice-in-Wonderland-like vinyl floral pattern. Punctuating the space were scenery wagons, mobile platforms that supported three-dimensional cutouts in the same floral pattern. Invited to activate this stage-like space, Machine created costumes for seven performers in a color palette and patterns that camouflaged their bodies until they began to move (pp. 34–35). The performers traversed the space with the gait and imperious air of runway models, in a performance broken up by campy pantomime and comedic interactions with props.[28]

Alongside his costume design and performance, Machine has also been an active songwriter, a practice he has honed over the past decade and has begun to develop for the stage.[29] His performance *Treasure* (p. 33) for the Guggenheim Foundation's Works & Process performing arts series opened its 2019 installation season at the Peter B. Lewis Theater at the Solomon R. Guggenheim Museum. *Treasure* combined a running monologue punctuated with songs written and performed by Machine about coming out to his mother, her revelation about a child given up for adoption, and her untimely death shortly after Machine's departure for New York.[30] The monologue and costumes are poignant and funny. Themes of escape, travel, and freedom (for both mother and son) extend to the costumes and accessories like suitcases made

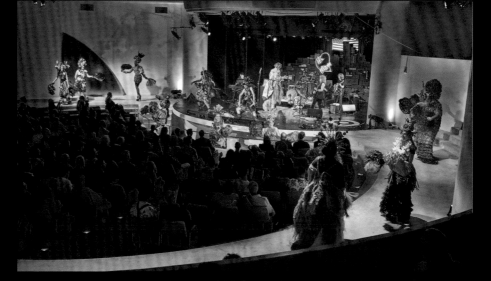

Machine Dazzle, *Treasure* (performance still), 2019. Commissioned by Works & Process at the Solomon R. Guggenheim Museum. Photo: Robert Altman

for thirteen performers who walk a fashion show (p. 118). During the pandemic, Works & Process premiered another piece by Machine, *Ghost Town in the Sky*. This work, in the form of a music video with two original songs, was presented online in the summer of 2020 and continued Machine's exploration of similar themes related to breaking loose and hope for a better tomorrow through the lens of quarantine and queer liberation as an inclusive movement.[31]

Queer Maximalism

Machine's maximalist aesthetic is best absorbed in person, but one can grasp a feel for its richness simply by considering the materials he brings together. For instance, here's what went into a costume most recently adapted for the performance *Treasure:* a voluminous swing coat (p. 113) made out of an enormous vintage canvas American flag painted with an atmospheric, impressionist landscape; festoons of artificial tulips, roses, daisies, daffodils, and lilies scavenged from a cemetery dumpster; over-size Swarovski crystals-cum-buttons; a pair of full-length lamé gloves. An earlier neckpiece for the look conjoined plastic gold coins and folded U.S. dollar bills, leading to a headdress (p. 37) that included a long wig of red sequined ribbons, scallop shells attached to a bedazzled peacock tiara combined with a Statue of Liberty crown, all topped off with the head of a plastic turkey projecting from the center. Machine harmonized the cacophony of the headdress elements into a cohesive whole by painting the ensemble in a metallic and rainbow gradient. Viewing this

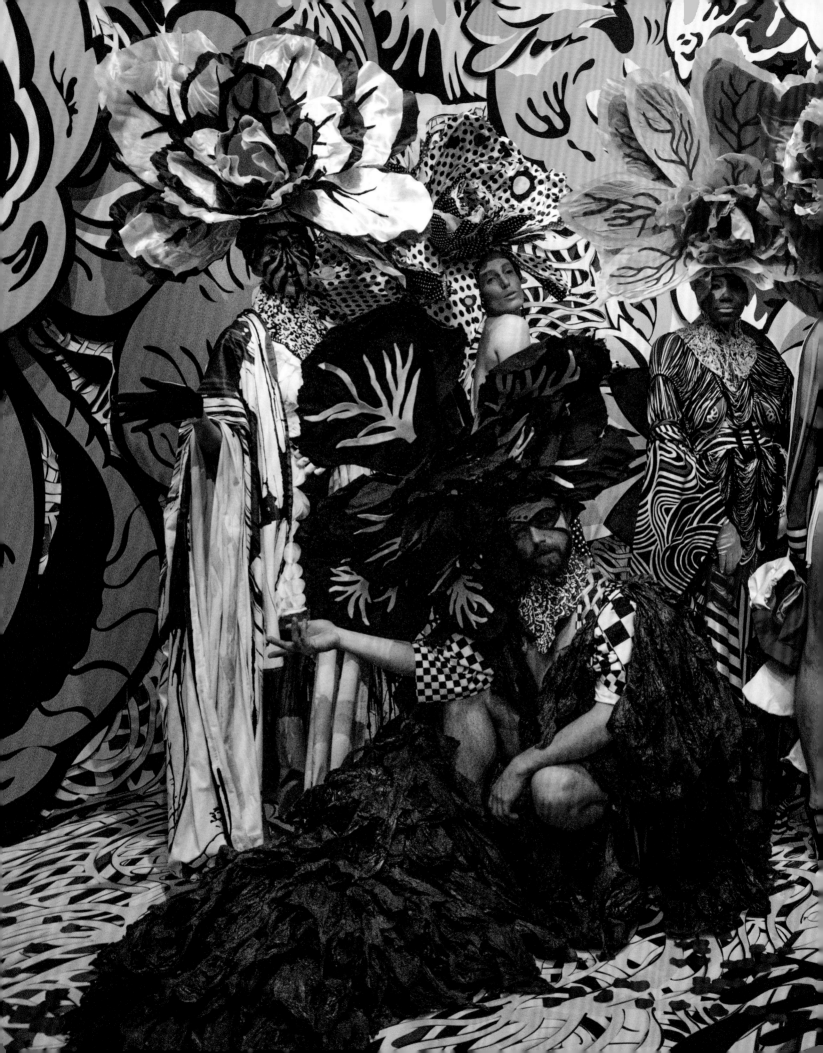

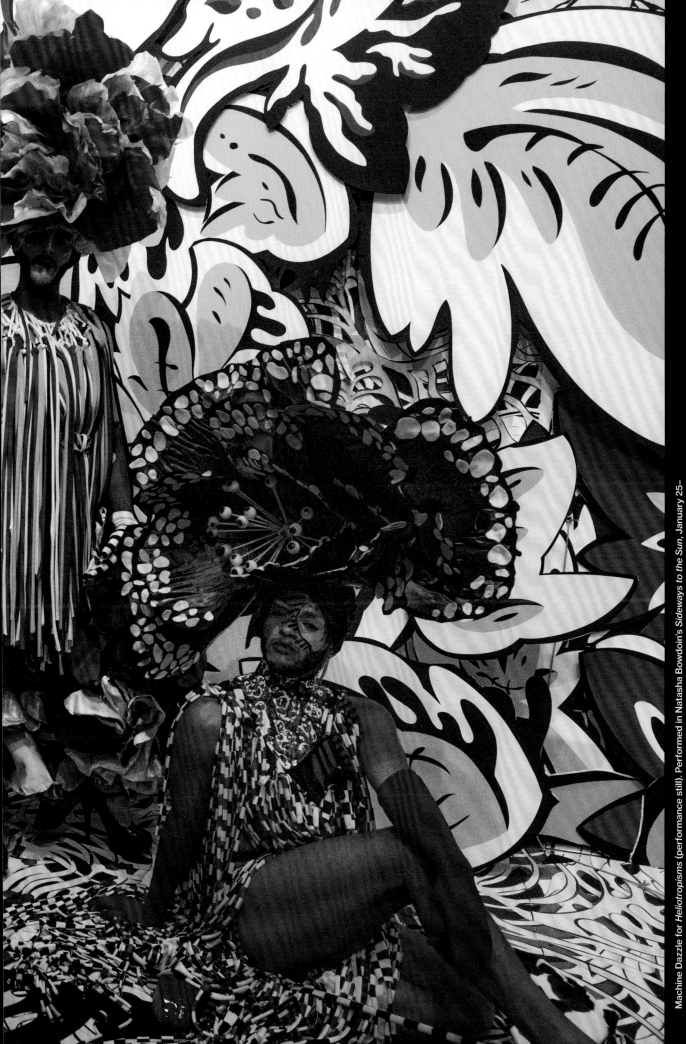

Machine Dazzle for *Heliotropisms* (performance still). Performed in Natasha Bowdoin's *Sideways to the Sun*, January 25–May 18, 2019, Moody Center for the Arts, Rice University, Houston, TX. Photo: Natasha Bowdoin

costume up close or on a stage, one sees that every inch of surface is covered – when the headpiece is worn, that includes Machine's face, which is made up to blend with it. The overall effect is spectacular and mesmerizing, captivating the eye and the mind with its clever unification of heterogeneous materials through surface treatments that seamlessly integrate objects that would otherwise appear a jumble. This powerful response is quintessential to maximalism as a style and way of making. When we encounter it, we are wowed, delighted, and inspired by the way it awakens our senses. But in an art world where aesthetic austerity and restraint have reigned as the gold standard of the post-war modernist avant-garde, to what visual tradition do these costumes belong?

Machine came of age as an artist in a time when surface pattern, ornamentation, and "the decorative," as it is known in the art world, evoked many deleterious associations. To call something decorative (even today) is to suggest that it is an embarrassing excuse as a work of art – that it is a minor, superficial, or pedestrian thing that might look like art but lacks the intellectual gravitas, truth, and rigor of critique that distinguish high culture from modes of entertainment, spectacle, and easy, pleasurable consumption. Furthermore, what is designated as decorative is deeply gendered due to its being equated with vernacular forms of décor found in the home – wallpaper, textiles, furniture – the implication being that it shares the status of a commodity or kitsch.[32] In addition, related to the definition of the decorative as a surface-oriented aesthetic, it was and remains associated with the unrestrained use of color, also an aspect of its gendered associations with femininity. The suspicion of vibrant color in art dates back to the time of Plato, who in his writing described color (in opposition to line) as a cosmetic treatment that dissembles or creates the mere look of art.[33] There is an impurity to the decorative object against which "real" art is defined, and like the female body (itself positioned as a decorative supplement to the masculine), the decorative is given connotations that include emotionality, deception through seduction, and shallowness.

In this scenario, there is an important history of creative agency and aesthetic recuperation that embraces the decorative as a language of the margin, challenging the high modernist exclusion of bodies, tastes, and ways of making deemed less valuable, shameful, or dissembling. Machine's layered, collaged, and surface-bedazzled style of design is part of this history. He is an artist who demonstrates a form of agency through craft-making and the creation of objects meant to be worn on the very bodies such aesthetic hierarchies were designed to dismiss.

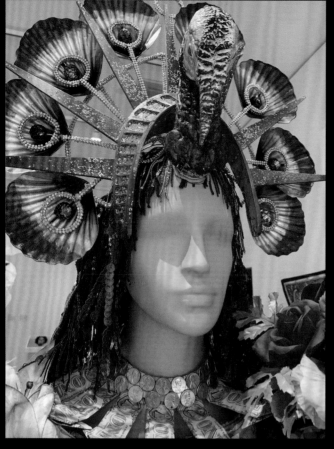

Machine Dazzle, detail of headdress, 2019. As installed in *Otherworldly: Performance, Costume and Difference*, Parsons School of Design, November 15–December 15, 2019. Courtesy the artist. Photo: Elissa Auther

This is a form of design that madison moore defines in this volume as "fabulous" – an embodied aesthetic category where decorative, maximalist surface effects are political acts of survival and resilience.[34]

Machine's style aligns with many examples of decorative or maximalist pushback by queer and feminist visual and performance cultures against the austerity and chromophobia of heteropatriarchy and its prohibition of spectacular surfaces. He cites an affinity with historical forms of camp and drag that rejected gender illusion for the glittered beards and eccentric sartorial styles favored by San Francisco's counterculture queer theatrical troupes of the late 1960s and early 1970s, like the Cockettes and the Angels of Light (p. 39). Within these circles the craft that went into both everyday and performance garments aligned their handmaking with utopian, counterculture world-making outside the bounds of gender and sexual convention.[35] The exploration of the queer body's association with excessive decoration and artificiality extends to others Machine recognizes as kindred spirits due to their embodied forms of costuming and performance, including Boy George's non-binary self-fashioning, Leigh Bowery's outlandish manipulation of his flesh,

Rammellzee's full-body "Garbage Gods" suits, and Narcissister's masked, neo-burlesque trompe l'oeil.[36] Through strange and beautiful costuming (and for George, Machine, Rammellzee, and Narcissister, their renaming), each participates in forms of world-building where cultural, sexual, gender, and racial difference is at the center of the identities they create and the stories they share. They are joined by multi-disciplinary artists such as Nick Cave, Raúl de Nieves, and Saya Woolfalk, whose meticulously handcrafted performance garments are also portals into alternative worlds and identities through the melding of the wearable and sculpture.[37]

In the 1970s, feminist artists consciously embraced the decorative as an intervention in a history of art that excluded women's creative traditions, craft, design, and the decorative arts. In doing so, they politicized the materials associated with women, the domestic sphere, craft (textiles, yarn, glitter), and techniques (quilting, crochet, decoupage) by incorporating them into their work. This politicization of materials and traditions of handmaking set the stage for the tremendous expansion of the embrace of handcraft among generations of artists to follow and remained a key driver of interest in the decorative as a critical artistic language. The return of the decorative in art was further expanded by artists associated with the Pattern and Decoration movement in the late 1970s and 1980s, and today it is enjoying a major revival spurred in part by the rise of queer visual culture, where the use of patterns, layered tableaux, and super-charged color palettes have once again activated the decorative as a form of aesthetic politics tied to queer visibility and a renewed critique of the sex/gender binary.

Finally, it is impossible to isolate Machine's visual style from the history of queer experimental theatrical genres, specifically the Theatre of the Ridiculous and the new context it created for visual extravagance and gender play. Emerging in the early 1960s in reaction to the realist staging and naturalistic acting of the time, the plays of the Ridiculous pilloried heteronormative culture with twisted, camp parodies of great works of literature and theater through excessive, anti-illusionistic drag, surrealistic staging, a profusion of glitter, and coded allusions to pre-Stonewall queer life. Many of the performers Machine has worked with, including Mx Justin Vivian Bond and Taylor Mac, represent the legacy of the Theatre of the Ridiculous, and the costumes he has designed for them channel the sense of humor, irreverence, and (now) openly queer politics that connect them to this radical tradition.[38] In the 1970s, the genre's play on gender identity and expression extended to glam

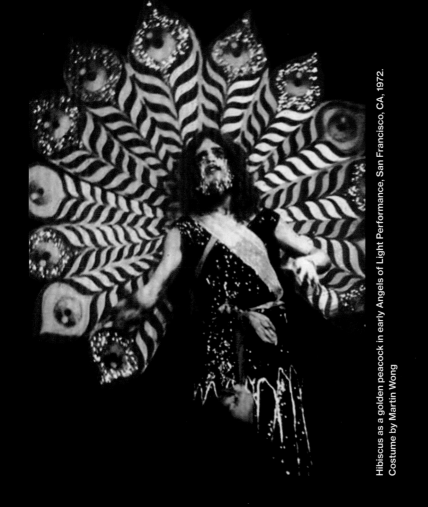

Hibiscus as a golden peacock in early Angels of Light Performance, San Francisco, CA, 1972. Costume by Martin Wong

rock, musical comedies like *The Rocky Horror Picture Show*, and alternative forms of drag that continue to evolve and form part of the vast lexicon of queer maximalist style from which Machine draws.

In the interview with Bond in this volume, Machine remarks, "I think you can change someone's life by walking across the room, wearing something very specific." For Machine, that something very specific is delivered through the language of maximalist, handcrafted design, adding a new chapter to the history of queer storytelling through color, pattern, and texture that invokes the sensuality and pleasure of the decorative. His work embraces all that has positioned maximalism and the decorative as a threat to existing aesthetic and social orders – its visual excess, its connections to kitsch and craft, and the beautiful surface presumed to be dangerous due to its association with feminine seduction or queer duplicity. As scholar of the queer decorative Rosalind Galt has astutely argued, aesthetic judgements that subordinate or dismiss the exuberance of maximalist treatment of surface are always

judgements about certain kinds of bodies – queer, female, those of color – and their right to participate in the creation of culturally valued forms of pleasure and beauty. The power of Machine's costumes to change a life lies in his creation of rich visual and narrative worlds for those very bodies, genders, and sexualities dismissed as aberrations, now walking across a stage to applause.

1 Elyssa Goodman, "Meet the Artist Radically Queering the Field of Costume Design," *them.*, September 5, 2019, https://www.them.us/story/machine-dazzle-treasure-costume-design.
2 Machine Dazzle, interview with author, June 2, 2021.
3 Exit Art existed from 1982 to 2012. Its first location was 578 Broadway in SoHo, and it moved to 548 Broadway in 1992. In this period, which includes Machine's tenure, the institution changed its name to Exit Art/The First World. Its final move in 2003 was to 475 Tenth Avenue. See "Jeanette Ingberman, a Founder of Exit Art, Dies at 59," *The New York Times*, August 26, 2011.
4 Machine performed as Matthew Flower at Exit Art/The First World in *The Shape of Sound* (October–November 1996) and in *Terra Bomba: A Performance View of Installation* (December 7, 1996–March 8, 1997). Both exhibitions presented multiple performances (thirteen and twenty-two, respectively) spread about the gallery and happening simultaneously, with *Terra Bomba* going as far as to encourage the audience to interact with the stage design and objects of the performances.
5 Organized in response to the 2003 invasion of Iraq, GLAMericans for Peace aimed to get an anti-war message "to a larger audience than a typical political rally through entertainment media coverage and our fabulousness" (undated flyer in Machine's archive).
6 Gracie Hays, "24 Decades, 24 Costumes," *The Curran[t]*, August 23, 2017, https://sfcurran.com/the-currant/interviews/machine-dazzle/.
7 Hays, "24 Decades."
8 Kalle Westerling, "Review of *A 24-Decade History of Popular Music*," *Theatre Journal* 69, no. 3 (September 2017): 408.
9 Hays, "24 Decades."
10 Credits include Julie Atlas Muz's *I Am the Moon & You Are the Man on Me* (2004), PS 122, New York, NY; Big Art Group's *House of No More* (2004); Layard Thompson's *Cup ... puC K Ohhhh, Beauty, full, vessel:* (2008), Dance Theater Workshop, New York, NY; Miguel Gutierrez's *Heavens What Have I Done* (2010), Center for Performance Research, New York, NY; Faye Driscoll's *There is So Much Mad in Me* (2010), DanceTheater Workshop, New York, NY; Chris Tanner's *Football Head* (2014), The Club at La MaMa; and Bianca Leigh's *A Night at the Tombs* (2010), Theatre Askew. For a more comprehensive list of projects see the CostumeDesign History in this volume.
11 A joint production between gallerist Jeffrey Deitch and his Deitch Projects, Creative Time, and *Paper* magazine from 2005 to 2007, the Art Parade brought together dozens of artists and performers in a procession of floats, portable sculptures, performances, and other street spectacles.
12 Guy Trebay, "And Then the Clothes Come Off," *The New York Times,* May 19, 2010. Mike Albo (aka Dazzle Dazzle) founded the Dazzle Dancers with Grover Guinta (aka Vinnie Dazzle) in 1996.
13 Michael Musto, "How Mayor Giuliani Decimated New York City Nightlife," *Vice*, March 6 2017, https://www.vice.com/en/article/bjjdzq/how-mayor-giuliani-decimated-new-york-city-nightlife. See also Michael Musto, "From the Vaults: A Tribute to Iconic '90s Gay Club Jackie 60 (November 1999)," *Out*, August 9, 2017, https://www.out.com/vaults/2017/8/09/vaults-tribute-iconic-90s-gay-club-jackie-60; and Donald Albrecht, *Gay Gotham: Art and Underground Culture in New York* (New York: Skira Rizzoli Publications, 2016).
14 *The Love Boat* (2008, CD). Produced by I Like It Electric and Craig C. for the Other One and Peace Bisquit. © The Dazzle Dancers/Peace Bisquit. For the video, directed by Bec Stupak, see https://www.youtube.com/watch?v=ytT7XDzB3Ok.
15 Justin Bond and the House of Whimsy, *Re:Galli Blonde (A Sissy Fix)*, October 22–30, 2010, The Kitchen, New York; *Lustre, a Midwinter Trans-Fest*, February 20–March 9, 2008, PS 122, New York; and *Lustre: A Summer Solstice Trans-Pervasion*, June 25–28, 2007, Abrons Arts Center, New York.
16 For a December 13, 2008 Mx Justin Vivian Bond show at Abrons Art Center, the Pixie Harlots were memorialized in video with Machine Dazzle performing as Suzie Snowflake. See https://www.youtube.com/watch?v=MIOzOpSYdAM.
17 Members of the Pixie Harlots included Jonathan Bastiani, Matthew Crosland, Layard Thompson, Darrell Thorne, and Jonathan Grauweiler. Producer Earl Dax was behind the formation of the Pixie Harlots.
18 *The Lily's Revenge: A Flowergory Manifold* premiered in New York at the off-off-Broadway theater the HERE Arts Center.

19 Taylor Mac with music by Ellen Maddow, *The Walk Across America for Mother Earth*, 2013, https://www.playscripts.com/play/2537.

20 Charles Isherwood, "Protestors Armed with Wigs and Sequins," *The New York Times*, January 20, 2011.

21 *A 24-Decade History of Popular Music*, world premiere, St. Ann's Warehouse, Brooklyn, NY, September 15–October 8, 2016.

22 In the twenty-second decade representing the devastation of AIDS, Machine "dies" and thus he appears for only twenty-two of the twenty-four decades in the show.

23 "Taylor Mac: A 24-Decade History of Popular Music," TDF.org, accessed November 1, 2021, https://www.tdf.org/shows/15132/Taylor-Mac-A-24-Decade-History-of-Popular-Music.

24 Hays, "24 Decades."

25 *The Fre* by Taylor Mac, directed by Niegel Smith, February 28–March 30, 2020, at the Flea Theater, was closed after previews due to Covid-19. Additional projects in this period include Soomi Kim's *Chang(e)* (2015); Pig Iron Theatre's *I Promised Myself to Live Faster* at the Humana Festival, Louisville, Kentucky (2015); Basil Twist, Joey Arias, and Julie Atlas Muz's, *Sisters Follies: Between Two Worlds*, (2015) Abrons Arts Center, New York, NY; *Bombay Rickey* (2016) the Prototype Festival, HERE Arts Center, New York, NY; Opera Philadelphia's *Dido and Aeneas* (2017); and Spiegelworld's *Opium* (2018), Cosmopolitan Hotel, Las Vegas.

26 *Whitman in the Woods*, aired on The WNET Group's *ALL ARTS*, on May 2, 2021, and is available here https://allarts.org/programs/taylor-mac-whitman-in-the-woods/full-episodes/. The Hang (2022), The Prototype Festival, HERE Arts Center, New York, NY.

27 *Machine Made* took place December 8 at Marion's Continental Restaurant, 354 Bowery, New York.

28 *Heliotropisms*, Dimensions Variable series, Moody Center for the Arts, https://moody.rice.edu/events/dimensions-variable-machine-dazzle. For documentation of *Sideways to the Sun* and footage of Machine's performance see "Natasha Bowdoin: Sideways to the Sun," Moody Center for the Arts, https://moody.rice.edu/exhibitions/natasha-bowdoin-sideways-sun.

29 For these projects Machine collaborates with his musical director, the composer and guitarist extraordinaire Viva DeConcini.

30 Jess Barbagallo, "Here Comes the Son," *Artforum*, October 7, 2019, https://www.artforum.com/performance/jess-barbagallo-on-machine-dazzle-s-treasure-at-the-guggenheim-80979.

31 *Ghost Town in the Sky* is available online at https://www.youtube.com/watch?v=Jq4RwYcVmGw.

32 The authoritative force behind the negative application of the term "decorative" in this period was the art critic Clement Greenberg, whose writing frequently invoked it as a value judgement. On the subject see, Donald Kuspit, *Clement Greenberg: Art Critic* (Madison: University of Wisconsin Press, 1979). Greenberg frequently equated the decorative with craft, and by extension the term effectively excluded certain materials and techniques from the modernist canon. On the subject see Elissa Auther, "The Decorative, Abstraction, and the Hierarchy of Art and Craft in the Art Criticism of Clement Greenberg," *Oxford Art Journal* 27, no. 3 (December 2004): 339–64.

33 On this history and its legacy, see Jacqueline Lichtenstein, *The Eloquence of Color: Rhetoric and Painting in the French Classical Age* (Berkeley: University of California Press, 1993); David Batchelor, *Chromophobia* (London: Reaktion Books, 2000); and Rosalind Galt, *Pretty: Film and the Decorative Image* (New York: Columbia University Press, 2011).

34 As moore argues, this is especially the case for the BIPOC queer community. See madison moore, *Fabulous: The Rise of the Beautiful Eccentric* (New Haven: Yale University Press, 2018). See also Rosalind Galt, *Pretty: Film and the Decorative Image* (New York: Columbia University Press, 2011) on the history of decorative recuperation in queer cinema and visual culture.

35 On the subject see Julia Bryan-Wilson, "Handmade Genders," in *West of Center: Art and the Counterculture Experiment in America, 1965–1977*, ed. Elissa Auther and Adam Lerner (Minneapolis: University of Minnesota Press, 2011), 76–93.

36 Hua Hsu, "The Spectacular Personal Mythology of Rammellzee, *The New Yorker*, May 28, 2018, 76; Jeffrey Deitch, "Jeffrey Deitch Interviews Narcissister," *Autre* 12 (Spring 2021): 160–65; Leigh Bowery and Fergus Greer, *Leigh Bowery Looks* (London: Violette Editions, 2005).

37 On the history of the performance garment in contemporary art see Alexandra Schwartz, ed. *Garmenting: Costume as Contemporary Art* (New York: Museum of Arts and Design and Lucia Marquand, 2022).

38 On this topic, see Sean F. Edgecomb, *Charles Ludlam Lives!: Charles Busch, Bradford Louryk, Taylor Mac, and the Queer Legacy of the Ridiculous Theatrical Company* (Ann Arbor: University of Michigan Press, 2017).

THE MUSES

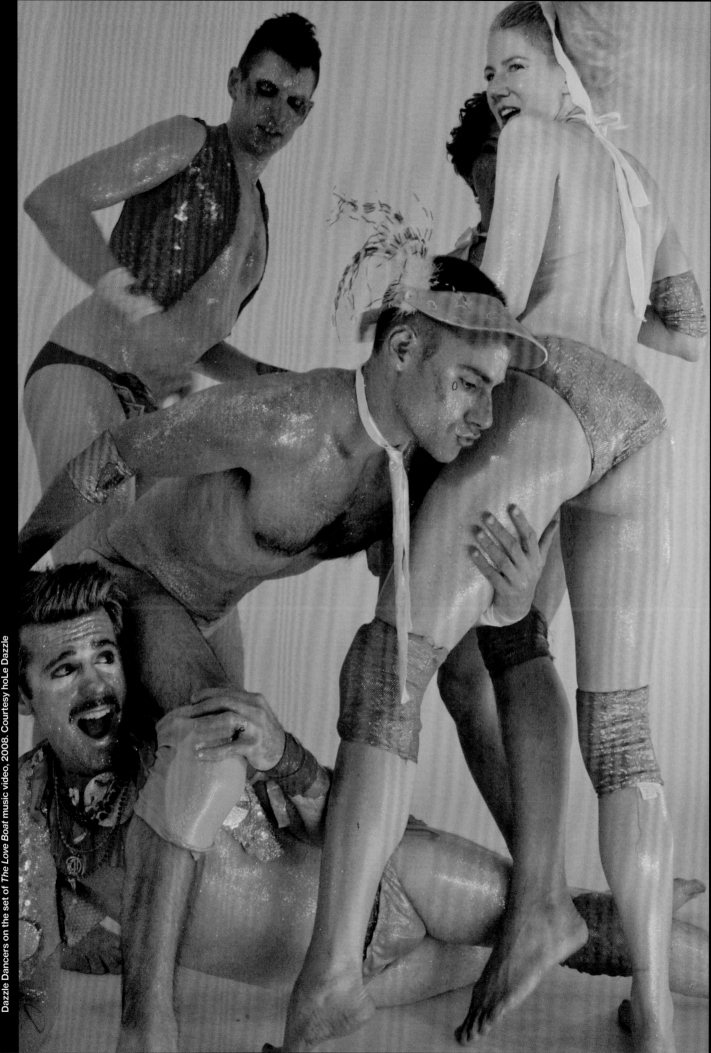

When Machine Dazzle was eight years old, he made up an excuse to his parents, hopped on his bike, and pedaled a couple of miles to see a movie called *Xanadu*. Machine's family was in Kingwood, a planned community northeast of Houston, created, like many suburbs, in the early 1970s, as a utopia of heterosexual whiteness.

But as with many suburban experiments, wear and tear was beginning to show. The movie theater was in a dangerous part of town, and the bike trails had become sketchy. "We had to be careful of, you know, 'flashers,'" Machine explained on the phone to me recently. Crime, or more likely the fear of it, was rampant. "There were Public Watch signs everywhere." But still, Machine had a mission. The unsupervised eight-year-old somehow bought a ticket and sat in a movie theater by himself to see this film.

It was 1980. The decade was about to emerge: Reagan, the War on Drugs, and with this new Republican agenda, mass incarceration, deadly homophobia, and new expressions like "welfare moms," "the homeless," and AIDS. The country hardened and greed was good, as were attitude and shoulder pads.

Miles away in northern Virginia, at the age of ten or eleven, I had the same unwavering urge to see *Xanadu*. I demanded my mother take me to see it with a friend down the street, Sandi, who had blond hair and loved to act out TV shows and dramatic dance scenes with me in the backyard. In the theater I made my mother sit rows back while Sandi and I sat closer to the screen. Somehow, I needed to be unsupervised, too.

The film begins with a street mural of beautiful women in diaphanous outfits suddenly coming to life. These are the Muses, and they shoot across the planet enveloped in soft, pillowy laser beams that look like *Star Wars* light sabers.

Xanadu is a terrible film. It stars Olivia Newton-John in a role that, while she was still riding high off her work in the 1978 blockbuster *Grease*, essentially killed her movie career.

The story: Kira (Newton-John), one of the Muses, descends to earth to inspire Sonny Malone, a scrappy artist played by Michael Beck, a sinewy, dirty blond-haired actor with an uncanny resemblance to Australian pop star Andy Gibb. Kira also reunites with her previous love, Danny McGuire (Gene Kelly in his last film role), whom she romanced the last time she was on the earth in the 1940s. There is also a B story about how they all try to open a new club called Xanadu, despite the odds.

The plot is lazy and the dialogue is half-written, but it all exists just to give a flimsy structure to an enduring soundtrack (by ELO, Newton-John, and Cliff Richard) that includes the title song *Xanadu*, the karaoke duet go-to *Suddenly*, and the film's biggest hit, *Magic*. If you were a gay preteen at the time, the songs whooshed into your ears like an air conditioner whispering something to you about sexuality. It was the first album I played so loudly that my mom banged on the door, yelling at me to turn it down.

The storyline is heterosexual, but you can sense the work of dozens of gays making sure Newton-John's skirt is perfectly draped. The movie is, as defined by Susan Sontag, "high camp": unintentionally bad, but captivatingly so. Machine and I were both enthralled. No matter how ill-conceived and dubiously produced it may have been, it landed in both our laps and the laps of thousands of other queer kids at that crucial moment when we needed it. Camp works like a vaccine of culture – containing the poisons of the age but somehow inoculating you against them.

Machine and I come from a specific demographic of gay identity. Our cohort is very narrow. We were gay kids born in the late 1960s/early 1970s who came of age sexually in the late 1980s/early 1990s, at the height of the AIDS epidemic. As white kids growing up in the suburbs, we were too young and relatively sequestered to have experienced much death ourselves. Still, AIDS lingered over us like a specter. We may have been too young to see friends die, but we were old enough to be terrified of what might become of us. Provided practically no role models or encouragement to love ourselves, we used what we were given. We found our color in moments, bad movies, backup dancers. Our inspiration came from foraging through a culture that, for the most part, did not care or want us to exist. No one was nurturing us then. The gay identity we were shown was one of persecution, death, sadness, and disdain, but still somehow we gravitated toward it. We stopped at nothing to pursue it.

Machine's aesthetic can be found in the final scene of *Xanadu* – a fourteen-minute confetti cannon of overproduction. Eighty percent of the movie's budget seems poured into that last scene. Every trend of the time is addressed: pop-lockers in zoot suits, roller-skaters in satin jackets, tightrope walkers in disco whites, women in Diane von Furstenberg dresses, cinched harem pants. It's interminable and tacky. Later, when both Machine and I were living in New York, the film became a reference point for queer downtown performance: drag queens would recreate the opening mural scene, the soundtrack would come on ironically at East

Village clubs. This trajectory ended (as often happens in the city) with a successful tongue-in-cheek Broadway show in 2007 that made a handful of producers some money.

Machine and I both moved to New York City in the early 1990s soon after graduating from college. (He went to the University of Colorado Boulder; I went to the University of Virginia.) We didn't meet until the early 2000s, when he became the principal costume designer and an integral member of the Dazzle Dancers, which I co-founded with my friend Grover Guinta.

The Dazzle Dancers were a legendary (in our own minds) dance collective that transformed culture forever.

Correction.

I meant we *are* a legendary dance collective that *transforms* culture. The Dazzle Dancers never use past-tense verbs. Though Machine hasn't made costumes for us for years, and we haven't danced since a small gig in 2018 in a Bushwick bar, like a rash, we refuse to go away.

Around 1995, Grover and I were at a party trying to think of costumes. Wigstock, the annual East Village festival of drag hosted by Lady Bunny, was coming up. We didn't want to do drag because we both felt unworthy — how could we compete with Bunny, Linda Simpson, Flotilla Debarge, and other drag superstars?

Grover and I did hits of poppers (no joke) and the idea came to us — we would be the Dazzle Dancers. We would dress in 1980s glittery outfits and emulate the dancers we grew up watching — those sexually slithering spandexed supporters on *Solid Gold*, *Soul Train*, and other 1980s countdown shows.

These dancers always fascinated me as a young gay boy. My eyes focused on them, as they gyrated behind some mainstream singer. Backup dancers were often a mix of races and genders you didn't see elsewhere. And the men seemed openly gayer, at least in the way they moved their bodies, allowed to flounce and swish. Added as décor behind a diva, they weren't central so they were free to be themselves, as if no one was watching except us queer few.

Our first Dazzle Dancers costumes were made by a tailor in Chinatown. We worked on a number to "Telephone," by Sheena Easton. We performed it in Tompkins Square Park, and then later on drag queen Hedda Lettuce's cable access show. We created other dance numbers to other 1980s and 1990s hits. Our ranks grew.

Cornflake Dazzle (Paul Broadbeck) at Wigstock, 2003. Tompkins Square Park, New York, NY.
Courtesy hoLe Dazzle

By around 2000, we developed into a diverse group numbering up to twenty-five on-call dancers with about twelve core characters with their own unique personalities, like collectible Garbage Pail Kids. Grover was Vinnie Dazzle, and I became Dazzle Dazzle. There is Cherry Dazzle, Pretty Boy Dazzle, Robbie Dazzle, Propecia Destiny Dazzle, DT Dazzle, hoLe Dazzle, Sochny Dazzle, Rinky Dinky Dazzle, Chunky Cupcake Dazzle, Negro Noir Dazzle, and many more. Machine became Machine Dazzle because one time at SqueezeBox!, the queer 1990s rock-n-roll night, Cornflake Dazzle saw Machine moving on the floor and said, "You are a dancing machine!"

By the time Machine joined our troupe, we were a forceful group of personalities – a family. We fought, we reconciled, we did drugs together, we stayed up too late together, we loved each other.

With no formal training (though he had accomplished a couple of costume designs, including for the performer Julie Atlas Muz) he used our bodies to learn how to shape his creativity into clothing.

His costuming assemblage backstage became routine: he sewed tubes of spandex fabric, splashed them with color, and then fit them over our bodies, cutting arm and leg holes and then ripping and tying knots into the fabric until it was a couture garment.

Machine's work blossomed during our busiest years as the Dazzle Dancers. He became more and more adept at manipulating fabric, and

Rinky Dinky Dazzle (Dominic Mondavi) performing at a party venue and bar, 2010, New York, NY. Photo: Kirsten Luce / The New York Times / Redux

the glitter-and-glue encrusted quality he created became our signature style. The glitter we smeared all over ourselves not only embedded in our scalps – it became our trademark.

Memorable costumes he designed included those for a Spanish-infused number we performed at a *Paper* magazine party celebrating Pedro Almodóvar's birthday: black and red striped outfits with black stockinged heads so that we looked like backup dancers for a bullfighter. Another outfit for the annual Glam Awards (I think 2008) consisted of princess sleeves in a satin fabric printed with the slogan Jesus Loves You along with matching jockstraps and fedora-styled hats made of Styrofoam cork board.

The peak years of our career as a troupe were from about 2000 to 2010. Our performances were in a post-9/11 landscape and against the backdrop of the subsequent Iraq war. This was when people were told to go shopping to save America, and a gentrifying waterproof stain had begun to spread across the city. In place of self-examination, the country embraced a consumer denialism. Things became more expensive. A cup of coffee cost five dollars. *Sex and the City* tour buses crowded outside of Magnolia Bakery. A certain con-man created a myth of being a successful businessman on one of the many reality shows that were about to bend reality.

Our dances matured from 1980s pop parodies to more conceptual: a rousing hula routine to "Get Ur Freak On," a circus-like dance that was

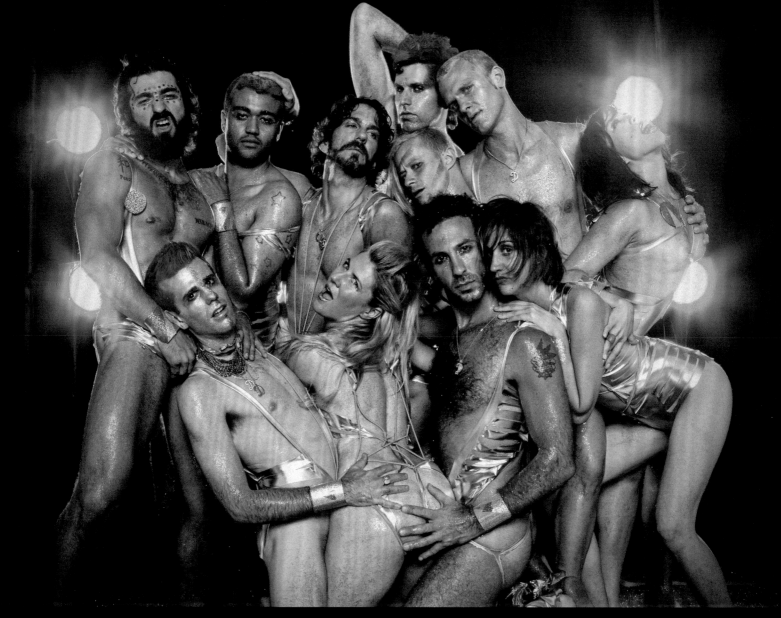

Dazzle Dancers, 2010. Photo: Mr. Means

performed turned away from the audience with mannequin faces on the backs of our heads. Over the busiest years we performed at clubs, outdoor festivals, parties, benefits, and, in 2000, with Blondie on South Beach in Miami to ring in the new year. We were (are) a mix of races, genders, sexual orientations, and body sizes. We were not good dancers, but we brought good energy to the room and always got naked at the end. We were hired for that purpose. We lit up parties. We were never totally in sync and some of us had a hard time keeping the beat, but we always got naked at the end of our number.

 We had an ethos about embracing all body types, being naked, seeking peace. I created our motto: "Having fun is a political act." We were pleasure activists before that term existed.

 If we had known what to do, we could have marketed ourselves. At our peak, we released a song, a remix of the *Love Boat* theme, and had a release party. It was fun. We didn't really know where it was going. There wasn't a plan, and Instagram's narcissistic powers of monetized attention were a decade away. There was no such thing as TikTok fame,

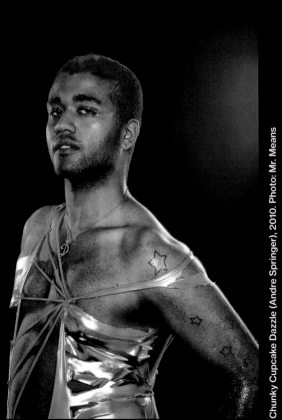

Chunky Cupcake Dazzle (Andre Springer), 2010. Photo: Mr. Means

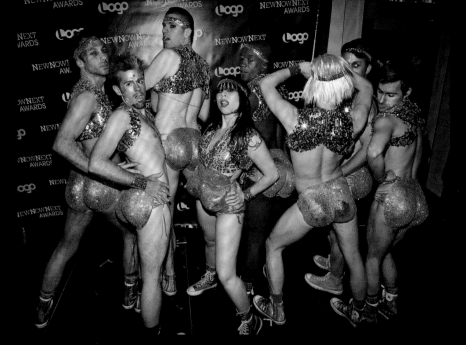

Dazzle Dancers arrive at the 1st NewNowNext Awards at MTV Studios, May 2008, New York, NY. Photo: Charles Eshelman/FilmMagic

though every dance we choreographed and performed would have been prime look-at-my-amazing-synchronized-routine fodder.

A lot of people didn't like us. We may have drunk too much from the bar. We were kicked out of venues and asked to stop performing at least three times. We got glitter everywhere. If you are backstage at some venue in downtown New York and you see a sign that says NO GLITTER, it may have been because of us.

We were a mess.

Sorry. We *are* a mess.

But Machine's aesthetic is about mess, so it works out. Mess is what we were given. He uses what is around to create something fantastical, something with sequins, something dirty, something bright, something noticeable, with what is here. He has developed a finely-tuned queer antenna for a level of display made from the materials of a culture that had no desire to accept him. The work he creates handles the debris of what is around — it expresses a resourcefulness, an inherent will, an insistence on being alive.

We can't choose our time to be alive, but somehow an artist finds their way despite all obstacles. And we can't choose our muses, but somehow they always seem to show up.

Kalle Westerling

QUEER MAXIMALISM, WILDNESS, AND MACHINE DAZZLE'S A 24-DECADE HISTORY OF POPULAR MUSIC

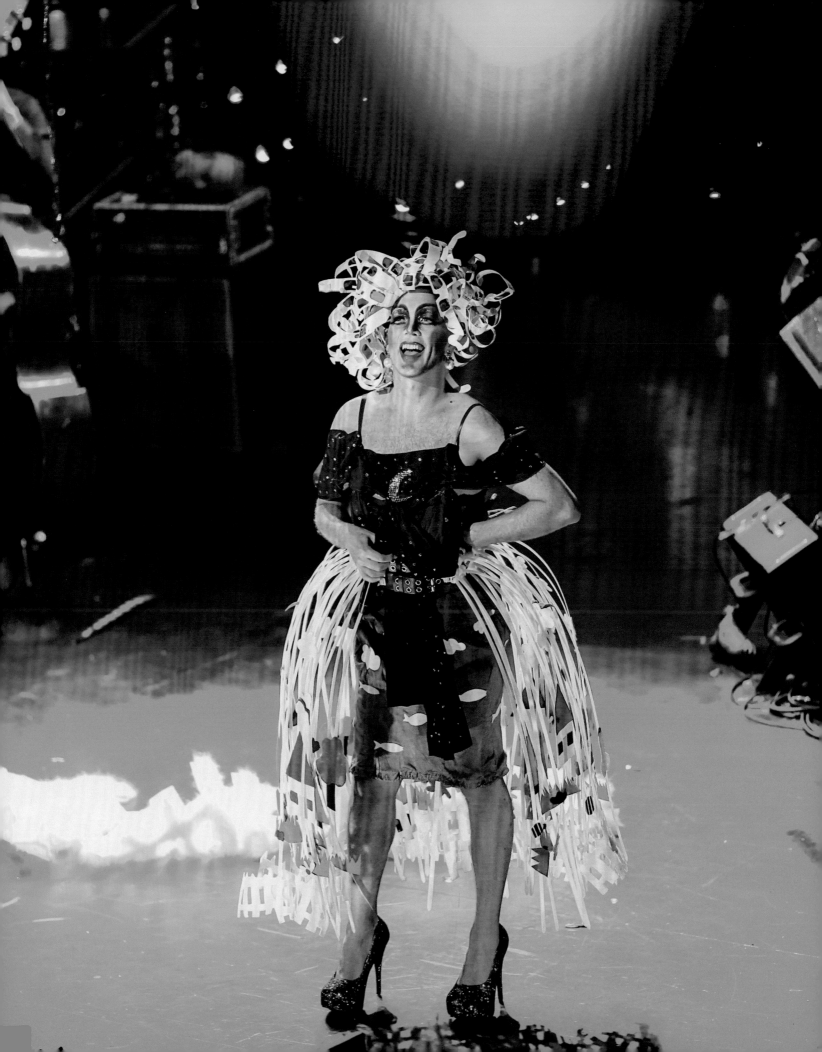

Go, go, go, said the bird: human kind
Cannot bear very much reality.
Time past and time future
What might have been and what has been
Point to one end, which is always present.

T. S. Eliot, "Burnt Norton"

The world is a place full of wildness, and along those lines, so is history. This aspect of reality and history—its unwieldiness, sheer size, messiness, and "thingliness"—is overwhelming and nearly unbearable for human minds to grasp. This raw wildness has captivated poets, too, including T. S. Eliot, who, in the epigraph, is shown to have struggled with formulating poetry about it.[1] Equally interested in the phenomenon are philosophers concerned with how we (as humans) need to trim the edges off that wildness in our eagerness to cultivate the ideas that we carry about ourselves—the very things that make up who we think we are, such as identities, borders, politics, power structures. And the trimming of the edges also has a more fundamental aim: to establish the importance and centrality of the human in the world.[2] Another way to express it is that we curb and domesticate the wildness to center and privilege the human experience, and this exorcising of wildness most often takes place through language: allegories, metaphors, or simple categorizations and dichotomies. Some philosophers have considered art capable of witnessing the "queerness" of this wild and potentially capable of offering "utopic visions" that go beyond our attempts to curb the wildness with language and can destabilize the centrality of the human.[3]

Such a reflection on the universe, the world, and language may seem a strange place to begin an essay on Machine Dazzle's costume design. But as I have been thinking about Machine's creations, I have sunk deeper into my experience of the anarchic world of Taylor Mac's *A 24-Decade History of Popular Music* at St. Ann's Warehouse on a long October day, night, and morning in 2016. For a long time, I thought the confusion and overwhelmedness I had experienced were illegitimate feelings, far from what a theater scholar should feel. But in this essay, I turn toward those feelings and explore them as integral to a certain sublime aesthetic experience of Machine Dazzle's costumes (and, by extension, Taylor Mac's performance). I would even go as far as to suggest that Machine's creations invite such feelings of confusion and uncertainty in their orientation toward the insignificance of the human body in History (with a capital H). Whereas Mac, in the performance

provides the fodder for the humans, Machine's creations combine his inventive mind with their recreation or enactment of the world's strange, wild beauty in maximalist combinations and permutations of found objects, or what many would consider "trash." (I don't believe this word exists in Machine Dazzle's eco-queer vocabulary.) His creations have an immense tangibility and "thingliness" about them, decentering the human and foregrounding instead objecthood and materiality. The anti-perfectionist streak of Mac's striking oft-quoted statement, "Perfection is for assholes," becomes in Machine's creations less about human "community" and more of an invocation of an eco-queer existence in the chaotic.[4] Machine's creations, thus, cannot be described as "drag" in the typical fashion of displacing or (re)inventing a person's gender. Rather, they are costumes that have Mac, the human, inhabit the world differently, stepping beyond the Anthropocene. Through Machine's ingenious designs, Mac is invited to go *further*, a word that gestures toward "something else," and which Machine has described as one of his favorite words.[5]

 This is how Machine Dazzle's costumes displace Mac's intention with *A 24-Decade History* of "trying to find the queers in American history,"[6] toward a different type of queerness. While the former is a noble and important mission in Mac and Machine's collaboration — trying to make sense of history, pointing out the damages and injuries made, and what could have been done differently, from the standpoint of our contemporary terms, identity categories, or binaries — Machine, through his creations, goes beyond that mission. He seems to raise this question: How many stories from history can we never get to tell, not only because no stories survive enabling the construction of the larger narrative, but also because the stories' protagonists are not readily legible in our contemporaneous terms? How many stories in the history of the United States cannot be understood with the cultural framework that we have to interpret history today? All the non-binary, ambisexual, shifting, hybrid, unyarded ones whose histories will never be told?[7]

 Even with the shifting lens of our contemporary moment, when an increasing number of us are embracing gender-nonconformity and non-binary pronouns, some still feel guarded about fully embracing a notion that we are on the path to betterment. What is to say that our "sharpened" senses of categories (or anti-binaries) are now, finally, capturing history "as it really was"? This is where Machine Dazzle's designs are ingeniously proposing a material answer to the speculative question raised by historian Roy Rosenzweig about what it would be

Machine Dazzle for Taylor Mac, *A 24-Decade History of Popular Music*, 2016, "Decade 14 (1906–1916): Songs Popular in the WWII Trenches." Feathers, neoprene, and mixed-blend fabric; dimensions variable. Courtesy Pomegranate Arts, NJ.
Photo: Little Fang

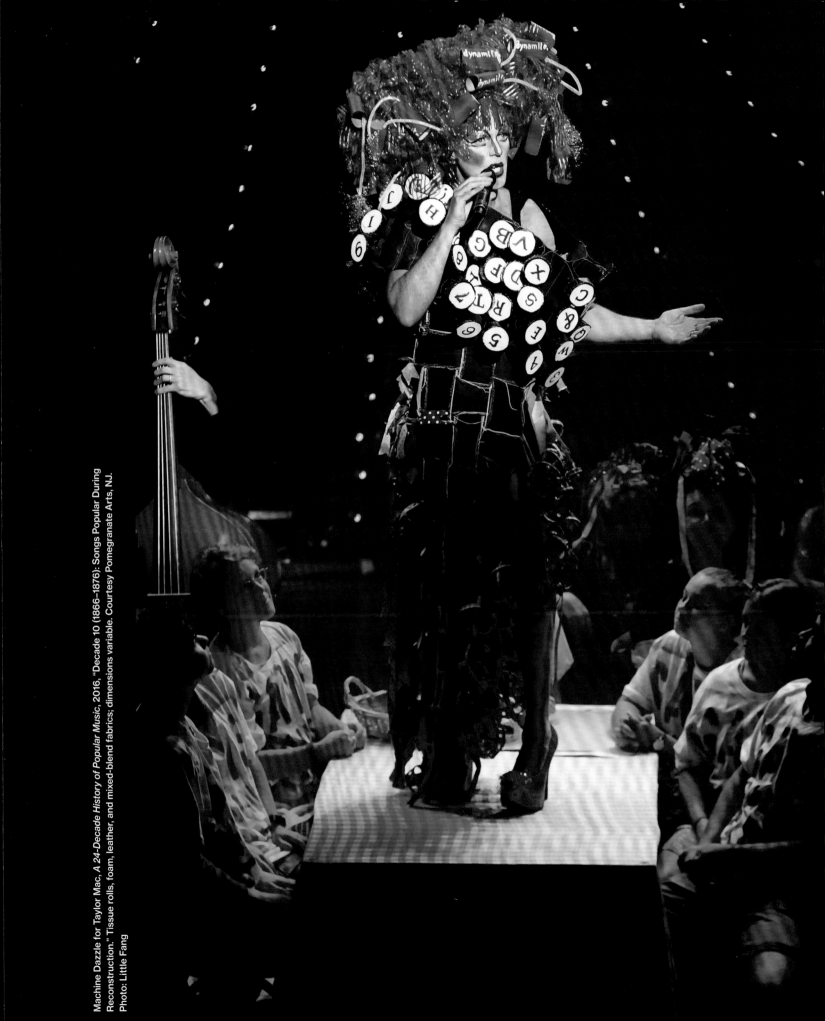

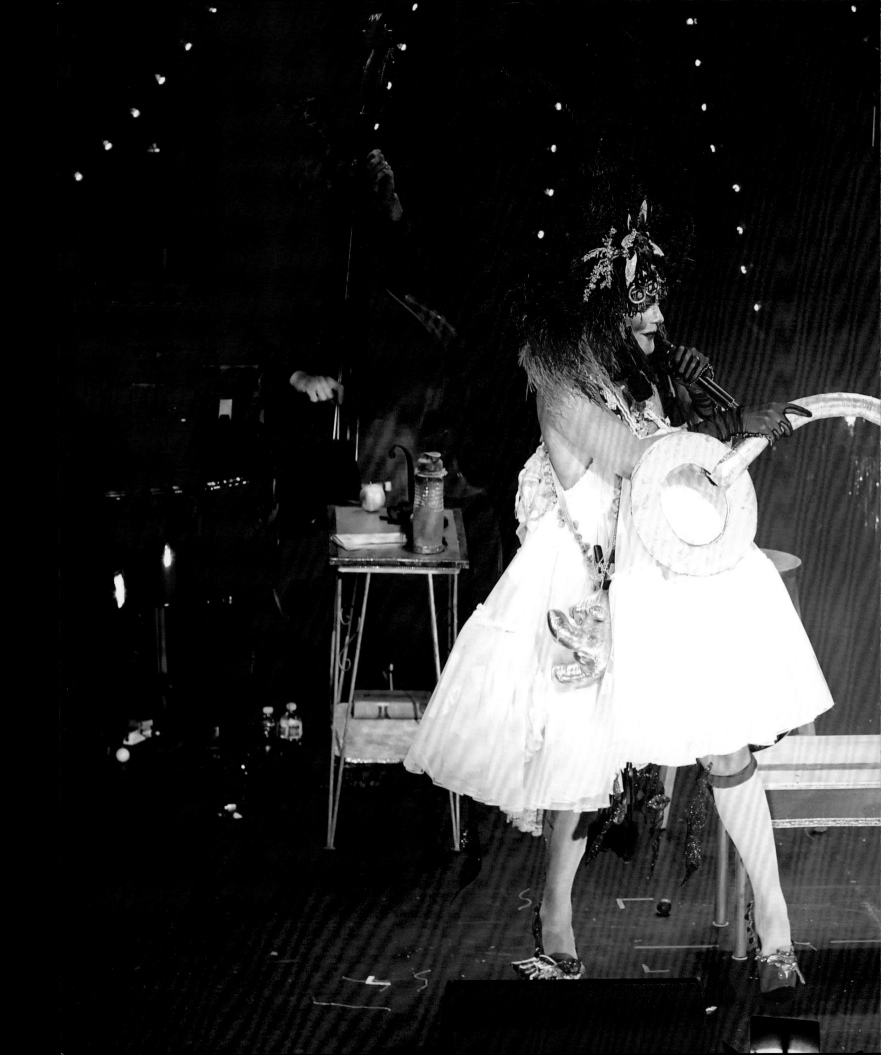

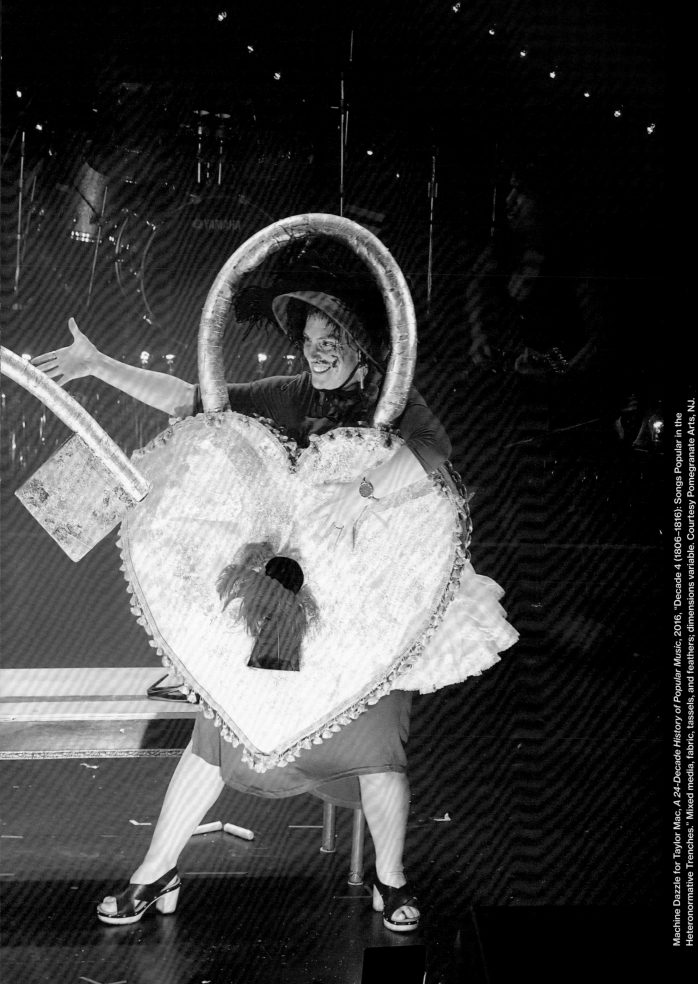

like to write history if we were faced with a complete historical record – if we, indeed, were able to embrace the overwhelming chaotic nature of history, human and non-human alike.[8] Rather than doing what regular costume design for the theater does most of the time – defining a character visually by setting them in time and space – Machine uses the costume to deploy a queer and wild logic that picks away at history's fabric of hegemony. Using the language of new materialism, his creations raise the specter of the agency of the objects themselves: Rather than demanding an articulation *to us* of history (as represented in the objects of Machine's creations) using our language, Machine's costumes ask of us, what can we really know about history? Thus, they put into perspective how we conventionally structure and circumscribe history in an anthropocentric way. That's why Machine's costumes can be overwhelming for audience members to experience: they bear witness to an unregulated, wild, strange, and inexplicable history.

Machine's "drag," if we stoop to calling it that, goes beyond the man/woman binary and far, far beyond any gay/straight binary as well. We're venturing here into a landscape where we encounter drag that pushes toward, or against, the experience of unbecoming human, of making oneself illegible. But, rather than seeing illegibility as a form of oppression, we can think of it as a strategy here. And the name of that strategy is queer maximalism.

In Machine's work, then, there are resonances with contemporary queer philosopher Jack Halberstam's work on the idea of *queer wildness*. Through his creations, Machine is searching beyond our existent vocabularies for ampler languages of existence, beyond colonialist and anthropocentric forms of knowing – asserting differences between one's self and the forces of nature, self and other, man and woman, white and black. He moves into a different place: the magical, delightful, and yet terrifying realm of unknowing. It is, in Halberstam's words, a "bewildering terrain."[9]

Ingeniously, Machine works with scale in order to create these relationships to the wild: the costumes almost read as miniature landscapes, but only deceivingly so. If anything, they should be considered maximalist miniatures, overwrought with references, bordering between human and non-human at all edges. Think of, for example, Machine's costumes for the first and second decades in *A 24-Decade History,* where they transform Mac into a visually deafening and smoking firework (p. 30), or the following decade where Mac becomes bottles whose corks are popping. Or the ninth decade, where Mac is transformed into a pile of sausages, ketchup, and mustard (p. 61).

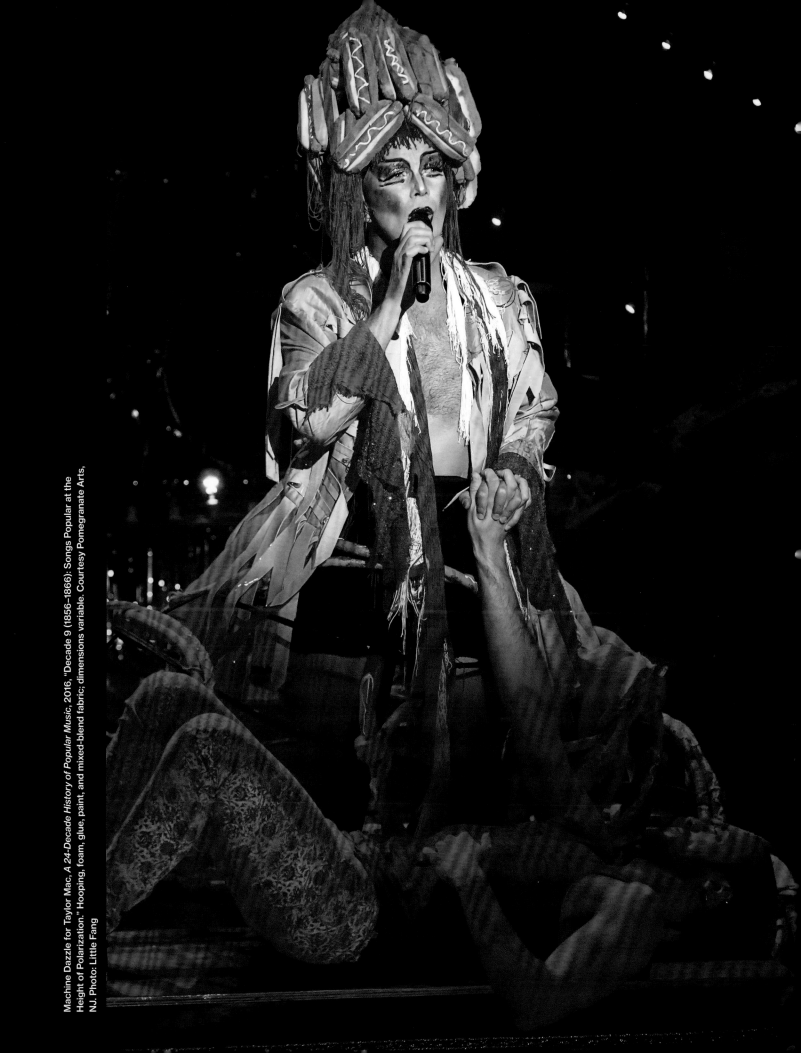

Machine Dazzle for Taylor Mac, *A 24-Decade History of Popular Music*, 2016, "Decade 9 (1856–1866): Songs Popular at the Height of Polarization." Hooping, foam, glue, paint, and mixed-blend fabric; dimensions variable. Courtesy Pomegranate Arts, NJ. Photo: Little Fang

Machine's costumes resist the idea of forcing the past to make sense to us today. Engaging with Halberstam's ideas, we can frame this type of queer maximalism as an unmaking of the world as we know it. Halberstam draws on the idea of Walter Benjamin's reading of Paul Klee's painting *Angelus Novus,* and the soaring pile of debris at the feet of the painting's subject. This pile stands in for the "wild forces that escape human knowledge," Halberstam writes.[10] Benjamin knew this, of course, as he wrote that we do not have access to history "as it really was."[11] But as we try to grasp history, we have a tendency or temptation to domesticate its unwieldiness, capture it with our language. But language, as we know, is not a neutral tool but has been shaped by racist, hetero-normative, patriarchal, and colonialist power structures. It is not so strange, then, that artists should look elsewhere for a way to "make necessary things," as Machine has expressed it.[12]

Machine Dazzle can choose a different path from Mac. He does not need to use verbal or written language but can rely on visual, affec-tive gestures. The result, a deliberately obfuscatory style in Machine's designs, addresses the wildness at the edge of human knowledge. We turn away from the miniature and its microscopic, colonial gaze and toward a different field of vision, that of queer maximalism.[13]

One of my favorite examples of Machine's affective visual language appears in the twenty-second decade of *A 24-Decade History,* when Machine dresses Mac in a shamanistic outfit, completely covered in cassette tapes (p. 64). At this hour, Mac's voice was already breaking in the performance I saw at St. Ann's Warehouse, and the vocal quality seemed to invoke the recording technology to which the dress paid tribute. In a mashup of Robert Palmer's "Addicted to Love" and Diamanda Galás's spoken performance piece "Let's Not Chat About Despair," the vocal stretching and distortion of Mac's performance became more about the words than anything else. The performance itself fore-grounded many of the motifs that were already framed in Galás's original performance of the spoken word piece: feelings of alienation, terror, despair, and feeling beside oneself.[14]

But the tapes of the dress went further than a symbol of a means of communication. Rather, they stood in for (temporary, magnetic) survival and memory. Writing our history as humans depends on different recording technologies, and none of them carry a relationship to nostal-gia and disappearance like cassette tapes. Likewise, the edges of Mac's silhouette were flittering with what appeared to be unraveling magnetic strips, rendering Mac's own body a disappearance. The tapes'

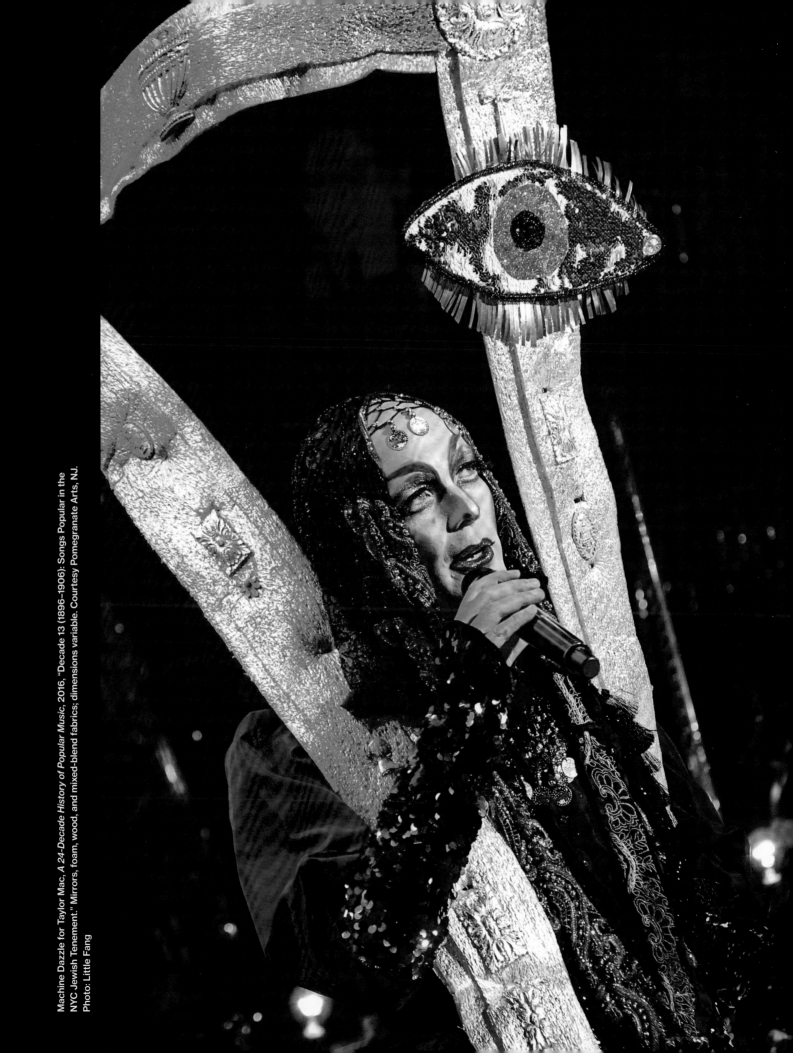

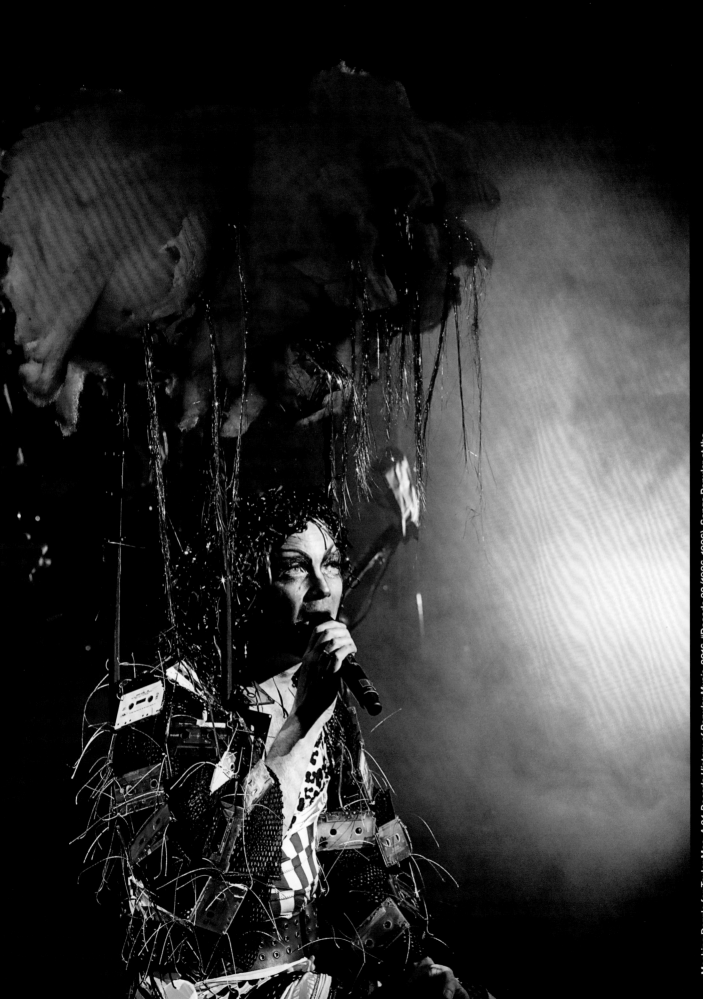

Machine Dazzle for Taylor Mac, *A 24-Decade History of Popular Music*, 2016, "Decade 22 (1986–1996): Songs Popular at the Height of AIDS." Cassette tapes, fabric, mesh, wooden dowels, lurex, foam, and batting; dimensions variable. Courtesy Pomegranate Arts, N.J. Photo: Little Fang

presumably recorded voices – perhaps our most important trait as humans – disappearing into the void and taking Mac with them invoked the loss of history itself.

Most importantly, on top of Mac's head were three heads attached that together created a queer Mount Rushmore, invoking death, and long-gone comrades in an explicit reference to the ongoing AIDS epidemic. The breathtaking quality of the headpiece in the twenty-second hour is hard to describe to anyone who was not there. In the delirious last hours of *A 24-Decade History*, at the brink of sleeplessness or sleepwalking, Mac's head underneath the three skulls, writhing in pain and spilling out life juice as silver streams through open jaws, was a vision almost too much to bear. The feeling of loss was palpable and, as Halberstam has written, it worked as a clear avenue to accessing the wild. It shook many audience members to the core as it opened up the reflection on our own bodies and their disappearance.[15] We do not know what happens after death and in this part of *A 24-Decade History*, Machine's creation makes Mac stand in for each one of us, relating Mac's own head with the three ghosts to ourselves.

In the end, Machine's creations present a new artistic way of chan-neling "our" history. He takes an assumption of wildness (and the tininess of human history, let alone the history of the United States) and, using the queerest maximalism, builds miniatures that explode with detail and intricacy. The creations, as such, are affective gestures toward a world that we know, somehow, but that is hard to grasp with language, as language has a way of destroying everything in its way with its rules, classification, and structures. His affective, maximalist miniatures resist conventional attempts to make known, to classify, to understand.

In the twirling dance of Crazy Jane, we lose ourselves. We are mesmerized by the devastating beauty of the lesbian separatist's labia wings becoming the womb through which Mac is born at the end of the performance. We are bewildered by the deep, haunting sadness of the cloudy Mount Rushmore heads figuring as ghosts of those who have passed in the still ongoing AIDS epidemic. History is invoked in *A 24-Decade History* not for us to linger for too long (although I'm sure Mac would have loved for us to stay a more uncomfortable amount of time),[16] but rather to open our minds about the power-induced chance structures that have ushered certain identities into the warm fold of recognition, while others have been giving way under definitional closure.[17] In the final lines sung in *A 24-Decade History,* Mac communicates in language that Machine's playful costumes have communicated all along:

the smallness of our lives and the futility of life does not give way to hopelessness but is an invitation for us to join the wild dances of the world.

Sleep well, get up, do it again.
Day after day, after day . . .
You can lie down or get up and play.[18]

1 See Jane Bennett, *Thoreau's Nature: Ethics, Politics, and the Wild* (Thousand Oaks, CA: Sage Publications, 1994).

2 Juliana Zylinska calls it "scalar derangement" in *Minimal Ethics for the Anthropocene* (Ann Arbor: Open Humanities Press, 2014).

3 Jack Halberstam, *Wild Things: The Disorder of Desire* (Durham, NC: Duke University Press, 2020), 47.

4 David Bisaha, "'I Want You to Feel Uncomfortable': Adapting Participation in *A 24-Decade History of Popular Music* at San Francisco's Curran Theatre," *Theatre History Studies* 38, no. 1 (2019): 145. For a discussion of how Mac envisions the community, see Paul David Young, "The Historical Taylor Mac," *New York Live Arts*, January 12, 2015, https://newyorklivearts.org/blog/context-notes-taylor-mac.

5 Machine Dazzle, interview by Elissa Auther, filmed January 15, 2020, at the Pocantico Center, Lenapehoking, NY. Video, 1:10:08, https://www.youtube.com/watch?v=sG2ZtB7fomc.

6 Young, "The Historical Taylor Mac."

7 Tadashi Dozono, "Teaching Alternative and Indigenous Gender Systems in World History: A Queer Approach," *The History Teacher* 50, no. 3 (May 2017): 425–47; Rachel Hope Cleves, "Beyond the Binaries in Early America," *Early American Studies* 12, no 3 (Fall 2014): 459–68.

8 Roy Rosenzweig, *Clio Wired: The Future of the Past in the Digital Age* (New York: Columbia University Press, 2011), 5.

9 Halberstam, *Wild Things,* 34.

10 Halberstam, *Wild Things,* 52.

11 Walter Benjamin, *Selected Writings*, vol. 4, ed. Howard Eiland and Michael W. Jennings (Cambridge: Harvard University Press, 2006), 391. The angel is present on page 392.

12 Machine Dazzle, interview by Elissa Auther.

13 Halberstam, *Wild Things,* 66; see also page 102.

14 Anabela Duarte, "Lou Reed, Diamanda Galás, and Edgar Allan Poe's Resistance Aesthetics in Contemporary Music," *The Edgar Allan Poe Review* 11, no. 1 (Spring 2010): 157.

15 Halberstam, *Wild Things,* 89.

16 See Bisaha, "'I Want You to Feel Uncomfortable.'"

17 Halberstam, *Wild Things,* 108–109.

18 The last lines of the 246th song from Taylor Mac's *A 24-Decade History of Popular Music*, "You Can Lie Down or Get Up and Play."

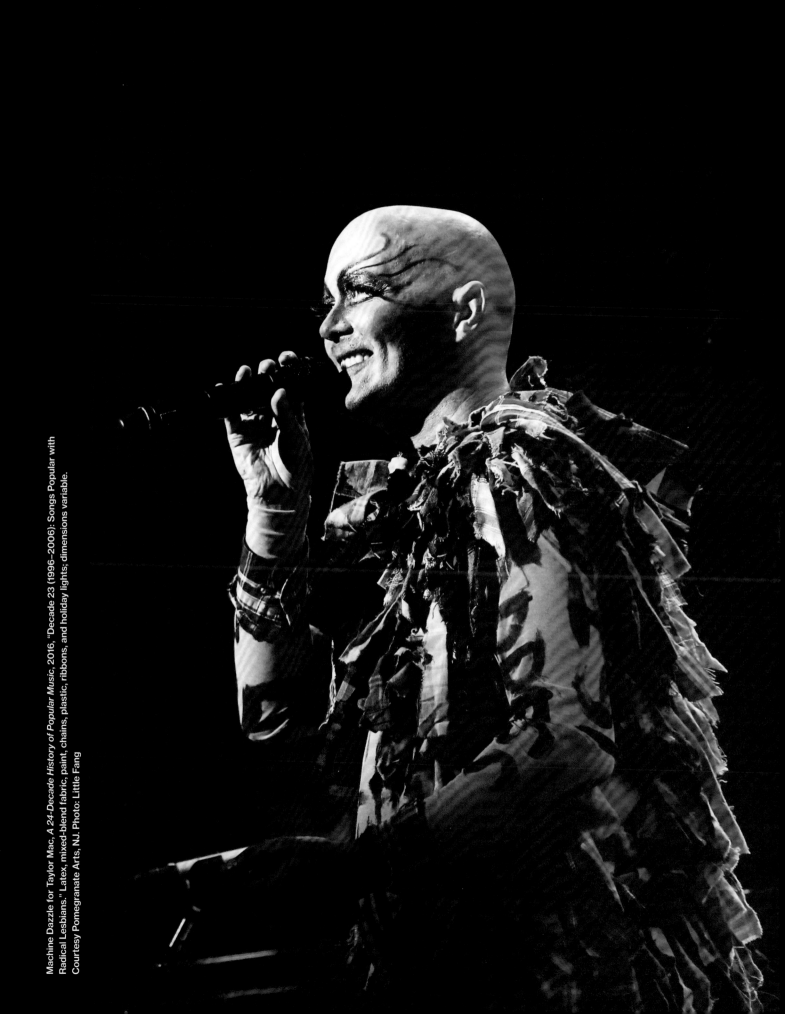

Machine Dazzle for Taylor Mac, *A 24-Decade History of Popular Music*, 2016, "Decade 23 (1996–2006): Songs Popular with Radical Lesbians." Latex, mixed-blend fabric, paint, chains, plastic, ribbons, and holiday lights; dimensions variable. Courtesy Pomegranate Arts, N.J. Photo: Little Fang

MX JUSTIN VIVIAN BOND

IN CONVERSATION WITH
MACHINE DAZZLE

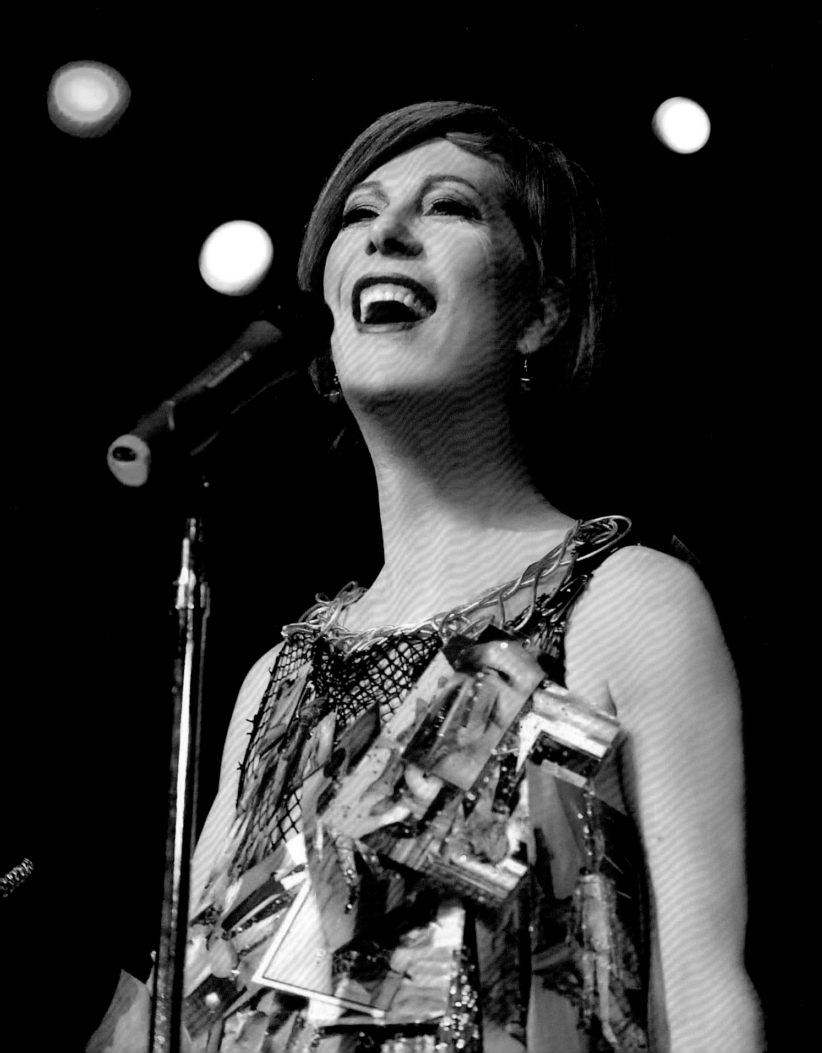

Mx Justin Vivian Bond x Machine Dazzle x (Whispering Angel) Rosé was recorded on August 25, 2020.

JVB How did you get your start in New York?

MD I landed in New York in the summer of 1994 on a hot and humid August day. It took me a bit to get my bearings since I'd never been to New York before. I was experiencing culture shock, and at first I wasn't sure I had made the right decision. But I found a job, and a place to live, and then I got to experience what before I had only seen on TV — famous clubs, music venues, nightlife, and more. For the first time in my life, I was making my own decisions, and I was able to begin to discover myself as a person and an artist. That's when I started to experiment with drag and costumes, sometimes buying things, but making most of it myself.

I had friends who started performing in a dance group called the Dazzle Dancers. I really wanted to be part of their magic! One day they asked me if I would make them costumes, and I was so excited! I was a bit intimidated at first, because I was new to sewing and had a makeshift way of making things. Ultimately, my makeshift experimentation turned into its own signature aesthetic. Instead of sewing things together, I tied things together; if I needed an armhole, I would cut one out. If I wanted something tight, I would rip and stretch it over the body. For the Dazzle Dancers, it was about having fun and taking ownership of our bodies through stripping, so I made things that were colorful, festive, and easy to take off in an instant. Eventually, I became one of the dancers, too! Of course, my name, Machine Dazzle, also comes from my participation in the Dazzle Dancers — my friends called me a dancing machine, so it seemed like an obvious choice once I joined the Dazzle Dancers.

A typical backstage scenario was me on the floor cutting spandex fabric into strips and tying it or stretching it over bodies while trying to score drink tickets. I made anywhere between eight and ten costumes per gig, depending on who showed up, and then for our video for our CD release *The Love Boat* in 2008, I created eighteen costumes for the entire troupe. Everybody wanted to be in the video, but not everybody wanted to cover themselves in glitter and dance at The Cock for no money every other weekend.

JVB Right.

MD Yeah, but some did. Some did.

JVB Thank God some did.

MD But generally, I recall everyone having a great time as I wrangled them into their costumes. We would playfully fight for the mirror to apply makeup and glitter by the handful all over our bodies. We made a mess! At the same time, I was making things for myself for going out. And people liked what I made for myself, and they asked me if I'd make them things. I created looks for lots of drag queens in this period.

Previous: Machine Dazzle for Justin Vivian Bond, *Happy Tranniversary!*, 2014, New York, NY. Photo: Michael Doucette

JVB Those were fun shows.

MD Mm-hmm. Mm-hmm.

JVB After that, I couldn't even care about any dance troupe for years.

MD I still don't. I still don't care.

JVB Unless they're wearing your clothes, I don't want to see them dance, to be honest.

MD I'm telling you. Garbage flitting about.

JVB Once they bring you up there to start designing for the New York City Ballet, I'll go, damn it. You will be doing that, eventually.

MD I don't know. I hope so. And I have people who want me to do opera. Saying, "You should be doing opera, because the costumes are so big."

JVB Well, the funny thing is, when I was interviewed for *Women's Wear Daily* and they asked about the opera *Orlando* I was in [2019 at the Vienna State Opera], they wanted to say something about the costume designer, who was Rei Kawakubo of Comme des Garçons. They asked me who I was inspired by when it comes to costumes, and I said I was inspired by you, and

that your costumes were the most genius costumes I'd ever worn.

MD Wow, did they print that? Thank you!

JVB It's perfectly fine, darling, but they could take a lesson. Everybody could learn from each other. And it's not very often you meet somebody who's your equal. I'm sure you know. And I would put you and Rei Kawakubo in the same category.

MD Thank you.

JVB But I wouldn't put you and many other people in the same category.

MD I mean, it's a category. I'm a niche category.

JVB It's an extraordinary, exceptional vision. And unique and beautiful. More people should be paying attention. But you're not in commerce. Who was the first person who got you really excited about making things for performers to wear?

MD Definitely the Dazzle Dancers as a group, but also Julie Atlas Muz, who asked me to create costumes for her performance *I Am the Moon & You Are the Man on Me*. That was at PS 122 in 2004 and that was an important commission for me.

JVB But you definitely got more exposure and publicity from your

work with Taylor Mac. When was your first show with Taylor?

MD We did small things together, leading up to *The Lily's Revenge: A Flowergory Manifold,* which was at HERE Arts Center. But *The Lily's Revenge,* which I began designing for in 2008, was our first big collaboration together. He won his first Obie Award and was on the cover of the *Village Voice,* and that was a big turning point for him. It really got him noticed. I remember Joan Rivers came to the show.

JVB Right, I remember.

MD Yeah. She asked me, out on the sidewalk, "You're Machine Dazzle, aren't you?" And I'm like, "Yes." She's like, "Beyond. Beyond." I always wanted to make her something, but it never happened.

JVB Yeah, Joan Rivers was amazing. She was really supportive of up-and-coming young performers. She loved Kiki and Herb and came several times to the show and that was so great. That's why I think a lot of older performers stay relevant. Because they stay interested in what young people are doing. And then you did *Lustre* with me, which was 2007, I think. Yes, I was still doing Kiki and Herb.

MD Yeah, *Lustre* included M. Lamar, Our Lady J, and Glen Marla. And of course, the Pixie Harlots performed. We [Darrell Thorne, Matthew Crosland, Layard Thompson, Jonathan Bastiani, and John Grauwiler] were just on the scene then. The producer Earl Dax put us together. *Lustre* was terrific. And of course, we did the Christmas specials [*Christmas Spells* and *Justin Bond: Close to You at Christmas, Darling*]. I remember our Susie Snowflake costumes, and the number is on YouTube. She's always ready.

JVB And you did the costumes for the transgender Huckleberry Finn *Christmas Spells.* And then, of course, the costumes for *Re:Galli Blonde (A Sissy Fix)* at The Kitchen in 2010. I still have my porn dress you made for my solo show in 2014, *Happy Tranniversary!,* at Poisson Rouge.

MD I would love to exhibit that. I don't know if they'll let me, or if they can section it off: "Okay, no children beyond this point."

JVB They should have an adults-only section. Because there's the porn dress, and then I have the balloon party dress you made for *Lustre: A Summer Solstice Trans-Pervasion,* the pooped out party girl balloon dress.

MD I really like the one for Poisson Rouge. Incredibly uncomfortable to wear, I imagine, unless you're wearing some kind of slip.

JVB It wasn't that uncomfortable. The plastic encased photos just hang like fish scales.

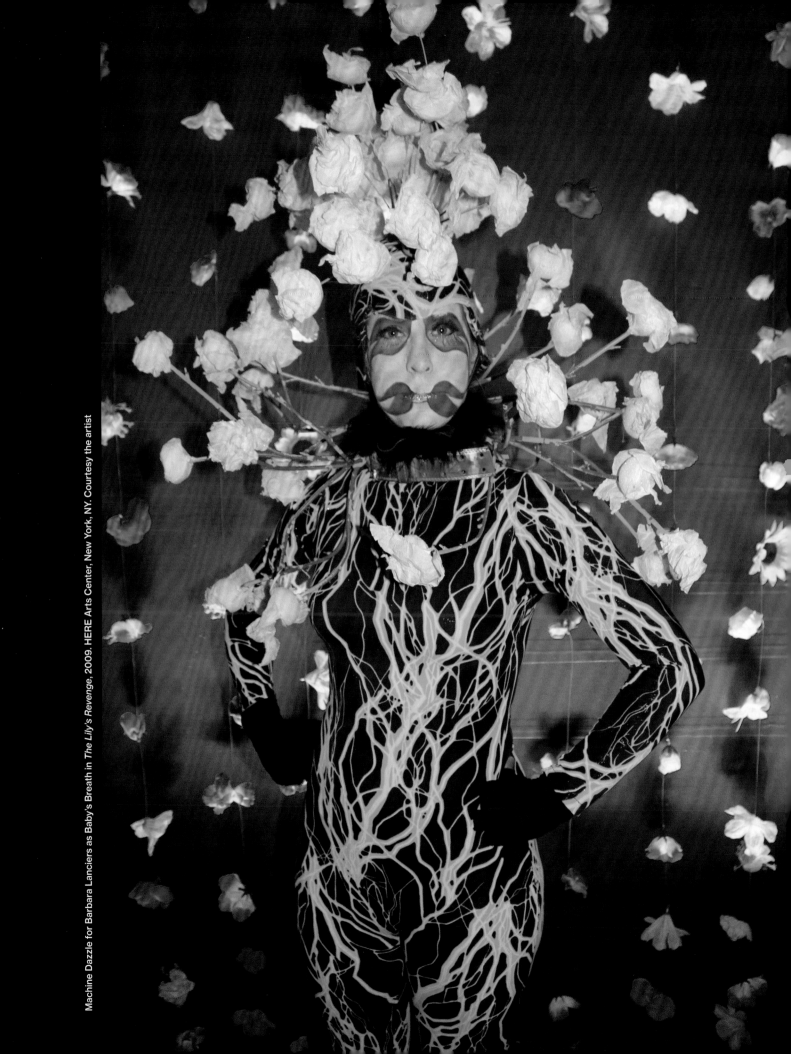

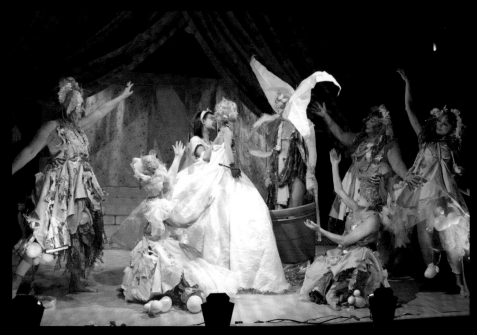

Flower girls in *The Lily's Revenge*, 2009. HERE Arts Center, New York, NY. Courtesy the artist

MD That's what I was going for.

JVB So, when did you debut as a performer? Weren't you in *The Lily's Revenge*?

MD I was. In the first act there was the bride, and I was one of the daisies that got plucked apart by the flower girls. And then I returned in the fourth act as the queen bee. If you remember, everyone was contained, and then the bees were buzzing outside. I was mentioned at that point as the costume designer. The next show I did with Taylor was *The Walk Across America for Mother Earth* at La MaMa. I loved the costumes, which were inspired by *commedia dell'arte*. *New York Times* theater critic Charles Isherwood claimed they were the "most fabulous costumes of the year"! And then work began on *A 24-Decade History of Popular Music.* That was a major feat.

JVB How many costumes do you think you actually made for that production? And did you remake them? Do you continue to remake them?

MD They all still exist and a large group are in the exhibition at MAD. I continue adding to them. I make them better. I'd like to say I made at least 100 costumes. Because there are 24 for Taylor, 24 for me. And then there were the Dandy Minions, who costumed themselves except for special moments, so that was probably another 30 costumes, and at one point there were 12 clowns, and there were 8 Mother costumes, and there were some random acts of fabulousness I put together. And let's not forget the various props. It was big.

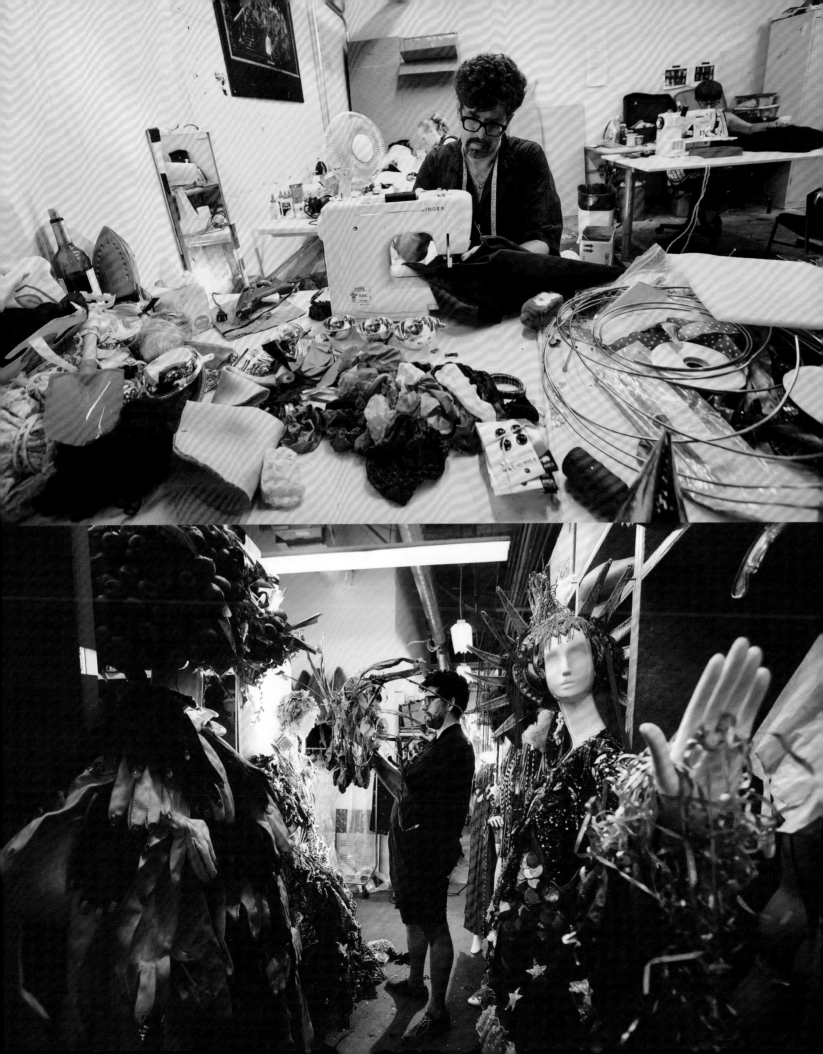

JVB More Whispering Angel?

MD Yes, please.

JVB What about the show where you had everybody dressed in buildings of the New York City skyline?

MD I did that for the Stanley Love Performance Group in 2004 on the anniversary of 9/11. That was one of my favorite things I've ever done. Of course, you know that Stanley is no longer with us.

JVB Right, and he is greatly missed. Just to be clear for the interview, the costumes were reproductions of iconic buildings in the New York City skyline. You made them for the Empire State Building, the Chrysler Building, and the former World Trade Center — played by two people, Stanley and Lauri Hogan.

MD Right. The World Trade Center was played by two people, Stanley and Lauri. There was also a costume for the Woolworth Building, and I made costumes for the Statue of Liberty and two firemen. We rehearsed all summer and on 9/11 we went to Central Park, found a spot, and put down a huge boom box — very Stanley Love–style. And we did a show for the public walking by.

JVB Had it been announced or was it word of mouth?

MD It was word of mouth to our fans; Stanley never really did big announcements.

JVB Plus, we didn't have the kind of social media we have now.

MD We did two sets, so we wore different costumes throughout that show. It was about a one-hour show. Everyone kept talking about how gorgeous the day was, and how blue the sky was. It was the same kind of September day. And we did two songs dressed as the skyline. We came out and I was the Empire State Building. Cathy [Richards] was the Chrysler Building. We danced to the Gap Band's "You Dropped a Bomb on Me." That's with the lyrics "You dropped a bomb on me, baby. You dropped a bomb on me." And then we danced, in the same costumes, to "This Used to Be My Playground" by Madonna. By this time people were weeping. Lauri and Stanley, the World Trade Center, did a final dance. It was beautiful. There were cops who probably were supposed to stop us from performing, because you're not really allowed to do that in Central Park without a permit. But they stood there and watched the show, too.

JVB Did they weep?

MD I don't remember them weeping. I was performing without my glasses because I'm always afraid that they will fly off. Also, glasses can ruin a look — it makes you more human instead of

something else. And I just wanted to be the Empire State Building without too much of my own personality. Anyway, I didn't see them, but the performers close to me, I could see that they were crying.

JVB When I saw it, I don't remember what the occasion was, but it was at the Highline Ballroom?

MD That's it. That was the following year.

JVB And I wept. It was so moving. And it was moving because of the choreography between Lauri and Stanley and the way the rest of the skyline watches their demise. It was a very emotional thing to witness. Are you going to be recreating things that you no longer have for the exhibition?

MD I think I have to. I have photo documentation of some things, and I have no problem recreating things. I know it doesn't sound as authentic, but I'm still making it.

JVB Exactly.

MD I love things that are old, that are tattered. One of my favorite things is old costumes from a production. I love to see how raw something is on the inside. Okay, this isn't a piece of fashion; this was a costume.

JVB Well, the things you made for me are in pretty good shape. It's just that they stink.

MD Well, you know what? We give it some vodka spray. You could give it a dip. Especially synthetic fibers, they really like to hold on to the stink.

JVB Oh, yeah. And also, when you're performing, your stress sweat from performing is much more intense than other sweat.

MD It is, isn't it?

JVB And also, at that time when we were working together, I started dating Nath Ann Carrera and neither of us ever wore deodorant.

MD I remember that. Not you so much.

JVB Nath Ann was funky.

MD He was really pungent. I was like, "Is that a San Francisco thing?" I met a few other people like him, who just never wore deodorant.

JVB And he had this boss — he worked at that store that sold minerals and fossils, Evolution. And his boss bought him deodorant and made him wear it, and it killed our sex life. Because I was really into all those pheromones. I was like, "I don't care what anybody says." I was into it. It was like a rebellion. I like to be in

love with somebody who makes me feel a little bit rebellious.

MD I like that, too. I like being naughty. I've been called sassy more than once. And I know that I am. Especially when I see video of myself. I'm like, "Oh, my God. I am sassy."

JVB You're a provocateur, as we say. I mean, not to keep bringing it back to that tranny porn dress for *Happy Tranniversary!* – and you're not even supposed to use that phrase anymore – but I can't believe I got away with the publicity shots I sent out and that appeared on the covers of *The Stranger* in Seattle and *SF Weekly* and the weeklies of towns abroad. There is one where there's a penis up against the lips of another person, and it's just right there for you to see. And it's like, "Enter at your own risk," or, "Slippery when wet," or whatever. But I loved it, because I hadn't even thought about it when I sent the photos out. I was like, "Oh, this is a great picture." And it was a great picture. And evidently, they agreed because they put it on the cover. And then – oh my God – it was in grocery stores.

MD Well, I mean, cheers to that.

JVB Blow jobs on street corners.

MD I would love to recreate the dress I made for you for the fashion show I did at San Francisco Museum of Modern Art as part of Earl Dax's theatrical cabaret, Weimar New York. It was a big, fabulous mess of crumpled up porn. I don't know what's with you and porn. But that was a fantastic, taboo creation.

JVB Back to your work as a performer. There are the groups you've performed with – the Dazzle Dancers, the Pixie Harlots, the Stanley Love Performance Group, and in Taylor Mac's productions – and then, all of a sudden, you just broke out. And you started doing not only your own thing, but your own songs.

MD I always wanted to do that. I just had to wait for the right moment, because I was always doing everything for everybody else. And the clock was ticking. It was like, "When am I going to fulfill this?" And I finally did it.

JVB Were you frustrated for a long time before that, or were you just biding your time?

MD I think there was maybe a mild frustration. But I think I was always happy that anybody wanted to work with me at all. I was like, "Wow. These people believe in me. They really love me, and I love them." And I just feel really lucky to have the life that I've had as a designer and a collaborator. I really do love being part of a bigger puzzle – part of a group that creates something collectively. However, there's no question that sometimes I've felt like

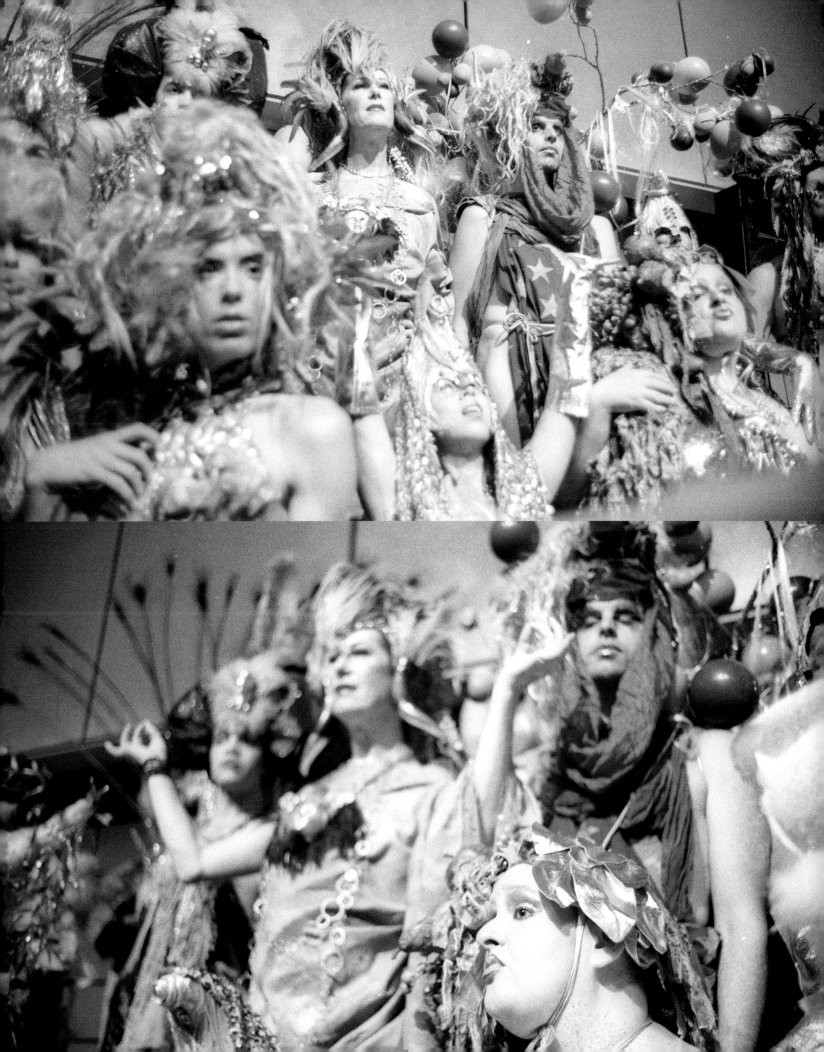

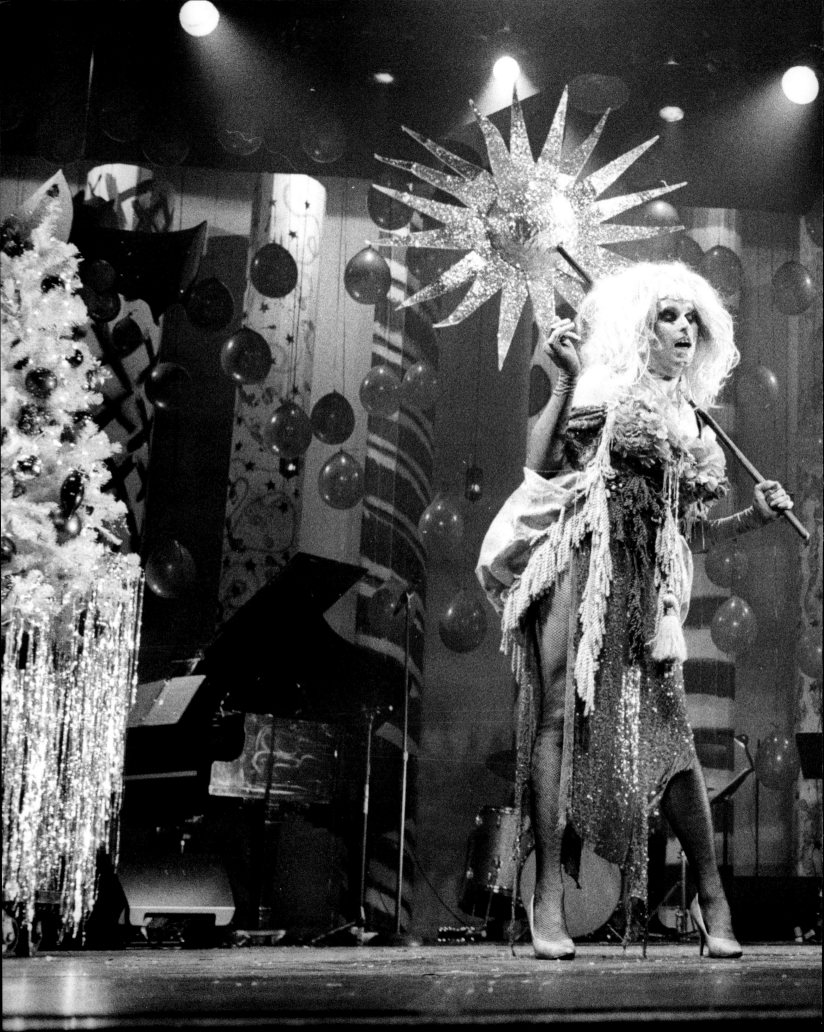

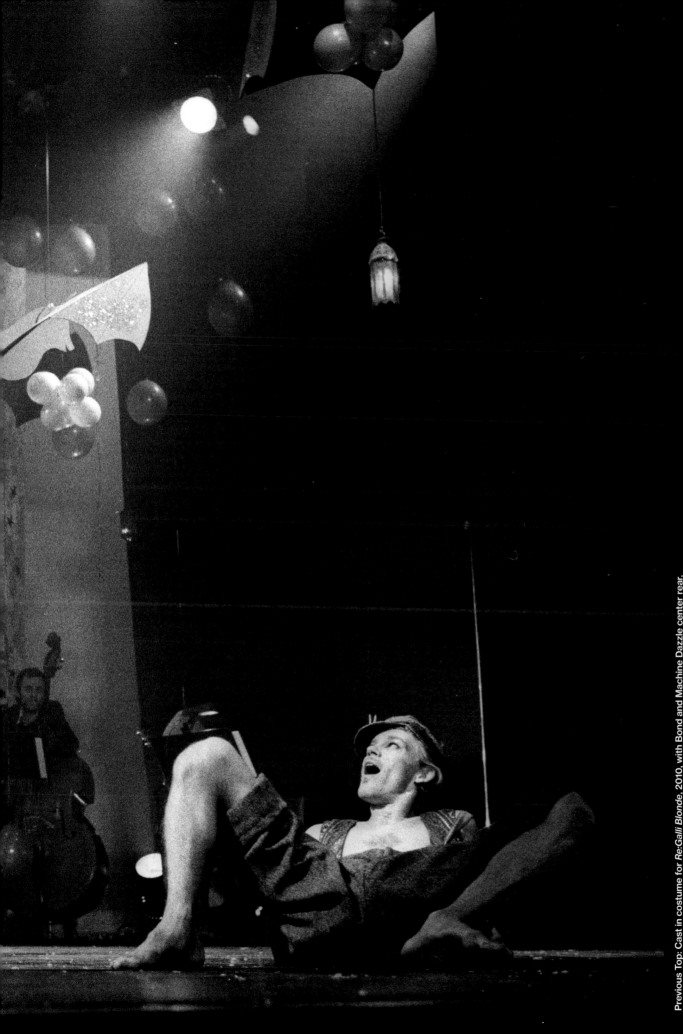

Previous Top: Cast in costume for *Re:Galli Blonde*, 2010, with Bond and Machine Dazzle center rear. The Kitchen, New York, NY. Photo: Eileen Keane

Previous Bottom: Cast in costume for *Re:Galli Blonde*, 2010, with Bond and Machine Dazzle center. The Kitchen, New York, NY. Photo: Eileen Keane

Left: Machine Dazzle as Miss Rosie in *Christmas Spells*, 2010. Abrons Arts Center, New York, NY. Photo: Eileen Keane

community is the death of my individual vision. You know what I mean?

JVB I do. Exactly.

MD And excessive individualism is the death of the community. I struggle with that back and forth. I have really strong ideas. And I've lost friends or stopped communicating with certain people because they always needed to be the lead. And there was no way they weren't going to be. They had to be front and center, they had to be in charge, and I just loved being part of a group. I think it's stronger.

JVB But now that you've been front and center . . .

MD Now that I've been front and center, I mean, there's power in that, too. I just want to weave that into what I already have. I don't have to be the main event the whole time. I enjoy sharing the stage.

JVB Well, even when you were front and center in *Treasure*, you were so clear about the fact that you were collaborating with Viva [DeConcini], that you had written these songs together. And so, it was clear that it was your vision and your words and music. But even then, you were very clear about how you made the work with other people. Which is really gorgeous.

MD I think of hierarchy like a pyramid. And the leader is on top. But to be on top, you need all these other layers supporting you. I think that's the way systems work. I think that's the way nature works. And I think any good leader is going to admit that they have a good team working for them and supporting them. I mean, I would think so. And if that leader doesn't acknowledge the people who are working under them, then I don't consider them much of a leader. Or I have less respect for them.

JVB I always felt like you were the leader because of your complete engagement. On a certain level, you were leading in many, many instances. Because you were engaged on a very intimate level with every person in the production. If you were making costumes for the Pixie Harlots, or for me and Nath Ann, or for the lighting room person and the set person, you were the thread that connected everybody in so many of the productions you were involved in. Don't you think? Are you aware of that at the time?

MD I felt like people did give me credit in that way, and I've always felt appreciated on that level, but I'm very sensitive about not taking anyone else's credit away from them. I want to pick back up the topic of finally breaking out on one's own. After my show *Treasure,* which was part of the Guggenheim Foundation's Works & Process performing arts series, I experienced the

sensuality that comes with performing for the first time – literally being in everyone's ears and mind in the moment. I left thinking, okay, I can do this. I can do this. And I also realized that I'm kind of a queer rock-n-roll hippie, and I love music separately from the visual arts. I don't know that I'll continue incorporating fashion shows as a part of music. It's nice when the music and the visuals can come together, but it's so much more work when you're doing everything. The show is your conception. You're doing the writing. You're performing the songs. And you're costuming everybody. It's a lot.

JVB Right. I've done all that without the costuming part.

MD It's hard.

JVB And producer and all of that. Which is enough. But on the other hand, the great thing about it is, there are so few people who are actually capable of doing all that you're capable of doing. How do you negotiate which part of your talent you're going to honor and indulge in any given moment?

MD I think I'll use Treasure as an example. I wanted to make sure that the music was good. That was the most important thing to me. So, Viva and I started rehearsing song by song beginning in January, and we finally did the show in September.

JVB Was that when I saw it at Lumberyard in the Catskills?

MD Well, Lumberyard happened right before the September premiere. So, you saw it before it went primetime at the Guggenheim. I didn't even have my proper costume yet, though I liked what I was wearing. So, the music was what I was prioritizing. Most people think of me as a visual person. I can accomplish the visual easily when I'm inspired. That's what I am most practiced at.

JVB Inspired?

MD I have to be. I almost had to make the show first before I could make something visual out of it.

JVB And that's what makes the visual work that you do so powerful and makes you, I would say, not a couturier. Even though your fabrics and everything are hand-done and there's great virtuosity in that regard, your stimulus comes from something that's more. You're not creating fashion in a void because you love creating fashion. You're creating fashion to make a statement that supports a thought that you're inspired by.

MD Thank you. I make things for reasons. I'm not the kind of person to just make something and have it hanging there. I'm not interested in products. Selling something that I make never crosses my mind. If I'm selling anything, I'm selling an experience. And it's your experience, whatever

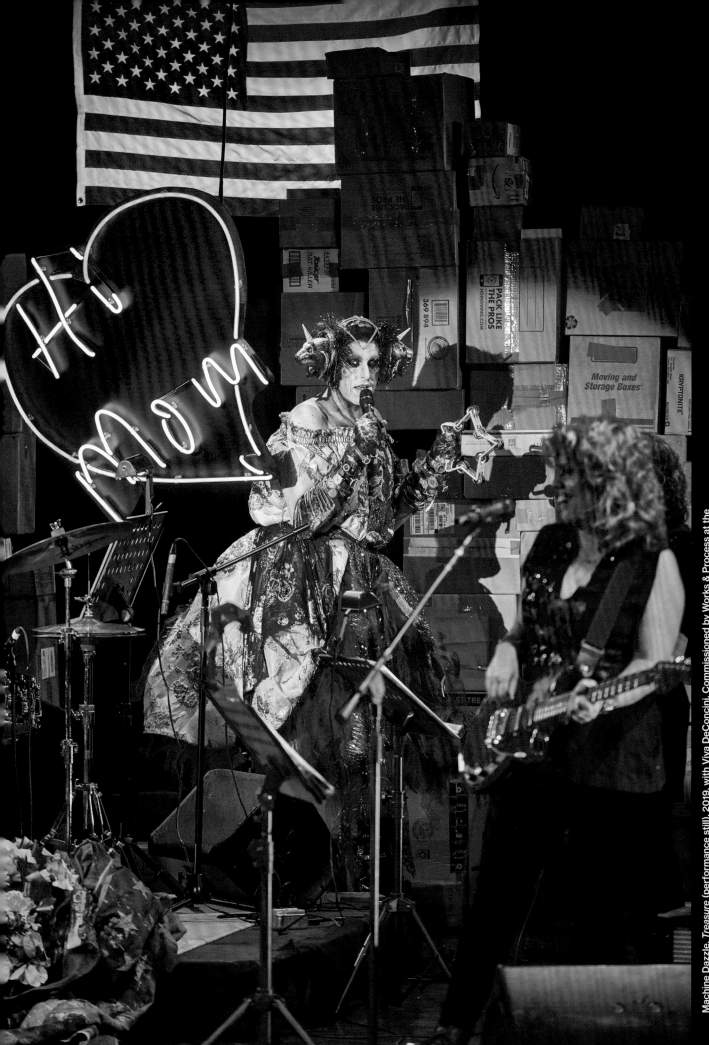

Machine Dazzle, *Treasure* (performance still), 2019, with Viva DeConcini. Commissioned by Works & Process at the Solomon R. Guggenheim Museum. Photo: Robert Altman

you have, your emotions, your thought in the moment, that's what the person is buying. That's what they're taking with them. It's not a product. That's not what I want to do, and that's not what I want my legacy to be. I want people to feel something that changes them. I don't know. I think you can change someone's life by walking across the room, wearing something very specific. Possibly for a specific reason.

JVB I mean, I've had my life changed by seeing somebody do that. Can you remember a moment when that's happened to you, when you've seen somebody walking across the room in something and it changed you?

MD It happens particularly when I take my work to the street. Let's say it's the Mermaid Parade, or it's the Easter Parade. And I love showing up in all my costumes and they always have a story to them. There's a reason for doing it. I'm not going to the Mermaid Parade as a mermaid, or just as a sea creature. Because that's what everybody else does. I mean, why are you doing this, besides the fact that it's fun? You know what I mean?

JVB Can you remember when you've seen something that has changed your life? One of those moments?

MD Well, one of my first memories stands out in this regard. I asked my parents to take me to *The Nutcracker* for my tenth birthday. And they weren't involved in the cultural and performing arts. We never saw art. So, in 1982 we went to the Houston Ballet's production of *The Nutcracker*. We were sitting up high, but we still had a pretty good view of the stage. And I sat there, and I just watched. And I was like, "Oh, my God, look. There's really a nutcracker. It's really dancing." I'd only seen things like these maybe in pictures, maybe on the television. I'd never seen live performance. I didn't know that it was possible. There were mice and other animals. There were objects brought to life. People moving in gorgeous, beautiful fabrics, and it was really, really happening. And then I saw there were children on stage, children my age. They might have even been younger. And I was like, "Wait, that's where I want to be. That's me." Not only did it change my life forever, but I was also depressed for a while, because I knew that I was so far away from it. I'm like, "How do I do that? Where has this been? This has never been an option for me." So, it took me until I moved to New York to make it happen. I was young when this happened. Of course, when you're young, everything makes an impression, everything you see. But this was huge. And I know people these days, friends of ours, who have kids they take to cultural events all the time. I think, wow, these kids growing up with that, on a regular basis. That's lucky.

JVB Right. It's interesting that you somehow knew to ask for it.

MD Somehow, I did ask for it.

JVB And your parents honored you. They did that.

MD They did. It was probably the best thing that they ever did, besides give me life. No, seriously, they worked hard. They were really good. They did what they could. We were in good school systems. We were in the public school, but we were in good public schools. Even though I was bullied, I always felt safe. You didn't have to deal with guns or, God, anything that kids have to deal with today. No pressure from social media.

JVB What's next for you?

MD I haven't done any recording yet, but I have at least four more shows practically ready, besides *Treasure*. So, *Treasure* was about my mother. The next one, I'm calling *The Painting*, and it's about my father. I'm conceptualizing the show as a canvas, and the painting is about what happens to the canvas, which is life. I will be working with Viva DeConcini again, of course. I'm the luckiest machine in the world to work with her, and her musical direction is brilliant. My gift is that I hear the songs before I know the melodies. I know how I want them to sound. But the way Viva and I work is that we get together, we go into the rehearsal studio, and I start singing the song into the microphone. And the words are there, the melody's there, the whole thing's there. Now, I'm hearing all the different layers. But I have to let Viva get on the same page as me. And I have to let her be, and I want it to be worth it for other musicians, too. I don't want it to be too

demanding. If there's something that I really don't like, then I'll say so. But otherwise, I'm like, "Well, let me put this out there and see how other musicians respond to it." And that's exactly how we did *Treasure*. I didn't tell anybody anything. I know the melody, I know how I want it to go, but otherwise, I didn't tell any musician what to do. Viva orchestrated that whole thing. And what a gift, because I wasn't playing any instruments. I played the tambourine during one part, but that's it. But I know how I want it to sound.

JVB That's how I am when I write songs, too. I started writing songs in the early 1990s and then I stopped for many, many years, and then I asked Our Lady J and Taylor [Mac] what to do. Taylor said, "Girl, you just write your monologues. That's all I do. I just take my monologues, and I put them to a melody." And it was so liberating to hear that, and that's how I started writing again. Lady J essentially gave me the same advice: "Yeah, girl, set up a rhythm in your mind, and then just set the words to it." So, I did that, and I would record the words in the rhythm and edit them. Then I could actually hear the song. And then I knew how to describe what I wanted. And then other people bring things to it.

MD Recording yourself and listening to it is such a huge lesson. It's so uncomfortable.

JVB It's so terrible.

MD But that's how you learn. I think you learn by facing your fears, not by running away from them. For a long time, I was running away from the process.

JVB What was the fear?

MD I think the fear was that I wanted people to like it. I wanted it to sound good. I wanted to give people a reason for listening to me. I don't want to just be like some pop song on the radio, where it's a little gratuitous, and it's a good beat, and the gays are going to wiggle their ass in the bar.

JVB But we like that.

MD I mean, I don't hate that. I speak that language. But I like things to be meaningful beyond that, too. Even though I think I make songs that get in there, I think they also come from a familiar place. I've had people tell me that they have certain songs stuck in their head. One of them is *Treasure*, and one of them is the song I sang at a benefit at Joe's Pub in falsetto.

JVB What's the name of that song?

MD That song is called "Graveyard." The opening lyric is, "You grew up across the street from a graveyard." My mother, she really did. She grew up in this beautiful Victorian-style farmhouse across the street from a graveyard. I have pictures of it. It represents a very magical place from a different time for me. Patti Smith is one of my idols (and we have the same birthday, December 30). She understands the layering of history, poetry, and melody to create meaning. I do that with my costumes, which I have often thought of as songs, and now I want to do it with my own songwriting and shows.

madison moore

YOU HAVE A WHOLE STAGE TO FILL — WHY NOT FILL IT UP!
MACHINE DAZZLE'S QUEER MAXIMALISM

During a September 2019 lecture at Brown University, costume provoca-teur Machine Dazzle recalled the best piece of advice an art teacher ever gave him, one that continues to shape his signature style to this day. That advice? Fill up the page. "[In] my very first studio class . . . at the University of Colorado in Boulder," Machine remembered, "we had a sketching assignment. There we were, out in nature, and I was really interested in this leaf . . . I had this big sketchbook. [My professor said], 'You have a whole page to fill up. Fill it up!'" From that fabulous little leaf to the boisterously queer kaleidoscope of colors, textures, and patterns that inform his surrealist take on wearable art, not to mention his eye-catching, over-the-top looks made for the club, the stage, and the catwalk, Machine Dazzle's theory of queer maximalism emerges. "I like to make things bigger than maybe what they should be," he said during that same lecture. "More exaggerated. . . . You have a whole stage to fill up — why not fill it up?"[1]

When thinking about the potential juiciness of queer maximalism as an aesthetic form, there is a temptation to gesture toward other creatives, like Coco Chanel, who famously warned us to remove an item of clothing or jewelry before we left the house for the day, or the abstract painter Ad Reinhardt, who believed that the more additions a work of art has, "the less pure it is. The more stuff in it, the busier the work of art, the worse it is. 'More is less.'"[2] Enter Machine Dazzle, whose creative practice exposes and explodes these conservative aesthetic conventions by suggesting not only that more is more, but also that more is queer.

Queer maximalism is an aesthetic practice that aims to expand the mind through the dramatic side effects of glitter and sequins. It is a method of escaping the ordinary to imagine a politics of style that chal-lenges and explodes what we previously thought possible. "A part of the definition of queerness," Machine has said, "is not settling. Constantly asking questions, not accepting the status quo, pushing the boundaries. That's what I like to do when I make work. Okay, you want the dress — great. Well, what else could it be? . . . Are we gonna stop at 'wig,' are we gonna stop at 'dress,' are we gonna stop at 'shoe'? That's it? There's no more? Really? No, more is more. Less isn't more."[3]

Queer expressions of excess and over-the-topness are under-girded by the fact that queer people are constantly denied rights, visibil-ity, resources, and access. In 2021, queer and trans livelihood is still subject to right wing culture wars and heavy-handed conservative legislation. If style is political, queer maximalism, in all of its color,

vibrancy, pomp, and circumstance, offers an antidote – a creative method of resisting a flattened human experience driven by tradition, conservatism, and monotony in favor an experience that is much more colorful, fun, and, indeed, dazzling. Machine Dazzle's pieces encourage us to wonder why on earth we settle for drab and boring when there is so much color and texture in the world. Why be dull when you could be FABULOUS, with GPS coordinates that are off the map? In this way, queer maximalism offers an escape hatch out of the doldrums and into the scintillating.

As cultural critic Rebecca Coleman writes, "Glitter has the capacity to world differently, to create a variety of futures."[4] Machine Dazzle is an artist who is certainly captivated by the variety of futures and stories that glitter can tell. In one experimental drag look (p. 91), which serves up an amalgam of concepts and ideas, a colorful Machine dazzles in an explosion of colors and patterns that clash into a symphony of pinks, yellows, oranges, and reds swirling in one direction, while purple fabric and gold embroidery flow in the other, the seemingly disjointed materials ultimately making their own connections. The look is tied together with an oversized silver belt, a silver sequin scarf knotted around the neck, five-inch dangling silver earrings, a zebra-print headscarf, and glitter smeared all over the face. Besides the hands and face, no skin is visible, as though the fabrics become a second skin. True to form, the entire canvas has been filled.

Like most of Machine Dazzle's pieces, this is a look equally suited to be worn on stage, in a pageant, or at the club. Indeed, part of what makes Machine's designs sing is their clear connection to the improvisatory queer maximalist style practices of the Blitz kids in 1980s London and the club kids of New York in the 1990s – two queer lifeworlds where there were very few boundaries between art, fashion, music, performance, and nightlife. For the club kids, over-the-top looks were fashioned and repurposed from trash, commercial items, and found objects, and this club kid lineage offers an important cultural context for Machine Dazzle's own creations.

While the residual glitter dust of Machine Dazzle's queer maximalism is a thematic that lives across his performance sculptures, perhaps its apex was the looks he created for performance artist Taylor Mac's 2016 piece *A 24-Decade History of Popular Music*, a work that tells the history of the United States with 246 songs dated from 1776 to 2016. Each decade lasts one hour, and every hour merits a look change, with the look change itself serving, too, as a queer aesthetic trope. In his

Backstage on the set of *A 24-Decade History of Popular Music*, 2017, Curran Theatre, San Francisco, CA. Photo: Little Fang

review of the show, critic Kalle Westerling recalled that Machine's looks included "excessive and fleshy fabrics of all colors and shapes and countless headpieces, complete with indescribable found objects, literal trash, blinking lights, and smoke machines," not to mention a wig made of wine corks (p. 94), a dress made of empty potato chip bags (p. 95), another made with cassette tapes (p. 64), and lots and lots of sequins.[5]

Many of these items, as with the majority of Machine's works, are materials that would ordinarily be cast aside or thrown out, not necessarily go-to items for costume design. But this is part of what makes Machine Dazzle's creations so vibrantly queer: the way he actively sees through disused materials and objects, trash, mess, and clutter, poaching them from one use context and dropping them into entirely new ones. For Machine, this de Certeauian reading strategy means seeing through the disused material or object to give it new meaning, a whole new life-world. When used within a fashion context, this use of detritus is a practice I have called "creative strangeness," or the process of making dramatic, highly editorial fashion moments out of objects that were not made to be worn or that have otherwise been discarded. Such creative strangeness can be found in fashion photographer Steven Meisel's editorials in the pages of Italian *Vogue,* the "bizarre" category of vogue balls in New York, Berlin, and Paris, as well as in the clubs of downtown New York in the 1990s, a laboratory where Machine Dazzle further experimented with club fashion and costume design.

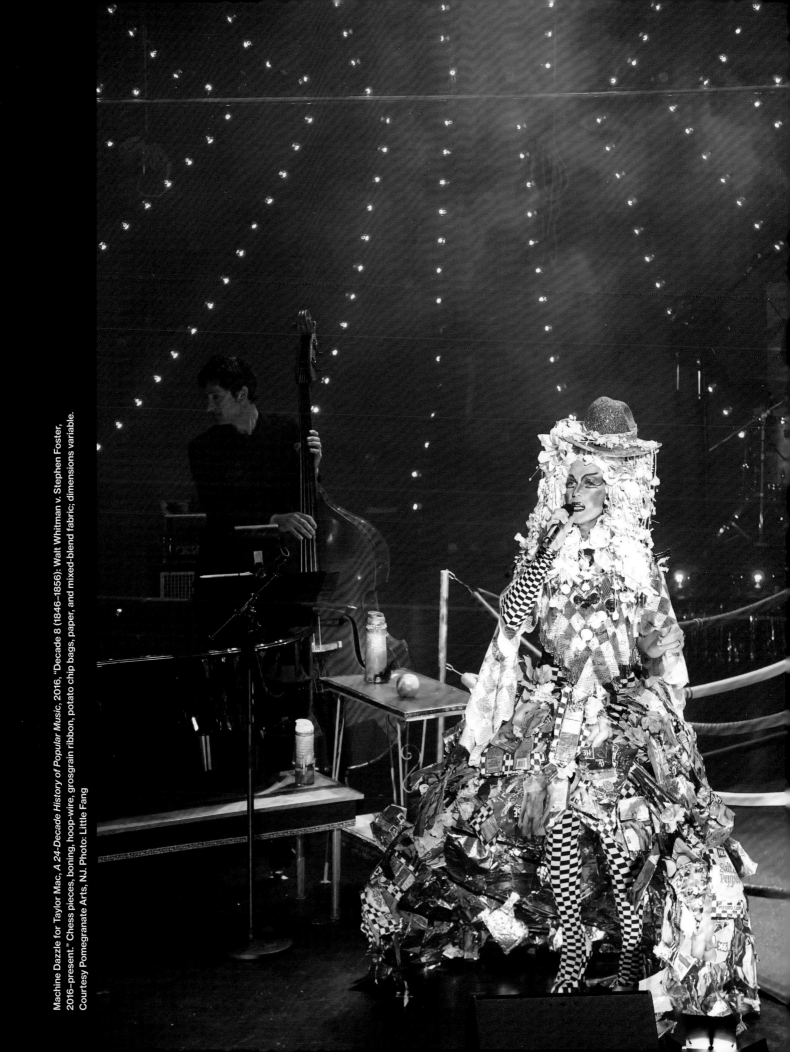

Machine Dazzle for Taylor Mac, *A 24-Decade History of Popular Music*, 2016, "Decade 8 (1846–1856): Walt Whitman v. Stephen Foster, 2016–present." Chess pieces, boning, hoop-wire, grosgrain ribbon, potato chip bags, paper, and mixed-blend fabric; dimensions variable. Courtesy Pomegranate Arts, N.J. Photo: Little Fang

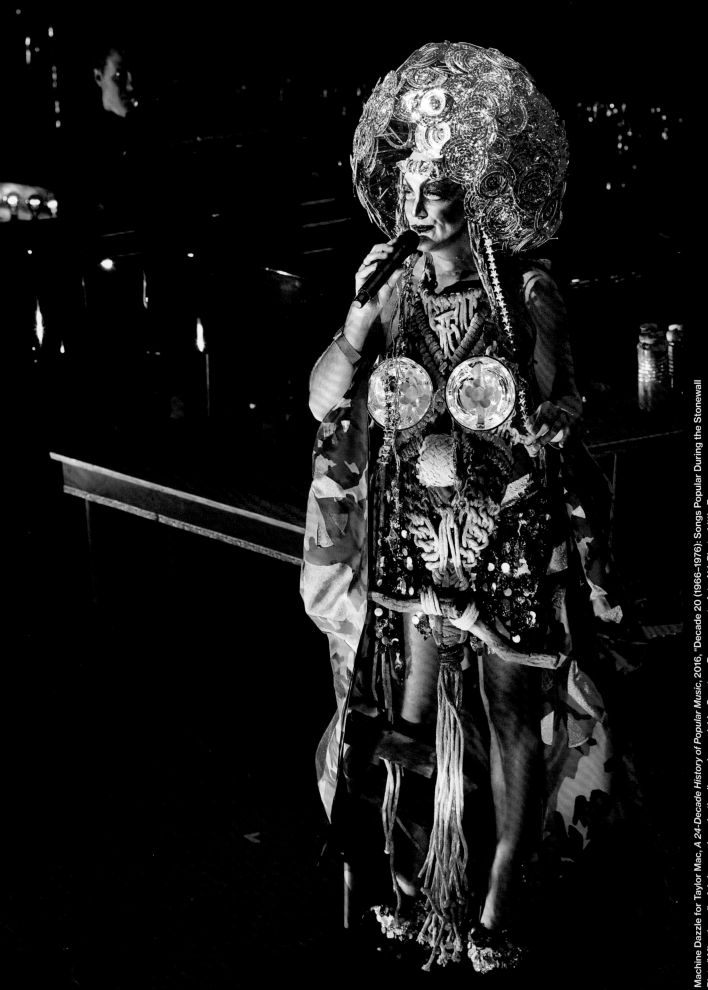

Machine Dazzle for Taylor Mac, *A 24-Decade History of Popular Music*, 2016, "Decade 20 (1966–1976): Songs Popular During the Stonewall Riots." Mixed media, fabric, sequins, plastic; dimension variable. Courtesy Pomegranate Arts, NJ. Photo: Little Fang

The power to see through an object's use in order to imagine it doing something else stems from an ability to understand the sequin in the rubble, the beauty amidst the debris. For Eddy Alvarez, Jr., finding sequins in the rubble "is both about materiality – textiles and synthetic materials like sequins, and rubble (physical debris left after a catastrophe or the wrecking ball) – *and* about a particular form of consciousness." That form of consciousness highlights "the way aggrieved communities make sense of their lives, consciously or unconsciously . . . an emancipatory mode of being and belonging in the midst of the rubble, literal and metaphorical."[6] In other words, finding sequins in the rubble offers a narrative of how marginalized people turn to the aesthetic realm – to the maximalist, to the fabulous, to the excessive and the over-the-top – as a form of escape, if not emancipation.

Perhaps the most vibrant quality of Machine Dazzle's brand of queer maximalism is glamour as resistance. We tend not to think of fashion, style, or glamour as resistance because they are easily written off as pure narcissism. Style can't be taken seriously because it's all fluff and no stuff. But for queer people, glamour is resistance because of the way it allows you to use aesthetics to seize space on your terms. Glamour as resistance means realizing you're fed up paying into heteronormative systems and structures that were not made for you. With glamour as resistance, you choose the instability and the messiness of queerness, you choose sequins and headpieces, you choose to make beauty out of detritus, and you use style as a tool to explode boundaries and binaries with maximum impact.

1 FirstWorks2004, "Machine Dazzle," filmed September 2019 at Brown University, Providence, RI. Video, 2:48, https://www.youtube.com/watch?v=eu6jlpSzOTE.
2 Ad Reinhardt, "Less Is More: Ad Reinhardt's 12 Rules for Pure Art," *ARTnews*, January 24, 2015, https://www.artnews.com/art-news/retrospective/less-is-more-ad-reinhardts-twelve-rules -for-pureart-3470/.
3 Elyssa Goodman, "Meet the Artist Radically Queering the Field of Costume Design," *them.*, September 5, 2019, https://www.them.us/story/machine-dazzle-treasure-costume-design.
4 Rebecca Coleman, *Glitterworlds: The Future Politics of a Ubiquitous Thing* (London: Goldsmiths Press, 2020), 1–2.
5 Kalle Westerling, "Review of *A 24-Decade History of Popular Music*," *Theatre Journal* 69, no. 3 (September 2017): 408.
6 Eddy Francisco Alvarez, Jr., "Finding Sequins in the Rubble: Stitching Together an Archive of Trans Latina Los Angeles," *TSQ: Transgender Studies Quarterly* 3, nos. 3–4 (November 2016): 620.

MACHINE DAZZLE,
IN HIS
OWN WORDS

I'm dedicating my section of the catalogue to Eileen Keane. Eileen's photographs serve as the most significant documents of how and when I started to build the maximalist artistic practice that people know me for today. Describing our relationship is like trying to define what life is, but here it goes.

I first met Eileen on a rather magical evening. It was early May in 2002 when I hopped on the subway and traveled to my friend Joachim's home on Fulton Street in post-9/11 Manhattan. I was dressed to the nines in my outfit for Night of 1000 Stevies, an annual tribute party to Stevie Nicks produced by the Jackie Factory. Joachim lived in an unusual and fabulous loft two flights up on the corner of Gold Street. There in the kitchen was a person who would change my life forever.

Eileen had just moved back to the United States from Japan, where she had studied. She is beautiful, with a disciplined appearance, and is soft spoken. She has two looks, casual and formal, and she is never without her Leica. I appreciate Eileen 's dedication to her practice – loading the film, shooting, reloading, all on the dance floor, at the bar, or anywhere else, in her vintage Dior gowns, gloves, and feather boas. Even as the world turned digital, Eileen stayed true to her old school ways.

I started seeing Eileen more often at events, parties, and parades. I admired her spirit and her ability to spark conversations with strangers and make friends. We became fast friends and she started documenting everything that I was doing. When I say documenting, I mean she captured moments, both public and private, and turned them into paintings using camera, film, and light. She wasn't afraid to get up close and personal, and I let her. Eileen has seen me at my best and at my worst. She has taken the most intimate pictures of me in and out of costume.

Night of 1000 Stevies is just one of the annual events we would enjoy. The Coney Island Mermaid Parade is another, along with Invasion of the Pines on Fire Island on the Fourth of July. The love of tradition is something we share, and the fact that we were in each other's company made these occasions even better. Ever thoughtful, Eileen always arrived carrying bags of surprises in preparation for the evening. Religiously, she brought fine Champagne and poured it into her own crystal glasses, but not before changing from slippers into Louboutin heels. Once everyone was taken care of, the Leica came out.

It would be months, sometimes years before I would see photographs from a particular event. Eileen developed her own film and worked in her own darkroom. Some of my most treasured memories were brought to life again when she gifted me books of prints and tests

from the darkroom from our excursions. I have a small library of these and treasure them.

Being photographed is important for a performer. Each image is an experiment in time, and it allows the artist to see themselves through the eyes of another. You can see where the makeup was spot on and you can see where the costume failed. Most importantly, you can see the moment, the emotions in the eyes, the position of the mouth. Was I smiling? Did I know the picture was happening? Was I in the middle of saying something? What was I thinking at the time? Where were my eyes? Was I posing or being natural? I could have done this; I should have done that. This is all valuable information, and it helped shape who I am as an artist today. I started to build bigger and more detailed costumes, giving Eileen even more to capture. Was I doing it for Eileen or for myself? This helped me learn that you can't change the past, but you can work to build a better future.

Eileen always knew when she had reached the last shot on a roll of film. I would pose until we finished the roll, and she always encouraged me into the light. She helped me see the beauty in my ugliness. She helped me see the beauty in myself. I'm very proud of what we made together. I love you, Eileen! XO

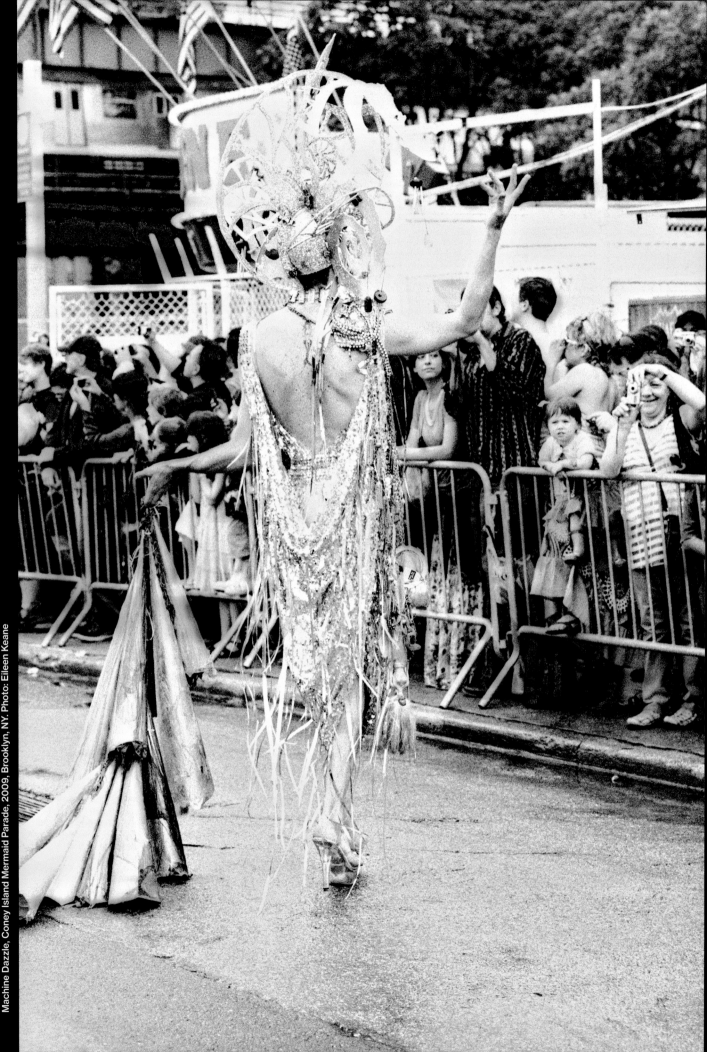

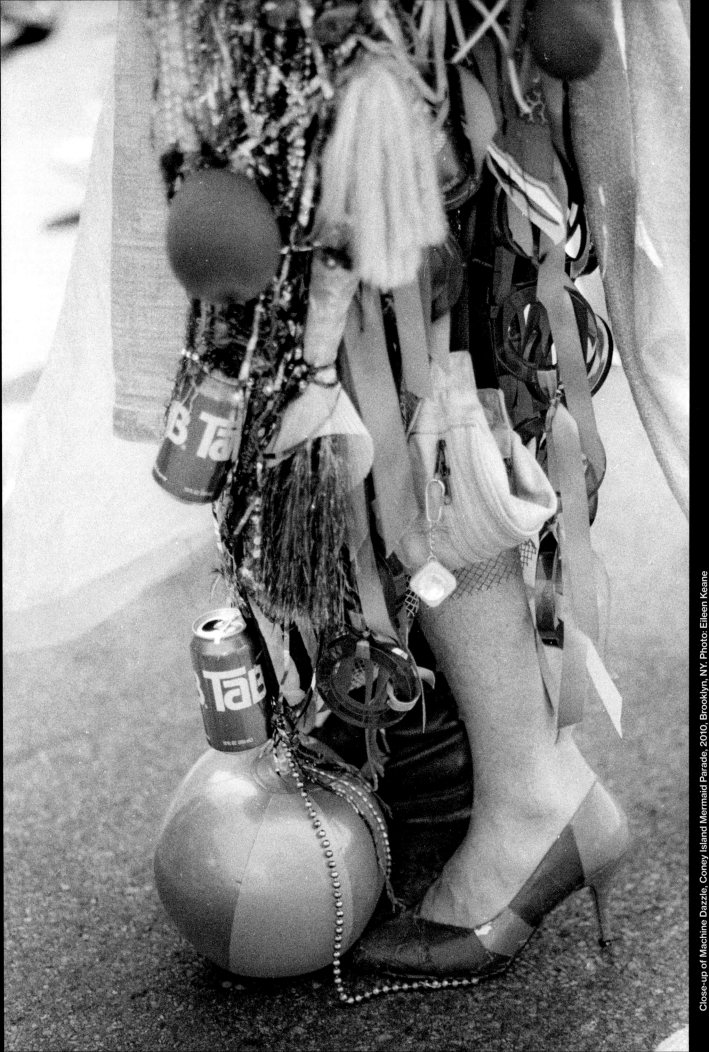

Machine Dazzle, Halloween, 2007, New York, NY. Photo: Eileen Keane

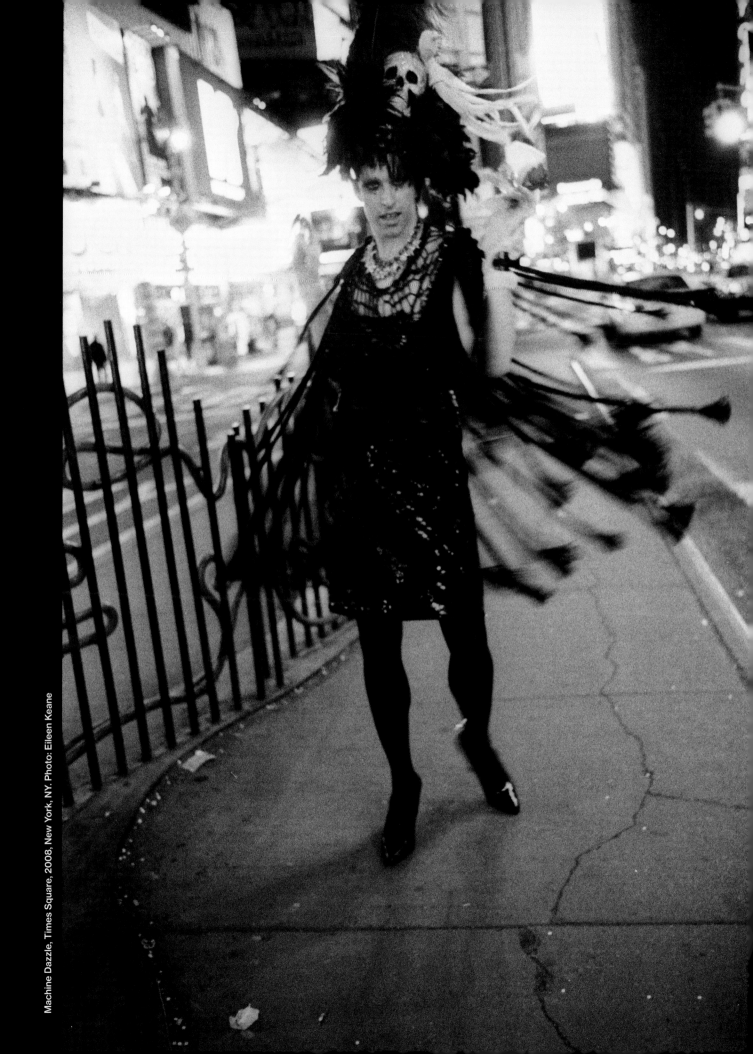

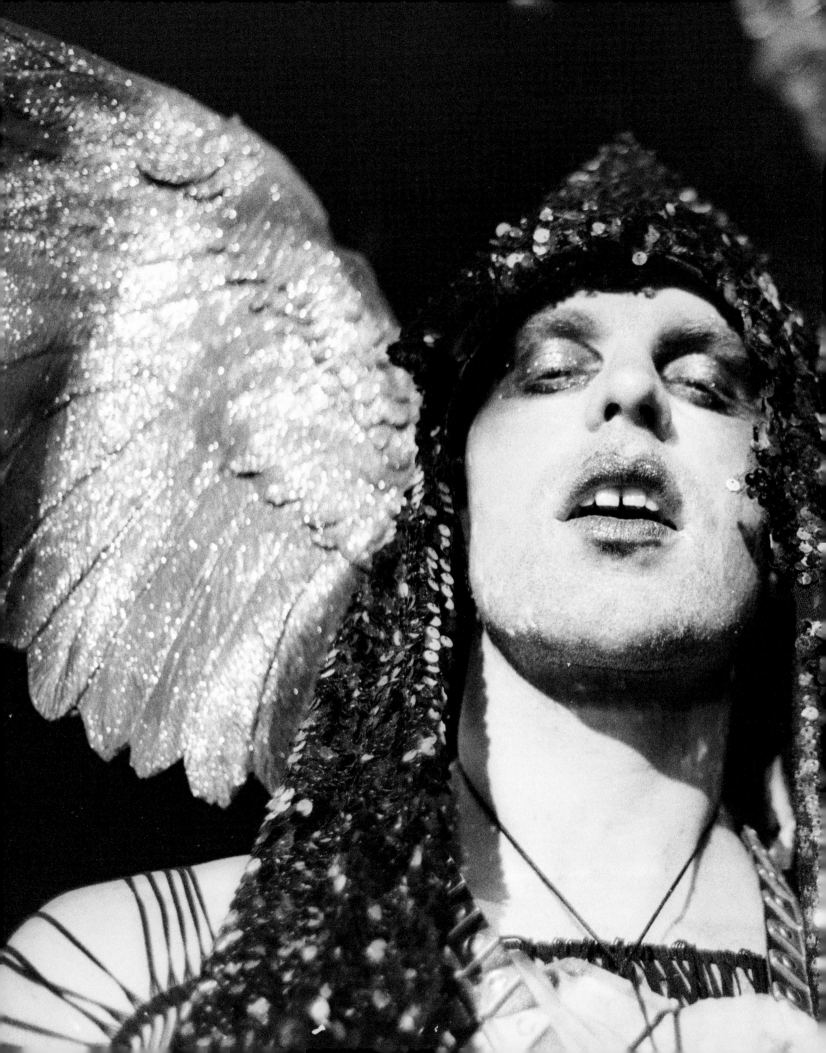

Machine Dazzle, Click + Drag 3.2: The Age of Aquarius, Santos Party House, 2010, New York, NY. Photo: Eileen Keane

Sally Gray

UTOPIAN FEELINGS
SPLENDOR, UNSETTLEMENT, AND FABULOUSNESS IN MACHINE DAZZLE'S *TREASURE*

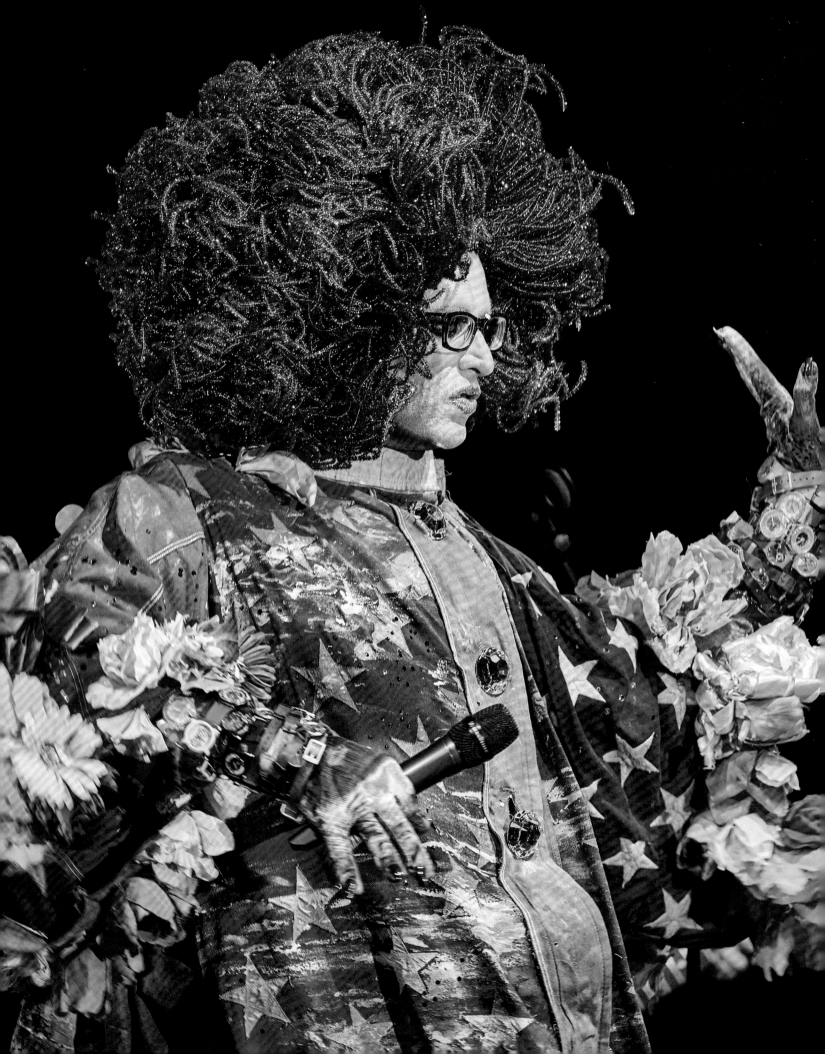

The utopian function is enacted by a certain surplus in the
work that promises a futurity, something that is not quite here.

José Esteban Muñoz, *Cruising Utopia: The Then and There of Queer Futurity*

"It was harder for gays before me," says Machine Dazzle in *Treasure* —
his extraordinary homage to his mother and to the cultural, sexual,
familial, aesthetic, and creative specificity of himself — at the Guggenheim
Museum in September 2019.[1] Both in the work itself, which is largely
about his own subject formation, and in his contemporaneous utterances
about his creative process, Machine places his life and his approach to
his work in a queer historical trajectory.[2]

In this essay I focus on Machine's unsettlement of cultural norms,
his insistence on enacting fabulousness while creating visual splendor
out of mostly found objects and materials. In doing this I refer to some
queer historical moments and speculate on utopian impulses in cultural
production and aspiration and also on notions of queer futurity as articu-
lated by the late queer performance scholar José Esteban Muñoz.[3]

In a prelude to his Guggenheim performance of *Treasure*, Machine,
invisible to the audience, was interviewed by dramaturg Melanie George,
who was wearing a Machine Dazzle original — essentially, a piece of
draped sparkly fabric. Seated on a chair on the darkened stage, she
asked into the airspace of the auditorium, "Machine, are you there?"
A deep and resonant, disembodied voice from backstage answered,
in playful camp inflection, "I'm *here*. . . . Present."

The audience had to be present, too, emotionally engaged in the
dark space with this voice from an invisible Machine. And we were not
to be entirely visually abandoned; the suspended pink neon heart, which
would stay with us through much of the show, appeared floating in the
dark, its scrawled blue text stating, "Hi Mom." So, she was here, too.

Treasure which Machine conceived, wrote, sang, performed, and
designed, is a patently emotional and ultimately loving queer tribute to a
troubled mother by a male performer. It's an imaginative work of radical
love and anger, an affective inquiry into mothering and queer subject
formation. It sensitively explores the impossible choices and emotional
challenges of a woman growing up in his mother's generation. Deborah
Jean Mills was born in 1947 in provincial Maine, where she grew up.
The madness of gender, sexual, and racial hierarchies and the craziness
of present-day broken American politics are repeatedly brought forth
into the intellectual and material space of *Treasure*: "First they verbally
degrade, then spit, poke, then beat; sometimes seven of them," he recalls

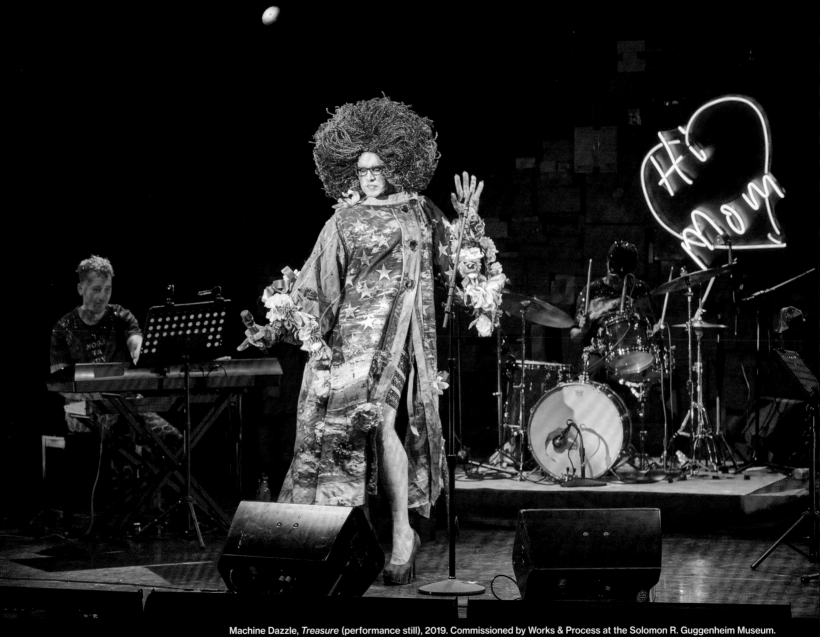

Machine Dazzle, *Treasure* (performance still), 2019. Commissioned by Works & Process at the Solomon R. Guggenheim Museum.
Photo: Robert Altman

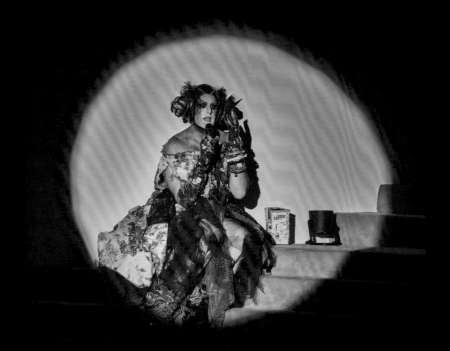

Machine Dazzle, *Treasure* (performance still), 2019. Commissioned by Works & Process at the Solomon R. Guggenheim Museum. Photo: Robert Altman

of his school years as a young boy.[4] In positing "what is" and "what was," Machine is also creating a cultural surplus, a conceptual space of "what if," "what else," "what's next," and "what's possible" – a reaching toward the "not yet here" affective unknowns of potential futurities.

In response to questioning from George about his creative process, Machine gives us a queer historical context in which to situate our experience of his costume design: "I like to mess with it. I like to put the queer into the history. I love the idea that queers have always existed, and radical thinkers have always existed. They're just not really in the history books. And so, I like to take all of my radical love, my anger, and everything that I've ever thought, been, and wanted to be, [along with my] dreams. [And] I put them all into a costume."[5] And certainly, the costuming for *Treasure* is visually extravagant, culturally expansive, as well as excessive in scale, color, surface, texture, and kinetics, presenting a self-invented aesthetic splendor.

The sober, frivolous, disciplined, meaningful, chaotic, silly, inspired, emotional performance of *Treasure* encompasses a depth of moral engagement. But there's more. The last part of *Treasure* is a kind of camp fashion parade. Crazy voguing, faux *défilé* gesturing, and excessively performed seriousness; repeated entries and exits with pieces of luggage. In terms of the attention to detail, these outfits are all both

storytelling.[6] All the same, the superficially frivolous runway show carries a reverence for enduring friendship; collaborative trust; co-creation of cultural worlds; ecstatic transcendence; respect for the subjective experience of those who are classed, racialized, and gendered less-than; and, on top of it all, the joy of excess. It provides a camp unsettlement of the emotional intensity of the whole. "The whole point of camp is to dethrone the serious," wrote Susan Sontag in her famous 1964 essay "Notes on Camp." "Camp is playful, anti-serious. More precisely, Camp involves a new, more complex relation to 'the serious.' One can be serious about the frivolous, frivolous about the serious," she wrote.[7]

This part of the show is both beside and beyond fashion, in the way that Machine's costume practice is both engaged with fashion and detached from it. While Elyssa Goodman of *them.* magazine remarked upon interviewing Machine that *Treasure* is "essentially a fashion show,"[8] fashion is cast as less than important in Machine's opening discussion with George at the Guggenheim. Despite early fascination with both

Machine Dazzle, *Treasure* (performance still), 2019. Commissioned by Works & Process at the Solomon R. Guggenheim Museum.
Photo: Robert Altman

117

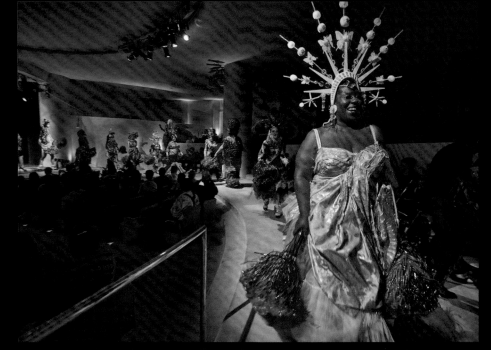

Machine Dazzle, *Treasure* (performance still), 2019. Commissioned by Works & Process at the Solomon R. Guggenheim Museum. Photo: Robert Altman

fashion and the highly produced events of couture runway shows, he states, "I'm not a fashion designer," and "I don't like fashion with my name," adding, "I have [my] reasons beyond costume design."[9]

Fashion and dress are both not overtly political and yet simultaneously, like all cultural production, implicitly political. Machine's ambivalence toward fashion and costume evokes this. His work with Taylor Mac and other queer performers has placed him primarily as a costume designer and his creative interventions also appear in specifically fashion contexts, like model and actor Cara Delevingne's fashionably sleek presentation on the red carpet of the 2019 Met Gala. The 2019 Met Gala coincided with the Metropolitan Museum's exhibition *Camp: Notes on Fashion,* curated by the Costume Institute's Andrew Bolton, and thus was indisputably a fashion moment. Delevingne wore rainbow-colored rompers by Dior haute couture, Swarovski shoes, and a Machine Dazzle headpiece. The headpiece – made of plastic dentures, eyeballs, plastic fried eggs and bananas, truncated prosthetic fingers emerging from lilies, and safety pins – met the commonly understood criteria of camp excess, resonating with other celebrity interpretations of camp that evening. Presented in a fashion setting, in a fashionable ensemble, it is both in and beyond fashion. The setting is *par excellence* part of fashion's cultural, financial, and ideological framing and the headdress an example

of fashion's longstanding employment of camp and queer sensibility as an engine of perpetual novelty. And it is also a confident piece of nonsense.

This complex set of cultural interfaces, this multivalent set of propositions about aesthetics and queer relationality, has cultural and historical antecedents, bringing us to the thoughts of Muñoz on queer futurity, expressed in the epigraph to this essay: "The utopian function is enacted by a certain surplus in the work that promises a futurity, some-thing that is not quite here."[10] And Machine Dazzle's relationship to fabulous excess – his "certain surplus" – has historical antecedents in the making of treasure out of junk and the seizing of the creative freedom to make a mess. "First I make a mess and then I clean it up," he states.[11]

Tracing "utopian feelings" in queer aesthetic cultural production, Muñoz posited the not-yet-arrived-ness of queer. In his famous phrasing, "Queerness is not yet here"; rather, it is a "structuring and educated mode of desiring that allows us to see and feel beyond the quagmire of the present."[15] An emphasis on feeling as a way of imagining and enacting a more expansive, inclusive present/future resonates for me in viewing Machine Dazzle's *Treasure* with its interest in loving collaborations, enduring friendships, and an acknowledgement of debts to others, including his mother. This is different from the me-first, greed-is-good, my culture/my gene pool/my nation/my desire-is-more-worthy-than-yours of currently reigning paradigms. So, in lockdown retrospective framing, and in homage to mobile queer affect and temporality, I'm thinking of disparate but connected historical moments:

I.

The invention of a here/now that leans toward unknowable but desired present/future existences is part of what might be thought of as the potential futurity of queer cultures. "Fabulous people imagine an alternative universe right now" is how madison moore, the artist-scholar, DJ, and author of *Fabulous: The Rise of the Beautiful Eccentric,* puts it.[16]

Embodying this sensibility in attitude and in sartorial performance, the 1970s Sydney-based queer performance group Sylvia and the Synthetics — one of the global antecedents to Machine Dazzle's fabulousness — carried business cards stating simply, "I'm Fabulous."[17] Turning exclusion into an ambit claim for a superior capacity to express and remake the world, they asserted the importance of queered pleasures; release from social constraint; visual excess; life as art; unsettlement of taste norms; mixing up of friendship and art; and use of drugs to alter consciousness, all while elevating this mix into a form of political and aesthetic conviction. The Synthetics were part of shocking, future-leaning, truth-telling contributions made by new forms of camp and queer at a time when in the Synthetics' hometown, gay male sex was illegal, violence against queers was normalized, mediocre dads were unquestionable, and ordinary straight white men were gifted with unearned authority over most things.

II.

Camp is a mode of creating a "metaphysical country of fabulous unsettlement and amazing splendor," writes cultural historian Fabio Cleto, in his lead essay for the Met's exhibition catalogue for *Camp: Notes on Fashion.*[18]

Two years before his death in 1992 in Paris from AIDS-related conditions, Peter Tully, the Australian queer artist, designer, jeweler, activist, performer, and inaugural artistic director of the Sydney Gay and Lesbian Mardi Gras, presented his extraordinary, shining installation *Treasures of the Last Future,* a multi-space exhibition, at Barry Stern Galleries in Sydney.[19] The "treasures" of this "metaphysical country" of the "last future" were made from plastic jewels, fake pearls, holographic tape and foils, chrome studs and chains, fluorescent plastics, shop display items, tourist junk, household appliances, furniture, and found items of all kinds. With these materials, Tully created a collection of ritual, precious objects of aesthetic and affective significance for an imagined queer civilization of a "last future." Tully's faux-erudite wall text introducing the exhibition read thus:

> Back in the twentieth century a culture existed which mysteriously vanished in a few short years. Historians have established that the largest centre of population was situated by a large harbour, surrounded by deserts and consisting of primitive skyscrapers and inexplicable concrete riverbeds. Archaeologists have suggested the population was a melting pot of many of the diverse tribes, which inhabited the earth at that time. Recent excavations have brought to light a trove of artefacts and objects, which have thrown some light on what seems to have been a rich and complex society.[20]

The material culture of this vanished civilization included bejeweled irons, shoes, and lamps; reflective holographic mylar underpants and vests; and thrones made from car hubcaps and plastic animal bones, and joyfully outstripped, in its splendid excess, high-brow museum exhibits of "ancient civilizations." As Muñoz wrote, a queer aesthetic "frequently contains blueprints and schemata of a forward-dawning futurity."[21] And as Machine Dazzle says, queers and radical thinkers have always been there.

III.

Queer aesthetics as a political domain of potentiality are important to Machine Dazzle: "Part of the definition of queerness is not settling," he told Goodman in his interview. He continued, "Constantly asking questions, not accepting the status quo, pushing the boundaries. That's what I like to do when I make work."[22] He refers often to the importance of

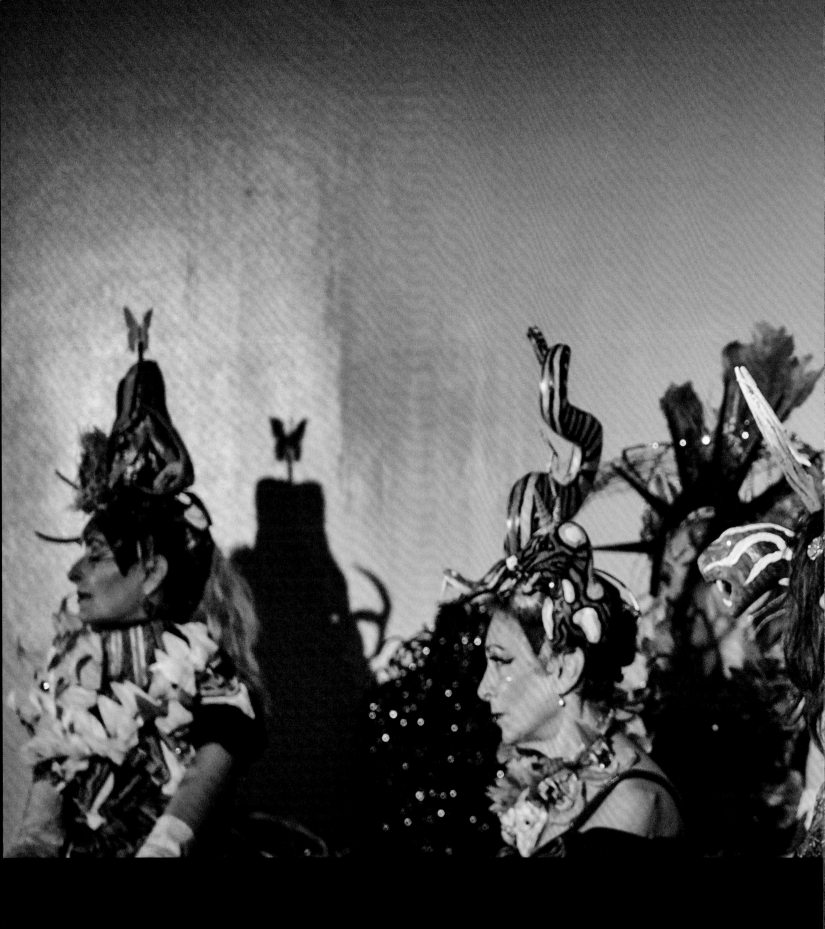

Machine Dazzle, *Treasure* (performance still), 2019. Commissioned by Works & Process at the Solomon R. Guggenheim Museum. Photo: Robert Altman

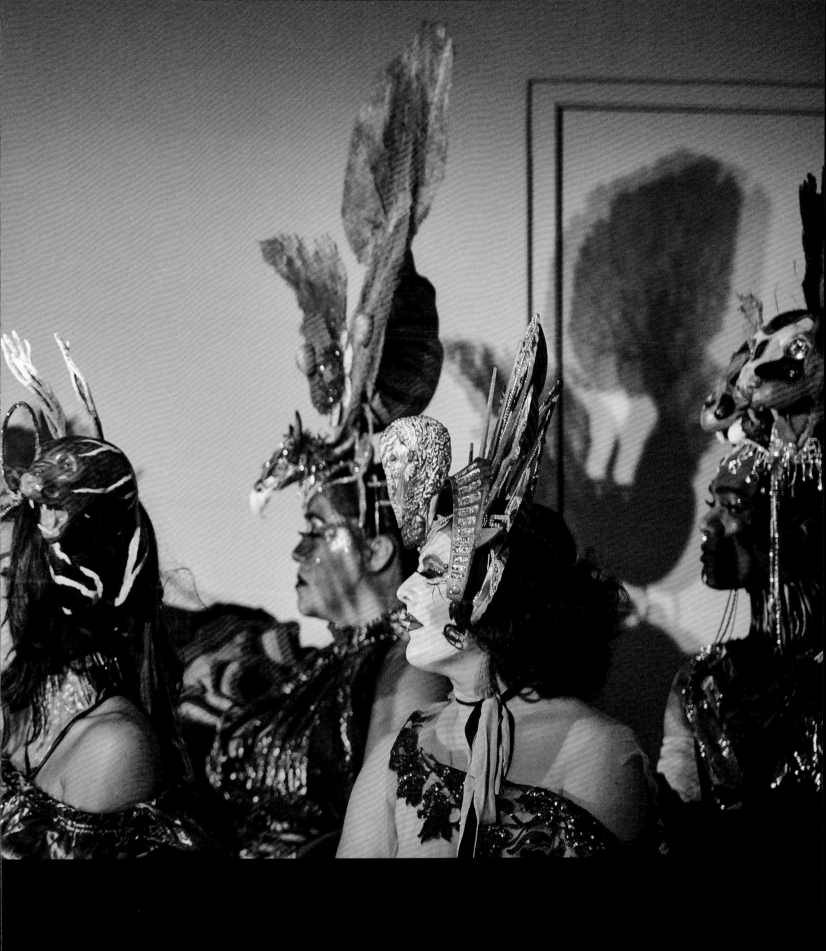

deas, concepts, storytelling, and domains of inventive potentiality in combination with cultural production – the choreography, the costuming, the makeup, the stage arrangements, the street appearances, the utterances, the signing, and the social media appearances. These instantiate Cleto's notion of splendor – splendor of scale, gesture, haptics, color, surface, glamour, texture, adornment, and stated intention – as well as his concept of unsettlement. For Machine Dazzle, the work necessitates "not settling" for that which is too well known, too culturally ascendant, too emotionally restricting. These are things that impede fabulousness, beauty, joy, love, excess, sexuality, justice, courage, personal dignity and gender possibility. Utopian? Yes. "The utopian function is enacted by a certain surplus in the work that promises a futurity, something that is not quite here," to quote Muñoz one final time.[23]

Part of, beneath, and beyond, the splendor of Machine Dazzle's *Treasure* is a capacity to embrace messiness, to incorporate it, to digest it, to speak from it, to laugh at it, to posit hope and potentiality from it, as evidenced in the emotional scope of the piece. The potentialities of, as Machine Dazzle puts it, "diving into the impossible."[24]

1 *Treasure*, conceived, designed, and performed by Machine Dazzle, commissioned and presented by Works & Process at the Solomon R. Guggenheim Museum, September 5–7, 2019.
2 I take the late pioneering queer theorist Eve Kosofsky Sedgwick's poetic, scholarly exposition of queer as my compass here. In her conception, queer is not linked to fixed sexual identities or an innate sexual nature. For Sedgwick, queer is a mobile open-ended concept, ripe with potentiality, a "continuing moment, movement, motive – recurrent, eddying, *troublant*." Tracing an etymology of queer, she wrote, "The word 'queer' itself means *across* – it comes from the Indo-European root *twerkw*, which also yields the German *quer* (transverse), Latin *torquere* (to twist), English *athwart*." Eve Kosofsky Sedgwick, *Tendencies* (Durham, NC: Duke University Press, 1993), xii.
3 José Esteban Muñoz, *Cruising Utopia: The Then and There of Queer Futurity* (New York: New York University Press, 2009), 7.
4 Machine Dazzle, *Treasure*.
5 Machine Dazzle, interview by Melanie George in prelude to *Treasure*.
6 Machine Dazzle, *Treasure*.
7 Susan Sontag, "Notes on Camp," in *Against Interpretation* (New York: Delta, 1964), 288.
8 Elyssa Goodman, "Meet the Artist Radically Queering the Field of Costume Design," *them.*, September 5, 2019, https://www.them.us/story/machine-dazzle-treasure-costume-design.
9 Machine Dazzle, interview by Melanie George in prelude to *Treasure*.
10 Muñoz, *Cruising Utopia*, 7.
11 Machine Dazzle, interview by Melanie George in prelude to *Treasure*.
12 Catherine Bennet, "Lessons from the Lockdown," *Inside Story*, October 19, 2020, https://insidestory.org.au/lessons-from-the-lockdown/.
13 Muñoz, *Cruising Utopia*, 1.
14 Machine Dazzle, interview by Melanie George in prelude to *Treasure*.
15 Muñoz, *Cruising Utopia*, 1.
16 madison moore, quoted in Michael Scaturro, "He Literally Wrote the Book on Fabulousness," *The New York Times*, June 8, 2018, https://www.nytimes.com/2018/06/08/books/madison-moore-fabulousness.html. See also madison moore, *Fabulous: The Rise of the Beautiful Eccentric* (New Haven: Yale University Press, 2018).
17 Jackie Hyde, Sylvia and the Synthetics performer, interview with the author, Paris, France, June 28, 2010. Sylvia and the Synthetics was a sexually anarchic, gender-diverse performance group in Sydney in the early 1970s. Performers included Doris Fish (aka Phillip Mills), Jasper Havoc (aka Peter McMahon), Morris Spinetti, and Miss Abood (aka Daniel Abood/Daniel Archer). See Doris Fish, "Doris Fish Remembers: Whatever Happened to Sylvia and the Synthetics?" *The Star Observer*, 1977,

n.d., in the Daniel Abood Papers, State Library of New South Wales ML321/96; Peter Blazey, "Sylvia Stuns the Canberra Mullets," *Outrage*, no. 137 (October 1994): 46–47; Sally Gray, *Friends, Fashion and Fabulousness: The Making of an Australian Style* (Melbourne: Australian Scholarly Publishing, 2017), 156.

18 Fabio Cleto, "Introduction," in *Camp: Notes on Fashion*, ed. Andrew Bolton (New York and New Haven: The Metropolitan Museum of Art and Yale University Press, 2019), 9.

19 As the inaugural artistic director (1982–86) of the Sydney Gay and Lesbian Mardi Gras, Peter Tully made an important contribution to Australian queer cultural expression and Sydney's urban nightlife. See Sally Gray, "Tully, Peter Craig (1947–1992)," in *Australian Dictionary of Biography*, National Centre of Biography, Australian National University, 2016, http://adb.anu.edu.au/biography/tully-pe-ter-craig-16280/text28222. See also Gray, *Friends, Fashion and Fabulousness*, 179–85.

20 Peter Tully, *Treasures of the Last Future*, Barry Stern Galleries, Mary Place Paddington, Sydney, December 1990.

21 Muñoz, *Cruising Utopia*, 1.

22 Goodman, "Meet the Artist."

23 Muñoz, *Cruising Utopia*, 7.

24 Machine Dazzle, opening song to *Treasure*.

David Román

UNFILTERED AND ALONE

MACHINE DAZZLE'S PANDEMIC SELF-PORTRAITS

In the spring of 2020, shortly after the Covid-19 pandemic unsettled everyone's day-to-day life, Machine Dazzle relocated temporarily from New York City, the epicenter of the early pandemic in the United States, to Maui. During his quarantine on the island, Machine posted a series of photographs of himself on Instagram. These images presented Machine dressed in costumes constructed from the island's bountiful natural resources. Mainly he created headpieces and masks composed of native flowers, palm fronds, plant stalks, and whatever else he found on the grounds of the rental property where he was staying. Without access to his usual resources, which more often than not were composed of the debris of the urban world, Machine's posts were contemporary pastoral compositions highlighting the beauty of nature. I was drawn to these images for several reasons. In the age of social distancing and facial covering, Machine's posts resonated deeply. Having followed Machine's brilliant and wondrous career, and mainly understanding his artistic practice in the context of collaboration, I was also taken by the centrality and exclusivity of Machine's self-presentation. There was no one else in the photographs to distract attention from the artist. It was Machine in nature and nature in Machine.

Until this moment, I had always experienced Machine's costumes and designs in an urban setting, most often in the theater. His collaborations with Taylor Mac are legendary, and rightfully so. Machine's highly innovative and wildly imaginative costumes for Mac were, as Machine called them in a 2021 phone conversation, "embodied sculptures." For *A 24-Decade History of Popular Music*, Machine crafted twenty-four costumes, one for each hour of the performance dedicated to a specific decade of American cultural and musical history, from the American Revolution to the present. These "embodied sculptures," or "wearable sets,"[1] as the scholar Sissi Liu describes them, offered an elaborate and flamboyant commentary on the historical decade performed. Machine not only created the costumes, but he came out on stage at the start of each hour in his own over-the-top creation and dressed and undressed Mac in front of the audience. These interstitial moments in the performance, the segue from one decade to the next, were essentially spotlights on Machine's contribution to the event.

Despite Machine's spectacular presence on stage, the focus remained on Mac. I was always struck by how Machine would enter the stage in costumes of such mind-blowing originality, only to be absorbed, a few moments later, into the pageantry of the broader performance. In other words, it was never about Machine even when it ostensibly was

about him. This type of humility and generosity toward his collaborators lie at the heart of Machine's practice. His artistry is about the creative project and not the ego. So that audiences could get a longer look at Machine's wondrous work, at every performance his costumes were displayed in the lobby on a set of white mannequins. These were dressed one by one as each decade unfolded, meaning that once Mac changed out of a previous costume and into the next one, the previous costume would be draped on one of the mannequins. But even here, it was hopeless to try to take in the entirety of Machine's artistry, given the visual and material overload of any one costume. As with the minutely detailed paintings of Hieronymus Bosch, such as *The Garden of Earthly Delights* (ca. 1500), it's nearly impossible to absorb all the discrete components of Machine's work with the human eye. There's simply too much to process. Consider this backstage self-portrait taken while touring the *24-Decade* project in Belfast in 2016 (p. 130). I have designated the image *Belfast Self-Portrait* not so much to elevate the work through the discourse of art history, although Machine's photographs are more than worthy of critical attention, but to conceptualize and understand these images as revelatory works of self-fashioning.

Machine's elaborate headdress in *Belfast Self-Portrait* – a skullcap embellished with tasseled fringe, balloon strings, sequin trim, a rhinestone chain, and remnants of a vintage dress, to name only the most identifiable elements – adorns an equally elaborate painted face. The color scheme of the facial makeup includes pastels layered upon each other, leaving very little of Machine's face unembellished. The array of materials in the design are attached to the sequined skullcap with safety pins, and, as Machine explained to me when I asked, the desired effect was "glamorous queer nomadic realness."[2] The discrete materials of Machine's makeup and costume are not fully legible to the viewer, since we only get a glimpse of Machine before he runs onto the stage. There's no time for him to stop and strike a pose for the camera; he only has a moment to take a quick selfie to capture the costume before rejoining the performance. And yet the photograph displays more than just a rushed moment in time. *Belfast Self-Portrait* captures the essence of Machine's creativity and self-expression, the artistry and the artist all at once. Machine has a sophisticated sense of color, design, texture, and construction, and though the costumes might sometimes look haphazard, they are anything but. Each costume is intentional and holds a reservoir of allusions and references, mostly obscured by the bewildering beauty of their execution. The grunge tonality typical of so many of his

designs is also purposeful and in conversation with a downtown aesthetic that is urban, nocturnal, and clubbish.

Machine's aesthetic style cannot be reduced to any one impulse, but it's fair to say that his artistry is neither subtle nor minimalist. As in *Belfast Self-Portrait*, Machine typically builds from the detritus of the urban landscape, the materials discarded or abandoned after the party, the parade, or whatever other festivities have ended. Machine recycles and repurposes these found objects and materials, the ephemera left behind by the individual and the crowd, to create his designs. As Elissa Auther outlines in the introduction to this catalogue, he gestures widely to other traditions. He is slightly campy, slightly grotesque, slightly edgy, always astonishingly original. He is deliberately over-the-top, so much so that his work often evades immediate comprehension. The result of such beautiful excess is that Machine breaks the visual frame. Whether in his costumes or performances, or even in his self-portraits, Machine is at once visible and invisible, at once attention-grabbing and absorbed into whatever environment he finds himself in or helps to create. This is

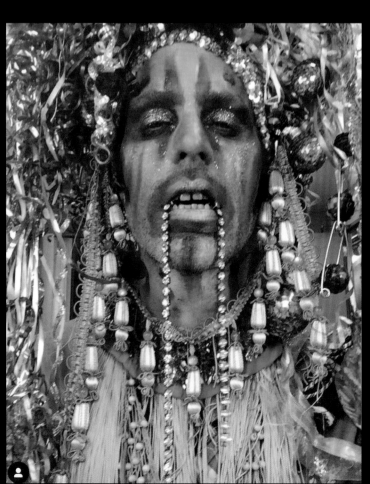

Belfast Self-Portrait, 2016. The MAC, Belfast, Northern Ireland. Courtesy the artist

especially true of the Maui self-portraits, and the later Sonoma portraits that he shot while in residency there in 2021.

In the Maui series of self-portraits, Machine appears on the lush property of his temporary quarantine home. He photographs himself outside in the so-called natural world, surrounded by palm trees and swimming pools (neither indigenous to the island) and dressed to suggest an affinity with this environment. He shot the photos on his iPhone without a tripod using the phone camera's self-timer. And tellingly, he chose not to use any filters. In this series, everything is stripped down to the basics. Given the pandemic, the beaches were closed, and local stores had little to no supplies for him to work with on his designs. Shopping online for materials was also not an option, as deliveries were very limited. Machine saw possibilities, however, in the natural detritus of the island, which was abundant and offered him a novel departure from his previous materials. The results are beautifully innovative costumes that share the theme of transformation.

Consider, for example, the vibrant design of the palm tree headdress that he wears with a pair of white pants imprinted with a large pattern of red and blue flowers (p. 127). I am calling this image *Self-Portrait with Palm Trees*, fully aware that Machine did not present this or any other of the Maui images as photographs to be catalogued or indexed by a museum. In fact, the opposite is true. The images, which I am calling self-portraits because I understand them as such, existed outside institutional documentation and the art market at large. Machine doesn't title his Instagram photos or offer the wall text that generally accompanies museum or catalogue display. I want to be transparent about exporting these images from their original Instagram context and using the institutional discourse of the museum and the academy to describe them. My titles are admittedly arbitrary and used primarily to differentiate the images from each other for the sake of clarity for this essay.

In *Self-Portrait with Palm Trees*, Machine's face is obscured by a mask — or is it? Machine's bold and colorful floral mask plays off the artificial floral print of the pants, but it also echoes the three palm trees in the background. Machine presents himself as one of the palms, albeit one that's a hybrid between the natural and the human, between what is perceived as normative and what stands in violation of it. In this sense, Machine forces us to question the basis for these distinctions. And yet, at the same time, he asks us to consider the evolutionary possibility of trees and humans themselves. Whatever the future might hold, this

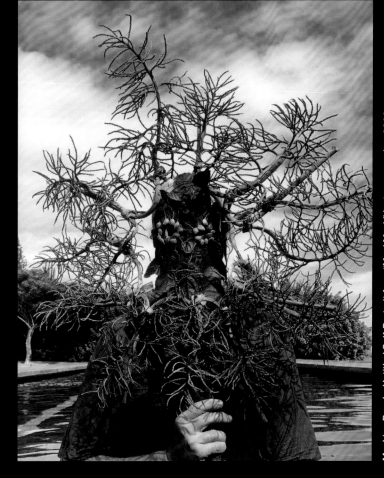

Machine Dazzle, Untitled Self-Portrait from "Maui Mask" Instagram series, 2020.
Courtesy the artist

self-portrait forces us to see both the natural and the human anew.
Machine's self-fashioning as palm tree, while fantastic and grotesque,
is also a form of camouflage. He attempts to blend in but in the process
stands out, a psychological conundrum familiar to many. In both the
natural and the human world, the relation between passing as normative
and being seen (or forced to be seen) as other is highly dangerous.
Passing is perilous because it is always contingent upon the perception
of others. Despite these risks, one gets the sense throughout the Maui
series of a joyful, even ecstatic, process of transformation, of becoming
something else. These self-portraits conceal as much as they reveal. We
cannot see Machine's face. But the camouflage, however you perceive its
success at passing, makes what is human seem not human. Within the
space of these photographs, Machine becomes an extravagant botanical
specimen as yet unknown to nature.

 This reciprocal transformation is evident throughout the Maui
series, where we see Machine photograph himself only to render himself
even more invisible, more outside the frame of recognition. This image

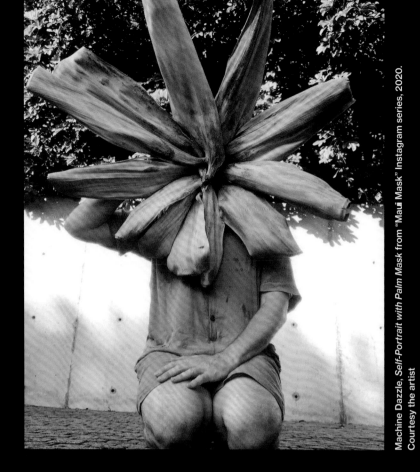

was posted on Instagram on September 30, 2020, and the text that accompanied it read, "Thank you Maui. It was fun, huh? Mother and Father nature, you give me strength. You are beautiful and frightening. You are life," accompanied by various hashtags, including #sheprovides and #masquerade. Machine refuses to present his work as a form of self-promotion, a standard use of social media. Instead, he honors Father and Mother Nature as collaborators, muses, and sublime lifeforces. The earlier images in the series likewise acknowledge the wonder of the natural world in all its fullness.

In a departure from the intense visual overload for which he is best known, Machine posted an untitled self-portrait just the week before. In this photograph, which I refer to as *Self-Portrait with Palm Mask* (p. 133), he kneels facing forward as if in prayer. The photograph is shockingly modest, and almost shockingly dull. The image stands out precisely for its subtle and muted palette. This self-portrait is nearly antithetical to the multicolor visual brilliance of the backstage selfie from Belfast. Here, Machine is dressed in a simple one-piece faded lavender jumpsuit.

The mask is composed of sun-dried palm tree husks assembled in a pinwheel design that also suggests a sunflower. Machine's head is in full-bloom, a gorgeous celebration of the lifeforce. Notice the subtlety of Machine's use of color — the light brown, nearly olive color of the husks matches Machine's skin tone, which blends undramatically with the pavement and the off-white wall in the place where he chooses to appear. The composition of the body is also telling. Not only is he kneeling, but his upper arm is holding the mask in place, perfectly in counterpoint to the other arm, which casually rests on his legs. Notice, too, how the button on Machine's lavender jumpsuit rhymes with the small holes on the concrete wall behind him, yet another way he is camouflaging and simultaneously remaking the environment. The overall effect is one of profound simplicity, a showcase for Machine's endlessly surprising artistry. This untitled self-portrait is perhaps my favorite of the Maui images for these reasons. It certainly was among the most stunning of his posts because of its quiet serenity.

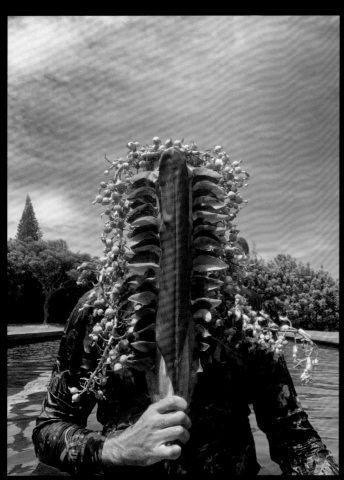

Machine Dazzle, *Self-Portrait with Mask and Crown*, from "Maui Mask" Instagram series, 2020.
Courtesy the artist

Nearly all of the Maui images conceal Machine's face. This is yet another twist on the practice of the selfie and the convention of self-portraiture. One exception, however, is worth noting. In a two-sequence juxtaposition (pp. 134 and 135), Machine initially presents an image of himself dressed in a wet colorfully patterned wine-colored Etro shirt immersed in a pool of water against a backdrop of lush greenery and cloudy blue skies. The mask was built from the husk of a palm frond and includes leaves from various plants, which were then stapled together to create the design. If you look closely, you can see that there is also a vined headpiece composed of green seedpods from a flowering bush in the garden of his rental home. The only visible part of Machine's body is the hand holding up the mask. This image, like the ones I have already described, is a variation on the theme of transformation and hybridity. Let's call the first image *Self-Portrait with Mask and Crown*, and let's call the second image *Self-Portrait: Unmasked*. In this second image in the sequence, Machine removes the mask to reveal what's behind it. But the image behind the mask still remains adorned.

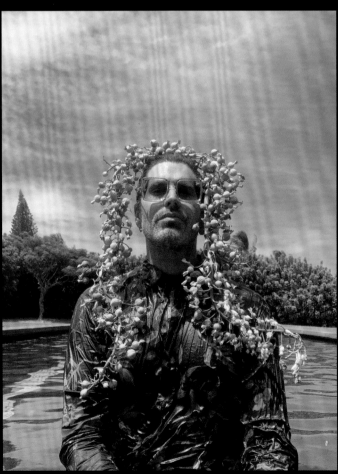

Machine Dazzle, *Self-Portrait: Unmasked*, from "Maui Mask" Instagram series, 2020. Courtesy the artist

we see a scruffy and bespectacled Machine looking directly into the camera. Machine wears the crown of green seedpods as if it were a natural part of his self. The glasses stand out more as "unnatural" here, even though, of course, selfies with the subjects wearing their glasses are routine.

What I love about this self-portrait is that it doesn't resolve the question of authentic selfhood, the essence of the actual person taking the selfie. The photograph participates in the delight and dilemma of the human in nature, and of nature in the human. The face revealed only intensifies this tension; Machine is at once a water creature and a botanical hybrid, something green and something blue. The general aura of the image is one of defiant resilience: Machine is outside in the middle of the day and lit by natural sunlight, and as in all of the Maui images he is alone and unfiltered. In the midst of the pandemic, Machine casts himself as a survivor. He is embedded in a world undergoing dramatic and unpredictable transformations; these images, boldly and with great poignancy, mark that moment.

After Maui, Machine was offered a residency at Haystack Farm in Sonoma during the spring of 2021. During this time, he continued to post photographs on Instagram in the spirit of the earlier Maui project, but working with the floral abundancy of the Napa Valley. Unlike the Maui works, which were initially an untitled series, Machine titled the Sonoma series "Scarecrow Off-Duty." I continue to understand these images, which follow the creative and artistic process of the Maui series (iPhone camera, no filters, natural elements) as self-portraits in that Machine photographs himself in costumes and masks to make a broader point about self-fashioning in the age of ongoing global crisis. The scarecrow motif is also one of camouflage and self-preservation, a means to avert the threat of danger through creative deception. A conventional sculptural scarecrow wards off predators by presenting itself as human, a straw man, so to speak. Machine reverses that logic by presenting the human as a hybrid ally to the surrounding environment, a type of garden figure superhero. Notice, for example, the luxurious beauty of the autumnal colored mask and costume he wears as he casually sits with arms crossed on a deck (p. 137). The setting is one of domestic affluence — cultivated gardens featuring rosebushes and plenty of space to maintain social distance. Machine sits completely absorbed in the costume; the mask is built on a cardboard foundation embellished with dried roses and alliums, and he wears materials cut and reworked from thrift store finds, including scarves and sweaters, that blend in with the upholstery of the

outdoor patio furniture. Behind the perfectly crafted layered circles of floral halos, we see Machine's eyes looking directly at us. The image calls to mind the portraits of Giuseppe Arcimboldo, the Italian sixteenth-century artist whose portraits featured minutely painted pieces of fruit, vegetables, flowers, and fish that aggregately formed the sitters' heads. Playful and grotesque, Arcimboldo's portraits convey in their proto-Surrealist dreamscapes something central to Machine's own intense imagination: visual intricacy making way for overall grandeur. I find this self-portrait strikingly beautiful both in the inventive wonder of the gorgeous floral mask and in the unexpected sense of belonging to nature Machine engenders.

In another image in the Sonoma series (p. 138), Machine moves indoors and poses alongside a set of vases overflowing with cut flowers. He is dressed in a kaftan made of sheer floral curtains found in a thrift store with a mask of dried purple cabbage leaves set against a cardboard foundation. As in *Self-Portrait with Palm Trees*, Machine embeds himself in an environment (this one interior and domestic) and puts himself in

Machine Dazzle, *Untitled*, from "Scarecrow Off-Duty" Instagram series, 2020.
Courtesy the artist

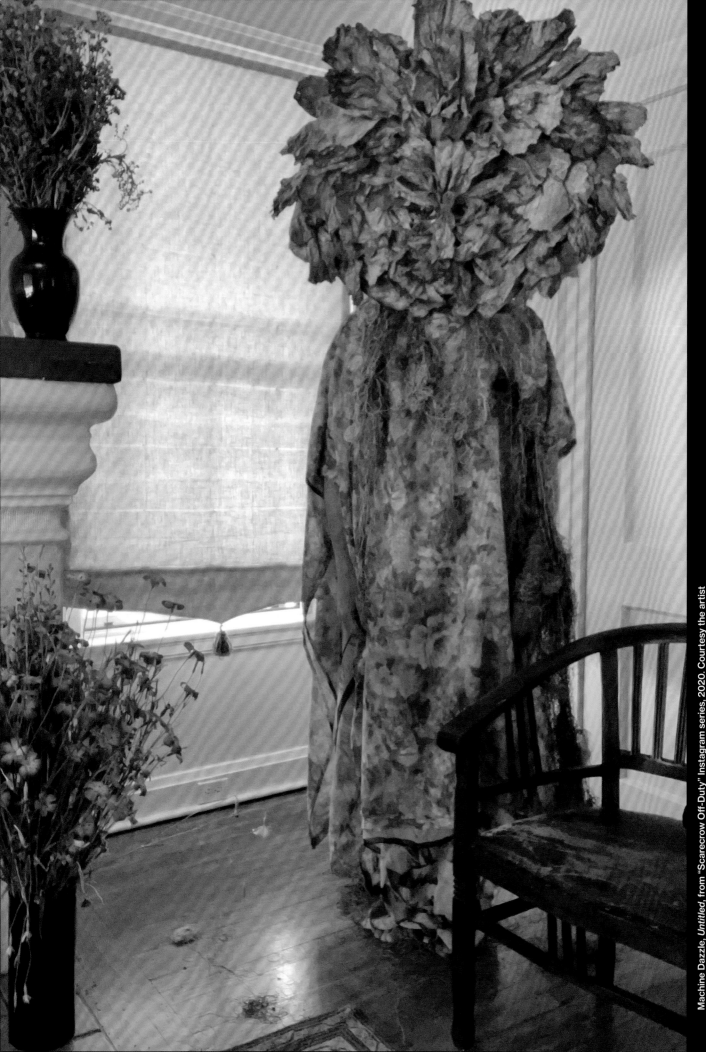

conversation with what is already there. He is as natural to the environment as the flowers, which have been similarly abstracted from their organic place of origin to beautify a space that, despite its wealth and privilege, feels a bit forlorn. Machine steps into the space and claims alliance with what is already there, joining the flowers to provide a sense of visual splendor.

As in all of his pandemic self-portraits, Machine seems to say, "This is where I am right now. There are resources available to me. I can create things. There is endless beauty in the world." No doubt, this is

Taylor Mac

ON MATTHEW FLOWER

(AKA MACHINE DAZZLE)
AN ADAPTATION OF
MELVILLE'S "THE LEE SHORE"

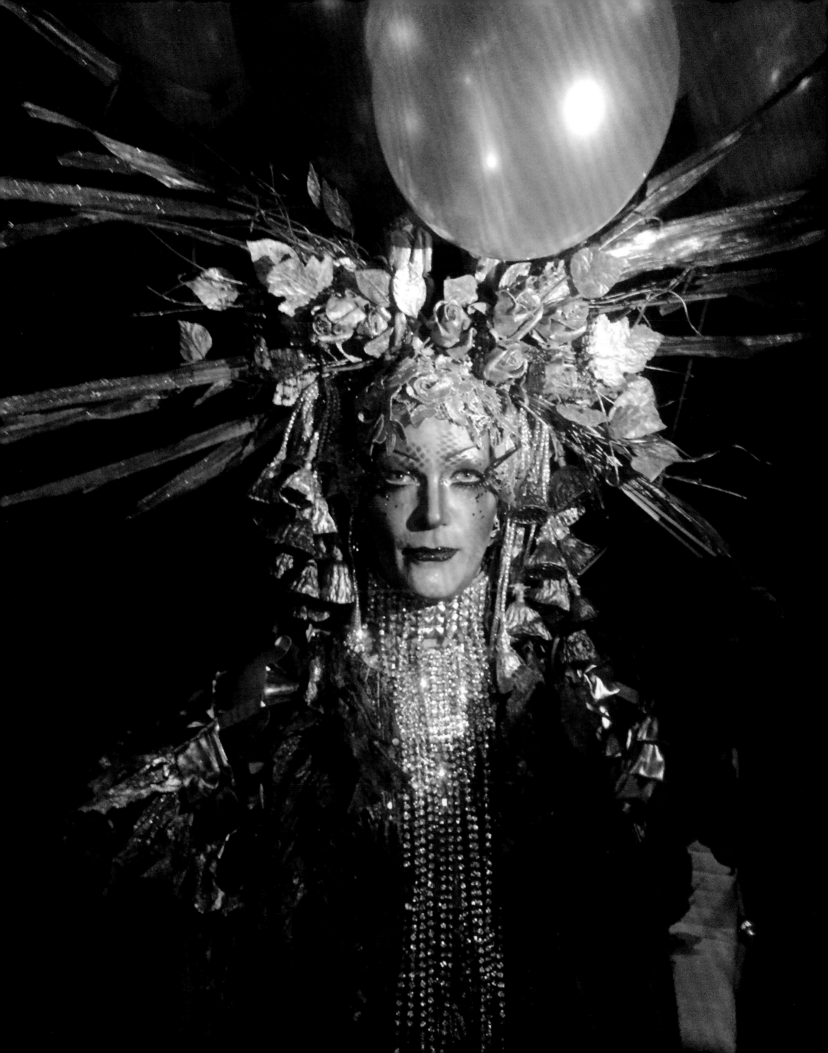

In childhood crawlspaces of suburban sprawl, a *glimmer* was conjured, a galactagogue, full-summer explosion, to nurture an escape route.

When, from those make-do-too-small hidings, a young giant's secluded queerness gives itself away via a fey foot or elegant finger poking out the hovel, it becomes a flare, reddening under the roasting sunlight of shame. Lucky for our beanstalk queer, who we'll name Matthew Flower, he is discovered, this time, not by those who would do him normal (with false stability and routine neglect) but rather, finally, by his own creation. His conjured *glimmer*. Or dazzle?

Have you, reader, in some moment of profound discovery, inhaled a eureka t'would blush Archimedes? If not, look to the tall shy boys. See how, in lives spent with eyes cast nether, they humbly observe the world. See how, once astonished into breath, this observation turns cosmic sucking. And so Flower sucks in his dazzle and with it, all existence.

His heart breaks instantly. And inside of the split core of him, he discovers more hearts. They break and more hearts are discovered inside of those, and on, and on. But how? It takes a broken heart to break a heart. That part is clear. But how *again and again*? How, when to break a heart Flower needs must pour his broken heart entire o'er the endeavor? How can there be anything left? Is the queen bottomless? (Cue demonic euphemism laugh.) Is he a machine? Yes. Now, not only Flower. Not after the great cosmic sucking. Now a dazzle machine. Machine Dazzle, to be precise. Some call him an artist. In truth: a heart-breaker. His, yours, mine; it's a calling.

So sew, queen, sew!

Chaos, alone, made a lover out of making and so made the multi-verse. Likewise Machine leaps and oozes into color and shimmer and the gooey yolk of being born to find love in the action of breaking hearts. Or, as a wise show-lesbian once said, "The only way home is through the show."

Know ye now Machine? Do you now see this heartbreaker caught in the perils of a singular vision, his only way to escape perilous solitude? And with this singular vision, has he broken enough of you that through cracks you glimpse this hope-inducing truth? That all innocent, impas-sioned creation is the drive of a heart to discover its ever expanding breadth, while the numbing doctrines of survival conspire to lock her in ash-ridden crawlspaces.

So, better is it to break the heart of a heart of a heart than be sequestered in contraction! For full of love, who would cravenly long for

less? Take broken-heart, take broken-heart, O Machine! Bear thee bravely up from the spray of thy creative juice. Alone? Nay. Make! For therein lies the apotheosis, love!

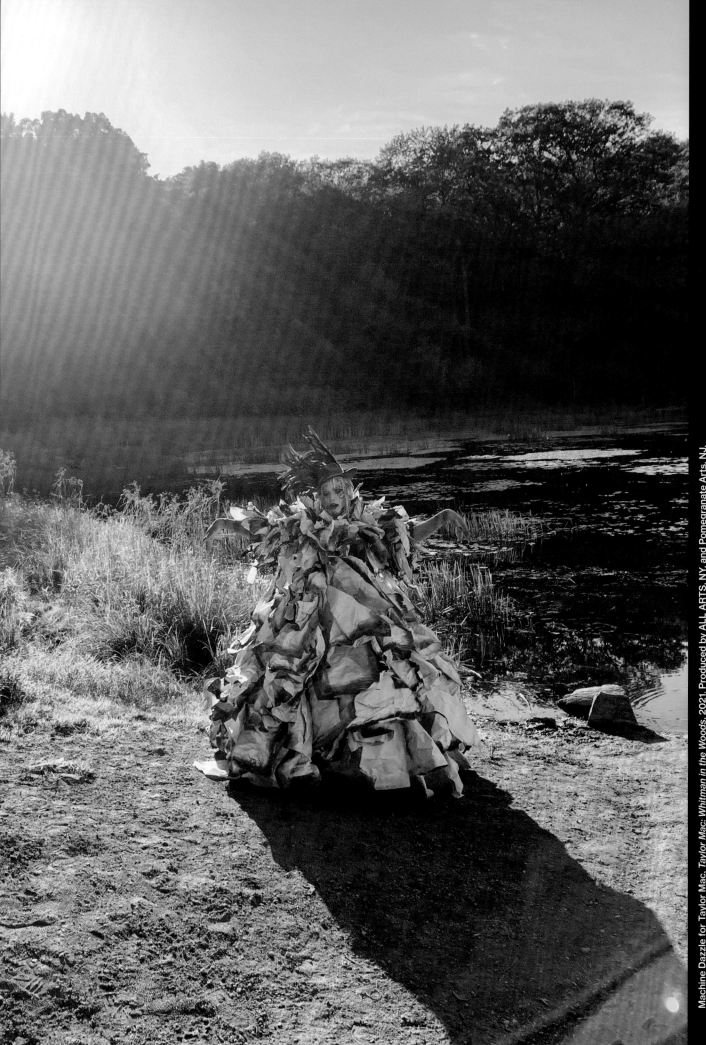

Machine Dazzle for Taylor Mac, *Taylor Mac: Whitman in the Woods*, 2021. Produced by ALL ARTS, NY, and Pomegranate Arts, NJ. Courtesy the artist

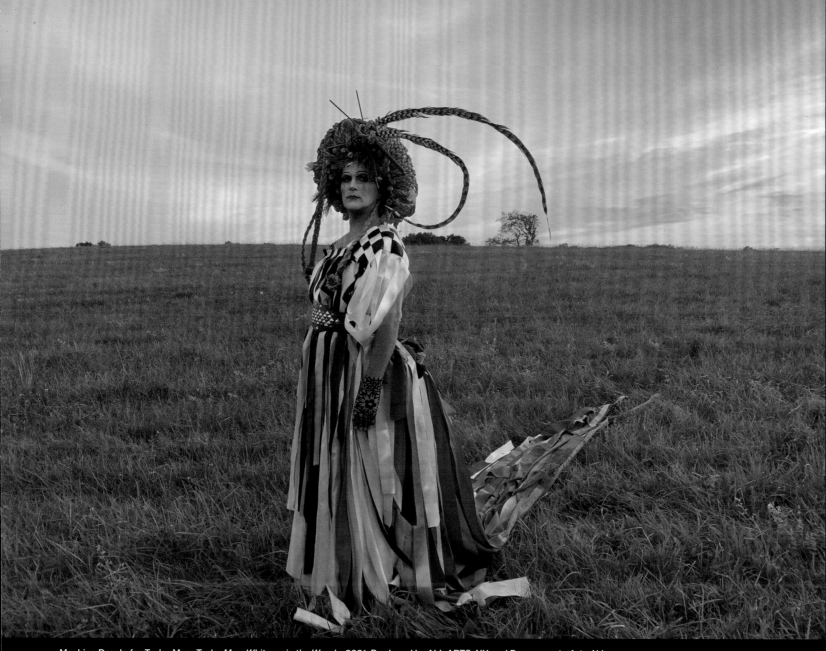

Machine Dazzle for Taylor Mac, *Taylor Mac: Whitman in the Woods*, 2021. Produced by ALL ARTS, NY, and Pomegranate Arts, NJ.
Courtesy the artist

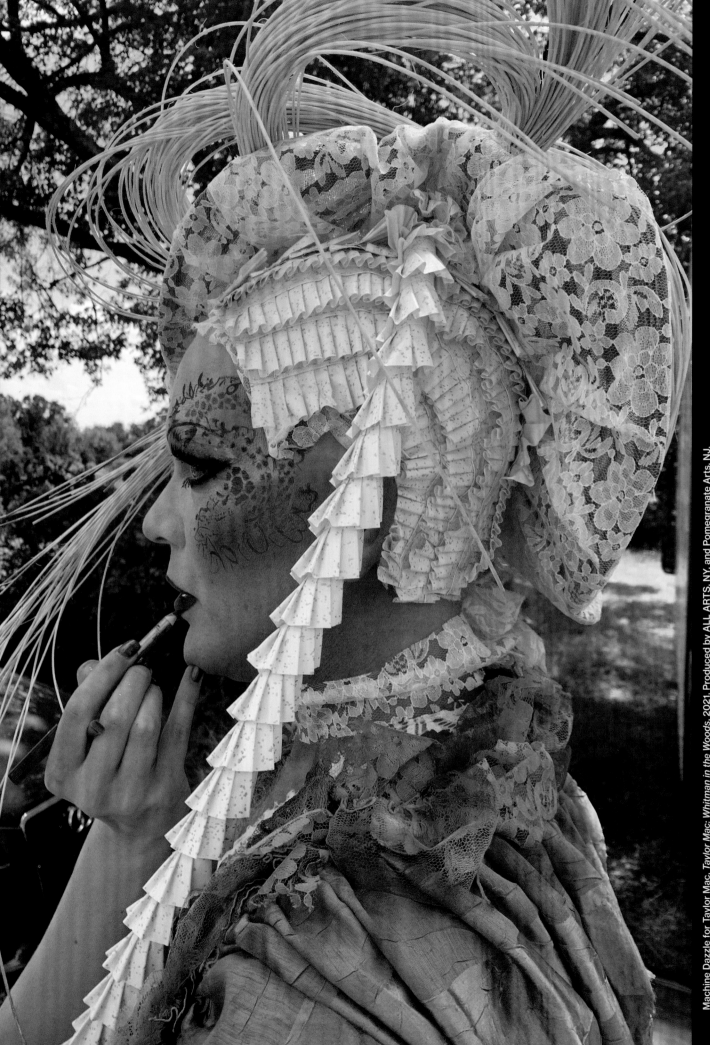

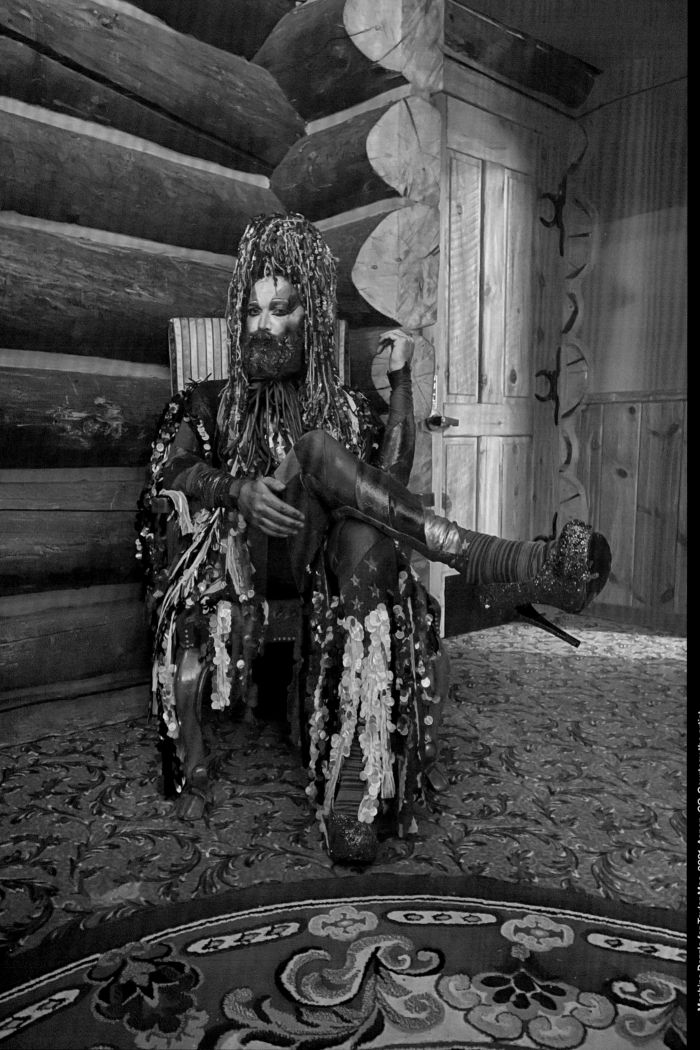

ACTIVISTS MAKE BETTER LOVERS

www.glamericans.com

PIX
GENDER
SATU

DANCE & MEDIA
AT HARVARD
PRESENTS

RTS

TRANS
ORMATIONAL
ABARET

ROPICANA
E DESIGN BY
E DAZZLE

ASSISTANT DIRECTED BY
ANNABETH LUCAS

MUSIC DIRECTION BY
CATHERINE STORNETTA

LIGHTING AND SOUND DESIGN BY
ANDY RUSS

7PM

M AND 10PM

AND 10PM

SE VISIT
ARD.EDU

RADICAL EARTH MAGIC FLOWER
BEC STUPAK
JAN. 12 - FEB. 25, 2006
& HONEYGUN LABS
OPENING THURS., JAN. 12, 6-9PM
DEITCH PROJECTS
76 GRAND ST., NYC!
WWW.DEITCH.COM

KIE HARLOTS

ABRONS A
HENRYSTRE

REB?CK LIVE!

URDAY, DEC. 5
8:30-CLOSE

Justin Bond's Lustre

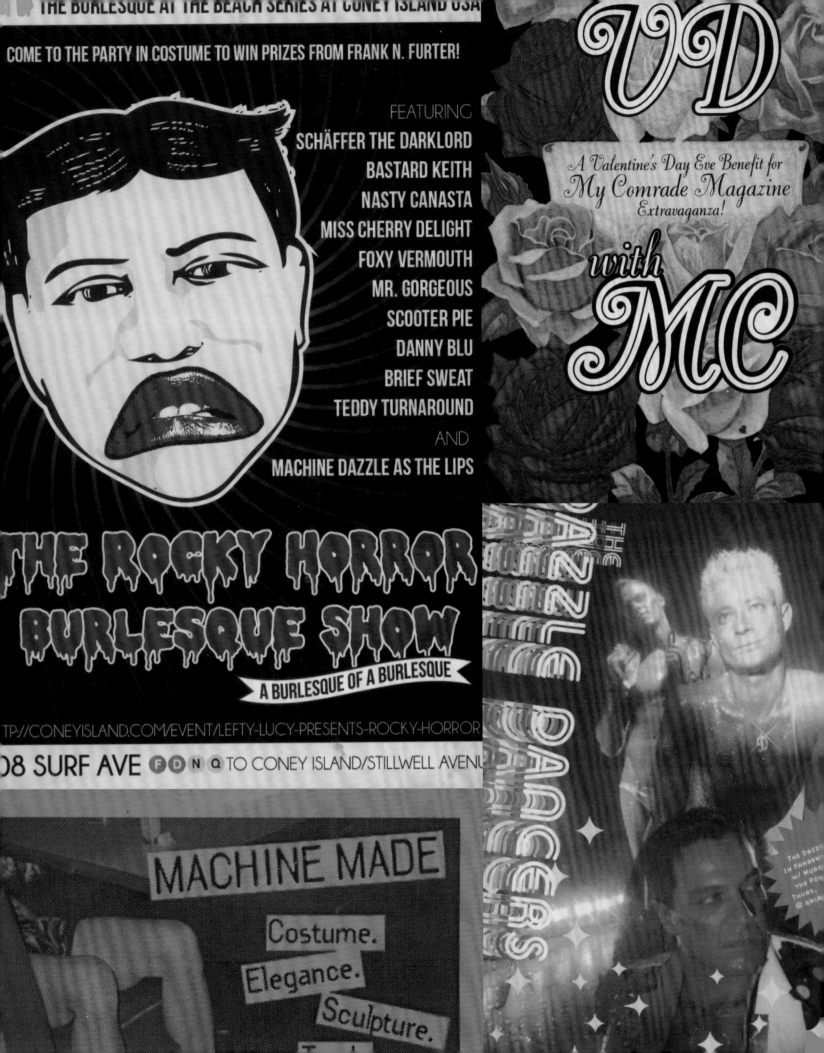

THE BURLESQUE AT THE BEACH SERIES AT CONEY ISLAND USA

COME TO THE PARTY IN COSTUME TO WIN PRIZES FROM FRANK N. FURTER!

FEATURING

SCHÄFFER THE DARKLORD
BASTARD KEITH
NASTY CANASTA
MISS CHERRY DELIGHT
FOXY VERMOUTH
MR. GORGEOUS
SCOOTER PIE
DANNY BLU
BRIEF SWEAT
TEDDY TURNAROUND
AND
MACHINE DAZZLE AS THE LIPS

VD

A Valentine's Day Eve Benefit for
My Comrade Magazine
Extravaganza!

with
MC

THE ROCKY HORROR
BURLESQUE SHOW
A BURLESQUE OF A BURLESQUE

TP://CONEYISLAND.COM/EVENT/LEFTY-LUCY-PRESENTS-ROCKY-HORROR

08 SURF AVE F D N Q TO CONEY ISLAND/STILLWELL AVENU

MACHINE MADE

Costume.

Elegance.

Sculpture.

TAREKE ORTIZ · EARL DAX
y
CABARET SILENCIO

☞ PRESENTAN ☜

WEIMAR · D.F. · NEW YORK
TRANS-BORDER INTERCULTURAL ORGASM
ON THE PRECIPICE OF REVOLUTION.

HOSTING

JOEY ARIAS
&
ASTRID HADAD

LINE UP

PHOEBE LEGERE
SVEN RATZKE
GEO WYETH
PIXIE HARLOTS
JUAN MANUEL TORREBLANCA

INVITADO ESPECIAL

HORACIO FRANCO

VIERNES 18 DE MAYO 2012
CASINO METROPOLITANO

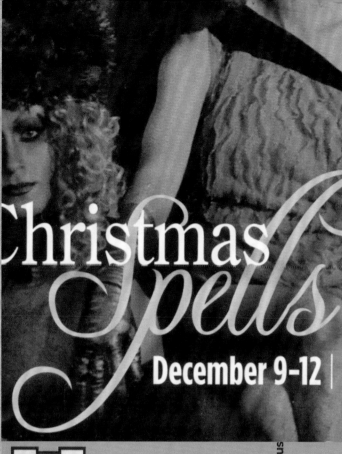

Christmas Spells
December 9-12 | 8

my comrade

Tonight We Dye!

An Easter Benefit Eggs-travaganza Celebrating
The New Issue Of My Comrade Magazine!

INCREDIBLE SHOWS AT 9PM & 11PM!

Celebrity Appearances Galore!
Dynasty Handbag * Dirty Martini * The Dazzle Dancers
Austin Scarlett * Marga Gomez * Da Lipstyxx
Barbara Patterson Lloyd * Brandon Olsen * Duch
Tommy Hottpants * Jennifer Snackwell * Shania Rendezvous
Sultana * And many more!

Hostess Linda Simpson * DJ Gant Johnson

Sunday, April 16th, 2006, 7pm until Midnight
Admission $10

Exhibition Checklist

All objects by Machine Dazzle unless otherwise noted.

Selected ephemera and photographs, 1994–present. Courtesy the artist

Selected costumes from New York City's Pride, Easter, and Coney Island Mermaid parades, 2000–present. Courtesy the artist

Selected costumes from Dazzle Dancers, 2001–07, reconstructed 2022. Courtesy the artist

Selected costumes for Mx Justin Vivian Bond, 2007–present. Courtesy Mx Justin Vivian Bond

Selected performance footage, 2008–present. Courtesy the artist and Pomegranate Arts, New Jersey

Selected commissioned costumes, ca. 2010–present. Courtesy the artist and various private collections

Selected costumes from *A 24-Decade History of Popular Music*, 2011–19, as worn by Taylor Mac, Machine Dazzle, and audience participants. Courtesy the artist and Pomegranate Arts, New Jersey

Costumes from *Treasure*, 2019. Commissioned by Works & Process, Guggenheim Foundation. Courtesy the artist

Costume from *Heliotropisms,* in Natasha Bowdoin's *Sideways to the Sun*, 2019. Moody Center for the Arts, Rice University, Houston, TX. Courtesy the artist

Natasha Bowdoin, selected work from *In the Night Garden*, 2020. Paint on board with cut paper and vinyl, dimensions variable. Courtesy the artist and Talley Dunn Gallery, Dallas

Selected costumes from *NEO NOWWW* (film), 2021. Courtesy the artist and opticnerve™, New York

Costume Design History

1996	*Storm Trooper: Seduced by the Dark Side,* Exit Art, New York, NY (solo or cabaret performance by Machine Dazzle, hereafter listed as solo performance)
1997	*Merrymaking the Peacemaker,* Exit Art, New York, NY (solo performance)
2000-present	Coney Island Mermaid Parade, Brooklyn, NY (solo performance)
2001–08	Dazzle Dancers, various venues, New York, NY (performance includes Machine Dazzle, hereafter listed as collaborative performance)
2001–present	Easter Parade, New York, NY (solo performance)
2001	*Machine Made,* Marion's Restaurant, New York, NY
2004	*I Am the Moon & You Are the Man on Me,* by Julie Atlas Muz, PS 122, New York, NY *House of No More,* Big Art Group, PS 122, New York, New York *The 9/11 Performance,* Stanley Love Performance Group, Central Park, New York, NY (collaborative performance)
2005–10	Pixie Harlots, various venues, New York, NY (collaborative performance)
2005–present	Night of 1000 Stevies, various venues, New York, NY (solo performance)
2007	*Lustre, a Midwinter Trans-Fest,* by Justin Vivian Bond, PS 122, New York, NY *Lustre: A Summer Solstice Trans-Perversion,* by Justin Vivian Bond, PS 122, New York, NY *Alien Nation-An Immigration Odyssey,* by Taylor Mac, HERE Arts Center, New York, NY *Alien Fashion Show,* Live Patriots Act 2 cabaret, HERE Arts Center, New York, NY
2008	*Justin Bond: Close to You at Christmas, Darling,* Abrons Art Center, New York, NY *The Boulevard of Berlin Dreams Cabaret,* Museum of Modern Art, New York, NY *Weimar New York: A Golden Gate Affair,* Museum of Modern Art, San Francisco, CA Dazzle Dancers, "I Like it Electric – The Love Boat." Directed by Bek Stupac [video], https://www.youtube.com/watch?v=ytT7XDzB3Ok (collaborative performance) *Cup...puC......K.....Ohhhhh, Beauty, full, vessel:,* by Layard Thompson, Dance Theater Workshop, New York, NY
2009	*The Lily's Revenge,* by Taylor Mac, HERE Arts Center, New York, NY (collaborative performance)
2010	*Re:Galli Blonde (A Sissy Fix),* by Justin Vivian Bond, The Kitchen, New York, NY (collaborative performance) *Easter Bonnet,* Broadway Cares/ Equity Fights AIDS benefit, Minskoff Theatre, New York, NY *There Is So Much Mad in Me,* by Faye Driscoll, Dance Theater Workshop, New York, NY *Heavens What Have I Done,* by Miguel Guiterrez, Center for Performance Research, New York, NY *A Night at the Tombs,* by Bianca Leigh, Theatre Askew, New York, NY *Justin Bond: Christmas Spells,* Abrons Art Center, New York, NY The Crystal Ark, "The City that Never Sleeps" [video], https://www.youtube.com/watch?v=5jH9zr5I-tE
2010–present	Puppet Parlor, HERE Arts Center, New York, NY
2011	*The Walk Across America for Mother Earth,* by Taylor Mac, La MaMa Experimental Theatre Club, New York, NY
2014	*Happy Tranniversary!,* by Justin Vivian Bond, Poisson Rouge, New York, NY *Football Head,* by Chris Tanner, La MaMa Experimental Theatre Club, New York, NY

2015 *I Promised Myself to Live Faster*, Pig Iron Theatre Company, Humana Festival, Louisville, KY
 Chang(e), by Soomi Kim, HERE Arts Center, New York, NY

2016 Bombay Ricky show, Prototype Festival, HERE Arts Center, New York, NY

2016–19 *A 24-Decade History of Popular Music* by Taylor Mac, Developed and Produced by Pomegranate Arts
 & Nature's Darlings, multiple iterations and venues (collaborative performance)
 Taylor Mac's Holiday Sauce, Developed and Produced by Pomegranate Arts & Nature's Darlings,
 multiple iterations and venues (collaborative performance)

2017 *Dito & Aeneas: Two Queens, One Night*, Opera Philadelphia, PA
 Sister's Follies: Between Two Worlds, by Julie Atlas Muz, Basil Twist, Joey Arias, Abrons Art Center,
 New York, NY
 Opium by Spiegelworld, The Cosmopolitan of Las Vegas, Las Vegas, NV
 Taylor Mac Sings 'Amazing Grace,' The Curran Theatre, San Francisco, CA. Directed by Ezra Hurwitz.
 [music video]

2018 Grand Marshall, Village Halloween Parade, New York, NY
 Do You Want a Cookie?, Bearded Ladies Cabaret, Fringe Festival, Philadelphia, PA

2019 *Treasure*, Guggenheim Foundation Works & Process, Solomon R. Guggenheim Museum, New York,
 NY (solo and collaborative performance)
 Ghost Town in the Sky, Guggenheim Foundation Works & Process [video], https://www.youtube.com/
 watch?v=Jq4RwYcVmGw
 Heliotropisms, Moody Center for the Arts, Rice University, Houston, TX
 Late Night Snacks, Bearded Ladies Cabaret, Fringe Festival, Philadelphia, PA

2020 *The Fre*, by Taylor Mac, Flea Theater, New York, NY
 The Painting, The Pocantico Center, Mount Pleasant, NY (solo performance)

2021 *Whitman in the Woods*, Film Shorts Conceived and Performed by Taylor Mac. Directed by Noah
 Greenberg. Produced by Pomegranate Arts, Nature's Darlings, and Fat Squirrel for WNET Group's
 ALL ARTS
 Egg Yolk, by Taylor Mac and Matt Ray, Lincoln Center Out of Doors, Lincoln Center for the Performing
 Arts, New York, NY

2022 *Sugar in the Tank,* by Taylor Mac and Matt Ray, Joe's Pub, New York, NY
 NEO NOWWW. opticnerve™; directed by Godfrey Reggio [film]
 The Hang, by Taylor Mac and Matt Ray, HERE Arts Center, New York, NY

Selected Bibliography

Albrecht, Donald. *Gay Gotham: Art and Underground Culture in New York*. New York: Skira Rizzoli
 Publications, 2016.

Als, Hilton. "Machine Dazzle Embodies a New Kind of Surrealism." *The New Yorker* 94, no. 33
 (October 8, 2018): 74–75.

Alvarez, Jr., Eddy Francisco. "Finding Sequins in the Rubble: Stitching Together an Archive of Trans
 Latina Los Angeles." *TSQ: Transgender Studies Quarterly* 3, nos. 3–4 (November 2016): 618–27.

Auther, Elissa. Machine Dazzle interview. Filmed January 15, 2020 at the Pocantico Center,
 Lenapehoking, NY. Video, 1:10:08. https://www.youtube.com/watch?v=sG2ZtB7fomc.

Auther, Elissa. "Miriam Schapiro and the Politics of the Decorative." In *With Pleasure:
 Pattern and Decoration in American Art 1972-1985*, 70–104. Los Angeles: The Museum
 of Contemporary Art, Los Angeles, 2019, https://www.artforum.com/performance/
 jess-barbagallo-on-machine-dazzle-s-treasure-at-the-guggenheim-80979.

Auther, Elissa. "Warhol, Wallpaper, and Contemporary Installation Art." In *Less Is a Bore: Maximalist
 Art & Design*, edited by Jenelle Porter, 160–75. Boston: Institute of Contemporary Art, 2019.

Barbagallo, Jess. "Here Comes the Son." *Artforum*, October 7, 2019.

Batchelor, David. *Chromophobia*. London: Reaktion Books, 2000.

Benjamin, Walter. *Selected Writings*, vol. 4, edited by Howard Eiland and Michael W. Jennings.
 Cambridge: Harvard University Press, 2006.

Bennett, Jane. *Thoreau's Nature: Ethics, Politics, and the Wild*. Thousand Oaks, CA: SAGE
 Publications, 1994.

Bisaha, David. "'I Want You to Feel Uncomfortable': Adapting Participation in *A 24-Decade History
 of Popular Music* at San Francisco's Curran Theatre." *Theatre History Studies* 38, no. 1 (2019):
 133–48.

Bryan-Wilson, Julia. "Handmade Genders: Queer Costuming in San Francisco circa 1970." In *West of
 Center: Art and the Counterculture Experiment in America, 1965-1977*, edited by Elissa Auther
 and Adam Lerner, 76–93. Minneapolis: University of Minnesota Press, 2011.

Cleto, Fabio. "Introduction." In *Camp: Notes on Fashion*, edited by Andrew Bolton, 1–9. New York and
 New Haven: The Metropolitan Museum of Art and Yale University Press, 2019.

Cleves, Rachel Hope. "Beyond the Binaries in Early America." *Early American Studies* 12, no. 3 (Fall
 2014): 459–68.

Coleman, Rebecca. *Glitterworlds: The Future Politics of a Ubiquitous Thing*. London: Goldsmiths
 Press, 2020.

Dozono, Tadashi. "Teaching Alternative and Indigenous Gender Systems in World History: A Queer
 Approach." *The History Teacher* 50, no. 3 (May 2017): 425–47.

Duarte, Anabela. "Lou Reed, Diamanda Galás, and Edgar Allan Poe's Resistance Aesthetics in
 Contemporary Music." *The Edgar Allan Poe Review* 11, no. 1 (Spring 2010): 152–62.

Edgecomb, Sean F. *Charles Ludlam Lives!: Charles Busch, Bradford Louryk, Taylor Mac, and the Queer
 Legacy of the Ridiculous Theatrical Company*. Ann Arbor: University of Michigan Press, 2017.

Eliot, T. S. "Burnt Norton." In *Collected Poems: 1909-1962*, 176. New York: Harcourt, Brace & World,
 Inc., 1963.

Galt, Rosalind. *Pretty: Film and the Decorative Image*. New York: Columbia University Press, 2011.

Goodman, Elyssa. "Meet the Artist Radically Queering the Field of Costume Design." *them.*,
 September 5, 2019, https://www.them.us/story/machine-dazzle-treasure-costume-design.

Gray, Sally. *Friends, Fashion and Fabulousness: The Making of an Australian Style*. Melbourne:
 Australian Scholarly Publishing, 2017.

Halberstam, Jack. *Wild Things: The Disorder of Desire*. Durham, NC: Duke University Press, 2020.

Hays, Gracie. "24 Decades, 24 Costumes." *The Curran[t]*, August 23, 2017, https://sfcurran.com/
 the-currant/interviews/machine-dazzle/.

Hernandez, Jillian. *Aesthetics of Excess: The Art and Politics of Black and Latina Embodiment*.
 Durham, NC: Duke University Press, 2020.

Isherwood, Charles. "Protestors Armed with Wigs and Sequins," *The New York Times*, January 20,
 2011.

Lichtenstein, Jacqueline. *The Eloquence of Color: Rhetoric and Painting in the French Classical Age*.
 Berkeley: University of California Press, 1993.

Liu, Sissi. "Designturgy, Being Queer: Taylor Mac Wears Machine Dazzle in 24 Decades." *Theatre
 Topics* 30, no. 3 (November 2020): 169–85.

moore, madison. *Fabulous: The Rise of the Beautiful Eccentric*. New Haven: Yale University Press,
 2018.

Muñoz, José Esteban. *Cruising Utopia: The Then and There of Queer Futurity*. New York: New York
 University Press, 2009.

Musto, Michael. "How Mayor Giuliani Decimated New York City Nightlife," *Vice*, March 6 2017,
 https://www.vice.com/en/article/bjjdzq/how-mayor-giuliani-decimated-new-york-city-nightlife.

Musto, Michael. "From the Vaults: A Tribute to Iconic '90s Gay Club Jackie 60 (November 1999)," *Out*, August 9, 2017, https://www.out.com/vaults/2017/8/09/vaults-tribute-iconic-90s-gay -club-jackie-60.

Román, David. *Performance in America: Contemporary U.S. Culture and the Performing Arts.* Durham, NC: Duke University Press, 2005.

Román, David, and Edgecomb, Sean F., eds. *The (Taylor) Mac Book.* Ann Arbor: University of Michigan Press, 2023.

Rosenzweig, Roy. *Clio Wired: The Future of the Past in the Digital Age.* New York: Columbia University Press, 2011.

Schwartz, Alexandra, ed. *Garmenting: Costume as Contemporary Art.* New York: Museum of Arts and Design and Lucia Marquand, 2022.

Sedgwick, Eve Kosofsky. *Tendencies.* Durham, NC: Duke University Press, 1993.

Sontag, Susan. "Notes on Camp." In *Against Interpretation*, 275–93. New York: Delta, 1964.

Trebay, Guy. "And Then the Clothes Come Off," *The New York Times,* May 19, 2010.

Warner, Sara. *Acts of Gaiety: LGBT Performance and the Politics of Pleasure.* Ann Arbor: University of Michigan Press, 2013.

Westerling, Kalle. "Review of *A 24-Decade History of Popular Music.*" *Theatre Journal* 69, no. 3 (September 2017): 403–15.

Young, Paul David. "The Historical Taylor Mac." *New York Live Arts*, January 12, 2015, https:// newyorklivearts.org/blog/context-notes-taylor-mac.

Zylinska, Juliana. *Minimal Ethics for the Anthropocene.* Ann Arbor: Open Humanities Press, 2014.

Contributors' Biographies

Mike Albo is a writer and performer. His books include *Hornito, The Underminer: The Best Friend Who Casually Destroys Your Life* (written with Virginia Heffernan), *The Junket,* and *Spermhood: Diary of a Donor*. He is a founding member of the Dazzle Dancers.

Elissa Auther, editor of this volume, is Deputy Director of Curatorial Affairs and William and Mildred Lasdon Chief Curator at the Museum of Arts and Design (MAD). She has published widely on a diverse set of topics, including the history of modernism and its relationship to craft and the decorative, the material culture of the American counterculture, and feminist art. Her book, *String, Felt, Thread: The Hierarchy of Art and Craft in American Art*, focuses on the broad utilization of fiber in art of the 1960s and '70s and the changing hierarchical relationship between art and craft expressed by the medium's new visibility. Her most recent exhibitions for MAD include *Surface/Depth: The Decorative After Miriam Schapiro* and *Vera Paints a Scarf: The Art and Design of Vera Neumann.*

Mx Justin Vivian Bond is a multi-hyphenate artist living in New York City. They have been awarded the Bessie, the Obie, and a Lambda Literary Award for Transgender Nonfiction and were called the greatest cabaret artist of their generation by *The New Yorker.*

Sally Gray is a curator and cultural historian whose curated exhibitions on art, fashion, history, and ideas have been shown in Beijing, London, Sydney, Melbourne, and galleries and museums in regional Australia. Her scholarly writing on art, fashion, queer cultures, and cities has appeared in refereed journals and books. Her 2017 book, *Friends, Fashion and Fabulousness: The Making of an Australian Style*, appeared in its second printing in 2019. She is currently working on a major project concerning the color pink and a new book on sexual politics and visual culture in the late twentieth century.

Taylor Mac is an American actor, playwright, performance artist, director, producer, singer-songwriter active mainly in New York City. In 2017, Mac was the recipient of a "Genius Grant" from the John D. and Catherine T. MacArthur Foundation.

Matthew Flower, aka Machine Dazzle, was born in Drexel Hill, Pennsylvania, and grew up in Texas, Idaho, and Colorado before living and working as an artist in New York City since 1994. Machine is a costume designer, set designer, art director, performer, and singer/songwriter.

madison moore is author of *Fabulous: The Rise of the Beautiful Eccentric* and an assistant professor of gender, sexuality, and women's studies at Virginia Commonwealth University in Richmond, Virginia. Their research and critical creative practice engages Black queer aesthetics, queer worldmaking, contemporary art, and visual culture. moore is currently working on *A Manifesto for Queer Nightlife* and *The London Sessions,* a critical exploration of gender, race, pleasure, and gentrification in London.

David Román is professor of English and American Studies at the University of Southern California. He's the author of several books on American theater and performance, including the award-winning *Acts of Intervention: Performance, Gay Culture, and AIDS* and *O Solo Homo: The New Queer Performance*. He is currently working on an edited volume on the work of Taylor Mac, *The (Taylor) Mac Book*. He serves on the board of directors of New York City's LAByrinth Theater.

Kalle Westerling is a performance scholar and historian. His doctoral research focused on itinerant drag performers around New York and along the Eastern Seaboard in the 1930s as part of a collective art form that brought queerness with them to towns and cities around the area. He has also written on topics ranging from queer indie wrestlers, boylesque and male-identified strippers in neo-burlesque, and the influence of "RuPaul's Drag Race" on the livelihood and aesthetics of contemporary New York City drag queens.

Published on the occasion of the exhibition *Queer Maximalism × Machine Dazzle* organized by the Museum of Arts and Design.

Museum of Arts and Design, New York: September 10, 2022–February 19, 2023

First published in the United States of America in 2022 by
Rizzoli Electa, A Division of
Rizzoli International Publications, Inc.
300 Park Avenue South
New York, NY 10010
www.rizzoliusa.com

Publisher: Charles Miers
Editor: Isabel Venero
Production Manager: Alyn Evans
Designer: Jesse Kidwell

Printed in China

2022 2023 2024 2025 / 10 9 8 7 6 5 4 3 2 1
ISBN: 978-0-8478-6967-1
Library of Congress Control Number: 2022935604

Visit us online:
Facebook.com/RizzoliNewYork
Twitter: @Rizzoli_Books
Instagram.com/RizzoliBooks
Pinterest.com/RizzoliBooks
Youtube.com/user/RizzoliNY

Pages 150–53: Assorted programs and flyers, ca. 2001–10. Courtesy the artist
Front cover photo: Gregory Kramer
Back cover: Machine Dazzle, Click + Drag 3.2: The Age of Aquarius, Santos Party House, 2010, New York, NY. Photo: Eileen Keane